LOOKING JEWISH

LOOKING
JEWISH

VISUAL CULTURE

MODERN DIASPORA

CAROL ZEMEL

INDIANA UNIVERSITY PRESS

Bloomington & Indianapolis

This book is a publication of

Indiana University Press
Office of Scholarly Publishing
Herman B Wells Library 350
1320 East 10th Street
Bloomington, Indiana 47405 USA

iupress.indiana.edu

Telephone 800-842-6796
Fax 812-855-7931

© 2015 by Carol Zemel

Manufactured in the United States of America

Library of Congress
Cataloging-in-Publication Data

Zemel, Carol M.
 Looking Jewish : visual culture and
modern diaspora / Carol Zemel.
 pages cm
 Includes bibliographical
references and index.
 ISBN 978-0-253-00598-4 (cloth : alk. paper)
— ISBN 978-0-253-01542-6 (ebook) 1. Jewish
art. 2. Jews in art. 3. Art, Modern—20th
century. 4. Art, Modern—21st century. I. Title.
 N7415.Z46 2015
 704.03'924—dc23

 2014044170

1 2 3 4 5 20 19 18 17 16 15

Cover: Photograph of Pearl Rabinowicz,
1900–1941. Daughter of Rabbi Yerachmiel
Tzvi Rabinowicz, Byaler Rebbe. Died with
her husband, Shalom Alter Perlow, 1941.

To the memory of my parents:

Joseph William Moscovitch, z"l
(Vaslui, Rumania, 1900–Montreal, 1949)

Beatrice (Rebekah) Greenblatt, z"l
(Izyaslavl, Ukraine, 1913–Montreal, 1981)

CONTENTS

PREFACE

I began this book many years ago, in what became a major reorientation of my scholarly work. I had just finished a book on Vincent van Gogh, and I returned to Amsterdam, the city that had nourished my interests for so many years, to seek a new direction. One rainy afternoon, I wandered into a bookstore across from the Amsterdams Historisch Museum, and saw among the tables, a remaindered stack of Roman Vishniac's *A Vanished World*. "Oh, yes," I remembered about the expensive publication, "those are the pictures of Jewish life I've wanted to see." Now the price was right. Still, I hesitated, moved away and back again several times, and finally decided that any images that left me, an art historian, so uncertain were surely worth investigating. I write about my ambivalent response to Vishniac's publication in chapter 3 of this volume. Visits in the next few days to the library of the Joods Historisch Museum led me to Moshe Vorobeichic's *Ghetto Lane in Vilna*. Naïve as I was about the pictorial repertoire of Eastern Europe's Jewish culture, the photographic combination of Vishniac and Vorobeichic emboldened me to explore the field of Jewish visual culture and self-imaging.

The new direction resonated with my long-held interest in my family's history. I was the child who badgered my parents, grandparents, great-aunts and -uncles about daily life in Vaslui in Rumania and Izyaslavl in the former Russian Pale. They indulged my curiosity, but with a certain reticence: they reported fragments—who was related to whom, who lived in

a "better" part of town, who read forbidden books, who married by family arrangement and who for love. The most stirring part of their narrative was the family flight from the marauding forces of the 1919–20 Petlura uprising in Ukraine: their journey through Poland, winter on the ship in Antwerp's harbor, and finally, arrival in Canada in 1921. By the time I was a young adult, ready to supplement their story fragments with fuller interviews, the grandparents' generation was gone. At the same time, my parents' desire for acculturated bourgeois Jewish life in Montreal distanced me from what I later learned was the city's rich Yiddish-ist culture. Though they too were fluent Yiddish speakers and moderately observant, for my family, that world was past. Even after the arrival of cousins who had survived the Shoah, little was said beyond "nothing and no one" remained. History may have documented their past, but memory shut down.

Amsterdam then, for me, became a site of a restored Jewish imaginary. Holland had, after all, a long history of Jewish tolerance. Expelled from Catholic Spain, large numbers of Jews sought refuge in the Protestant Dutch Republic at the end of the sixteenth century, and notwithstanding the wartime loss of 75 percent of Dutch Jews, I assumed a thriving and largely Jewish population had existed there—much as they had in Canada. It did not strike me as unusual that the Dutch Jews who became close friends were so thoroughly assimilated that they knew very little of Jewish custom and practice.

That summer too, I read Isaac Bashevis Singer's novella *The Certificate*, and at last learned of a world that seemed entirely new to me: a society of modern Jews—men and women—in prewar Warsaw, who were secular, intellectual, politically radical, and culturally productive. Drawn to a modern Jewish history that I had scarcely imagined, I determined to explore its culture and its visual field. For those who lived it, and for me looking back, I wondered: how did that world look, and how and what did it see?

There seemed no clear place for such a project in the art history I knew. "Jew in the home, but not as your scholarship" was the tacit variant of a familiar maxim. No place for Jewish art as such, even though modern art history was organized along national and anthropological lines—French art, American art, Oriental art, primitive art. Jewish art might mean Israeli art, but most often it referred to ancient archaeology and Judaica—ritual

objects, medieval manuscripts—or in the modern period, synagogue ar-
chitecture. I realized, with some chagrin, that the Jewish visual culture
that interested me had an uncertain place in the histories of modern art.

I came to see this as a challenge of diaspora. I was a Canadian woman,
raised in a minority culture (Jewish) that was part of a larger powerful mi-
nority (English-speaking) culture that dominated the majority (French-
speaking) society of Quebec. That complex layering had seemed normal
to me. I now recognized it as the multifaceted norm of diaspora's double-
consciousness. The structural challenge became clearer as I sought to
explore work by artists whose work referred to their Jewish identity, and
who achieved recognition and success among both Jews and the non-
Jewish cultural mainstream.

In the course of this project, I have been helped and encouraged
by many friends and scholars. Elissa Bemporad, the late Peter Yankel
Conzens, Margherita Pascucci, and David Shneer, fellow students at the
YIVO/Columbia Yiddish Summer Program, shared their enthusiasm and
expertise, and welcomed me into a new scholarly environment. I am grate-
ful for their continuing friendship and stimulating company. In 2000–
2001, I was fortunate to receive a fellowship for study at the University
of Pennsylvania's Center for Advanced Judaic Studies. As I embarked on
this book, my research and writing was invigorated and challenged by my
colleagues there; I thank Zachary Braiterman, Amy Horowitz, Barbara
Kirshenblatt-Gimblett, Gideon Ofrat, Anna Shternshis, Susan Suleiman,
and Nina Warnke for their wise counsel. Philadelphia scholars Laura Lev-
itt and Michael Steinlauf, frequent visitors to the Center's colloquia, of-
fered further advice and encouragement through the thickets of my new
field. By great good luck, in Philadelphia I shared the home and friendship
of Wendy Steiner; the breakfast table on Pine Street soon rivaled the Penn
Center in its play of ideas and intellectual adventure.

In 2001, I returned to Canada and Toronto's York University, where I
have learned immeasurably from new friends and colleagues. I thank Ju-
dith Hamilton, Yvonne Singer, Shelley Hornstein, and Sara Horowitz, for
their insights and continuing support. I have relied intellectually, socially,
and emotionally on the adventurous minds and considerable humor of
my friends Deborah Britzman, Alice Pitt, Sharon Sliwinski, Jeff Peck, and
Tim Forbes. They have made Toronto feel like home.

At the YIVO Archives, I benefited from the wisdom and generosity of archivists Krysia Fisher and Marek Web. At Indiana University Press, I thank Janet Rabinowitch for taking on my manuscript, and thank Robert Sloan, Jenna Whittaker, Darja Malcolm-Clarke, and copy editor Carol Kennedy for their careful attention to my text and for easing the manuscript along the journey to publication.

Portions of these chapters appeared earlier in the following publications: "Diaspora Culture, Photography and Eastern European Jews," chapter 1 in *Diaspora and Modern Visual Culture,* ed. Nicholas Mirzoeff, Routledge Press, 1999; "'My, Zydzi polscy . . .': tozsamosci artystyczene Brunona Schulza" (Polish), chapter 2 in *Polak Zyd, artysta; Tozsamosc a awangarda,* ed. Jaroslaw Suchan, Lodz: Muzeum Sztuki, 2010; "*Zchor!* [Remember!]: Roman Vishniac's Photo-Eulogy of Eastern European Jews," chapter 3 in *Shaping Losses: Cultural Memory and the Holocaust,* ed. Julia Epstein, Lori Lefkovitz, University of Illinois Press, 2001; "From Hadassah to Halakha: Queer Jewish Performance Art," chapter 4 in *Jews, Theater, Performance in an Intercultural Context,* ed. Edna Nashon, Brill Publications, 2011; "Diasporic Values in Contemporary Art," chapter 5 in *The Art of Being Jewish in Modern Times,* ed. Barbara Kirshenblatt-Gimblett and Jonathan Karp, University of Pennsylvania Press, 2008.

My diasporic journey began, of course, with my parents, Joseph William Moscovitch and Beatrice (Rebekah) Greenblatt. I dedicate this book to their memory.

LOOKING JEWISH

Introduction

... and let us make a name for
ourselves, lest we be scattered abroad upon
the face of the whole earth [Genesis 11:4].

In Diaspora, life has a force of its own. So would
Diasporist painting, never before particularly
associated with pariah peoples. For me, its time has
come at last.

—R. B. Kitaj, *First Diasporist Manifesto*

"Diasporist painting, which I just made up, is enacted under peculiar historical and personal freedoms, stresses, dislocation, rupture and momentum." So wrote the American Jewish painter R. B. Kitaj (1932–2007) in 1989, in a 128-page illustrated manifesto that declared himself—and many others—a diasporist artist.[1] This book takes up Kitaj's designation and uses it retrospectively to explore the history and challenges of Jewish visual art and culture in modern diaspora. Unlike most art history, which shapes its discourse around a national culture, my study centers on the cultural space of a minority population—a space that is occasionally bordered or fenced, but is more often fluid and irregular, and even defies a fixed geography. Rather than seeing diaspora culture as a sequestered ethnic pocket within a larger national scheme, it may be more accurate to consider it interactively, as cultural life in relationship to—and with—a neighbor, a contiguous but different society. My project is not,

then, to seek out Jewish artists and install them in a modernist canon. Nor is it about uncovering an established artist's little-known Jewishness. While the focus generally is on images of Jews by Jews and for Jews, the works I discuss are neither provincial nor parochial. Indeed, they exceed both the appeal and the confines of ethnic art production, and address instead a wide audience even as they incorporate the experience of the diasporic Jew.

Kitaj's ruminative text establishes some basic contours for this framework. "The Diasporist lives and paints in two or more societies at once," he wrote; "Diasporism, as I wish to write about it, is as old as the hills (or caves) but new enough to react to today's newspaper or last week's aesthetic musing or tomorrow's terror. I don't know if people will liken it to a School of painting or attribute certain characteristics or even Style to it. Many will oppose the very idea, and that is the way of the world."[2]

Kitaj offers more ideas on diaspora's cultural forms, but this passage may serve as the gist, with its reference to "two or more societies at once" and to a perpetual presence—"old as the hills . . . new [as] today's newspaper . . . or last week's aesthetic musing . . . tomorrow's terror." Always with us—"old as the hills"—diasporism takes its form and formats from history; it nevertheless contained history's uncertainty, a dark side or "tomorrow's terror." And though Jewishness and Jewish history are major concerns, diaspora for Kitaj was neither exclusively Jewish nor a disparaging condition.[3] Rather he considered modernist art and its diasporic dimensions part of a wider phenomenon of people—and individuals—on the move, relocating, resettling in situations that were both uncertain and liberating. "Diasporism," the text states, "is an unsettled mode of art-life, performed by a painter who feels out of place much of the time," and further on, "I want to suggest and manifest a commonality (for painting) in dispersion which has mainly been seen before in fixed places."[4]

For Kitaj, diaspora's essence (if we can use such a term) is its unfixed and fluid character, hence the difficulty of pinning diasporist painting to any conventional aesthetic or national style. Attachments and associations may be evident in such work, but so too are signs and exploration of difference. The diasporist may be a quasi-outsider, but that status—evident in Kitaj's buoyant tone—also suggests a distinctive opportunity. As with any manifesto that calls for a glorious future, Kitaj proffers a rallying point

for Jews—and others—in acknowledging the shifting boundaries and cultural territories of the modern world.

"Paint it Jewish!" is Kitaj's exuberant call to undertake an uncharted journey.[5] With it, Kitaj encouraged a new view of modern art, one that acknowledged but also superseded the national paradigms that structure Western histories of art. Modern life, and especially post-Holocaust experience, demanded new artistic perspectives, a re-visioning of the conditions of creativity, and, as I shall discuss in the book's final chapter, meeting this challenge as a Jewish artist preoccupied Kitaj for the last two decades of his career. Picture it Jewish: so I might modify the proclamation to encompass other pictorial media, while reiterating Kitaj's sense of aesthetic urgency. What it would mean not only to imagine but also "to picture" in Jewish? And how, in the varied contexts of diaspora, would this artistic imperative extend beyond parochial Judaica, resist assimilation's disappearance, and embrace Jewishness among its several identities?

Ken Aptekar's deceptively simple painting *Albert: Used to Be Abraham* (1995) (figure 0.1) sets out issues of both diasporic life and cultural production. Engraved on glass, the title floats over a double portrait of a man, which in turn is based on a painting by seventeenth-century Dutch artist Isaak de Jouderville.[6] Looking slightly to his right in the picture's upper half and reversed in the lower section, Albert/Abraham appears in extreme close-up, with heavy dark brows over deep-set eyes, a highlighted cheek, longish nose, and full sensual mouth. We do not know which is the before or after view: which face is Abraham, which Albert? This is a name job, not a nose job, and the difference is hardly visible. As for the picture's subject, Abraham/Albert Aptekar, worked for many years for the Ford company in Detroit (he retired as vice president of the Tractor Division), and as his artist grandson put it, "Nobody there knew he was Jewish."[7]

This tale is familiar enough to diaspora's residents. In the painting, however, the barely discernible change signals more complex matters of culture and identity, for the assimilating maneuver occurs through portraiture, a genre dedicated to certifying individual and social identity. Further, Aptekar appropriates another artist's picture, hitching a ride for his own image and artistic identity on the composition and credentials of another. That de Jouderville—as homonym, Jewtown?—was a student of Rembrandt and his picture, for some time attributed to the Master, inten-

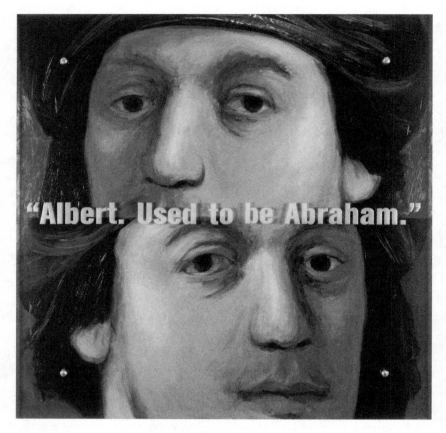

FIGURE 0.1

Ken Aptekar, *Albert, Used to Be Abraham,* 1995, 30" × 30" oil on
wood, sandblasted glass, bolts. Coll. Barbara and Steven Goldstein
Hertzberg, Great Neck, New York. Courtesy of the artist.

sifies the ironies in the modern work of layered identities. If Aptekar's sub-
ject illustrates assimilation's urge to masquerade, the picture's appearance
in the Jewish Museum's 1996 *Too Jewish* exhibition demonstrates further
the cultural maneuvers of that Jewishness.[8]

I shall return later in this book to Aptekar's pictures, their in-your-face-
Jewishness, and their presentation of Jewish masculinity. My purpose
here is to call attention to image production as a signifying practice of
Jewish diasporic life. I base my discussion on case studies, through which

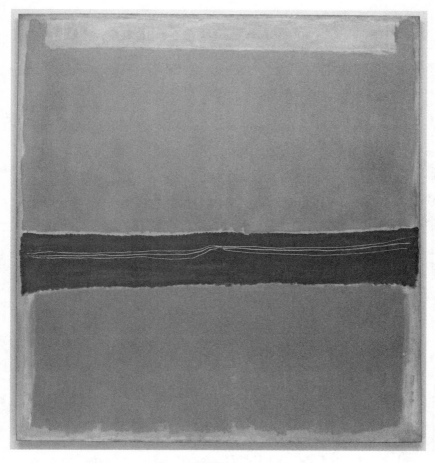

FIGURE 0.2

Mark Rothko, *No. 5/ No. 20*, 1950. ©Kate Rothko
Prizel & Christopher Rothko/ SODRAC.

I suggest a response to the question: "what in the modern period can we
consider Jewish art?" The issue has been a vexed one since nineteenth-
century formulations of the nation-state and Jewish participation in the
larger cultures of which they are a part. Does modern emancipation and
citizenship require assimilation—and potential erasure—as many Jews
feared, or an almost Marrano-like existence, as Aptekar's painting sug-
gests? In that frame, is Mark Rothko to be considered an American artist

without regard to his position as American Jew? (Figure 0.2.) The question itself invokes a hunt-and-peck search for an essentialized Jewishness to be found, willy-nilly, beneath the surface of all art produced by Jews. Are the atmospheric fields of color in Rothko's paintings, for example, interpretable in Jewish terms as a cloudlike sublimity that veils the face of God? Is modernist abstraction the only way to escape parochialism, or what critic Clement Greenberg called provincial content?[9] Or is the alternative for Jewish artists only a form of separatism, with appeal to a narrow public? What of the substantial diasporic position between these two poles, not easily subsumed within assimilation or ghettoization, where the art is as innovative as any in the broader cultural field, and appeals to multiple— sectarian and nonsectarian—audiences? Is this where we might place art by R. B. Kitaj, or Ken Aptekar or Eleanor Antin or Vera Frenkel—though both Kitaj and Aptekar have been critiqued at times as "too Jewish"? My interest in these questions is prompted by the present multicultural moment, the proclaimed end to artistic purities and universals, and the postmodern dismantling of hegemonic cultural forms. The consideration of Jewish visual culture as it appears in the modern multicultural mainstream illuminates, I believe, not only the vicissitudes of artistic success, but also the exigencies and the promise of diasporic life.

The five chapters in this book consider pictures by Jewish artists that deal with the status and character of Jews in modern diasporic communities. My focus is the culture of Ashkenaz: the Yiddish-speaking Jews of Eastern Europe and their North American descendants, who until recently constituted the majority of twentieth-century Jewish immigrants to Canada and the United States. The emphasis on modernity is crucial, for the changes wrought internally by the Jewish Enlightenment, or *Haskalah,* and externally by industrial capitalism, urbanization, and cultural modernism generally, produced sweeping changes in Eastern European Jewish community life. A small town or *shtetl* way of life, residue of enforced ghettos, and closely bound to the institutions and practices of traditional Jewish orthodoxy, metamorphosed into a secular bourgeois and proletarian society, with social and cultural forms that maintain and affirm Jewish identity, but are also related to the forms of the Gentile majority. The process, then, involves a diasporic community acutely aware of cultural challenge and which actively represents its own transformation.

Some account of diaspora, the term itself and its historical variation, is warranted here. The word derives from the Greek *diaspeirein,* to scatter or spread about, but to most Jews the word is less benign; it implies a disabling fragmentation and scattering of a once unified people. This unity stands as the "before," the time and space before dispersal, and as a cherished cultural myth, it evokes the site of "home" and territorial nationhood. But diaspora implies duration as well as geography. A diasporic people endures dispersal for lengthy periods. The longing for return remains, formulated in shared cultural rituals and reinforced by intercommunity ties, at the same time as the diasporic condition acquires its own coherence and becomes a way of life. Thus, more than the condition of exile, which is bound by memory and experience to a still-existing homeland, diaspora society is "at home" in its dispersal, and there it teeters between assimilation and difference with varying degrees of comfort or unease.

In its current formulations, the diasporic framework is nothing if not elastic.[10] Defining a Jewish model, William Safran proposed a six-point paradigm; among the features he deems essential for a diasporic people are incomplete acceptance by a host nation—though it is not clear what, beyond citizenship, this acceptance means—and the will to return and maintain an ancestral homeland.[11] The paradigm is familiar enough for Jews, though more than sixty years after the establishment of the state of Israel, the redemptive and teleological dimension of Zionism remains the subject of debate.[12]

At the same time, we can note the proliferation of diaspora studies in the academic world as evidence of diaspora's changing connotations and currency. As James Clifford points out, Safran's model of an ideal diasporic type does not allow for modern variants—the Black Atlantic, for one.[13] Nor does it embrace the postcolonial dimensions of contemporary diaspora theory, a model of social and cultural resistance advanced by scholars Kachig Tölölyan, Paul Gilroy, and others. A further and crucial dimension of diaspora—again, not part of Safran's schema, but central to the models of Homi Bhabha, Franz Fanon, Clifford, and others—is ambivalence. This is not unlike the double consciousness theorized by W. E. B. Du Bois early in the twentieth century for African Americans, for whom a constant sense of "two-ness . . . two souls, two thoughts, two unreconciled strivings; two warring ideals in one dark body"[14] may be

the only essential condition of diasporic peoples and their experience as juggled selves.

Given this ambivalence or doubleness, modern diaspora for Jews is not really encompassed by the Hebrew *Galut* or the Yiddish *Golus,* which insist on a sense of loss and redemptive hope. In the pluralist early twenty-first century, diaspora has become a willing choice for many people, someplace more immediate as home than as memory or mythic homeland. Indeed, diaspora is almost content outside of Eden. The "almost" is crucial, for a diasporic identity is always aware of its minority status, and in that respect, its assimilation is not complete. In that incompleteness lies its ambivalence: the discomfort but also the pleasure of diasporic life. Whether unable or unwilling to assimilate, diaspora challenges the ideological claims of the homogeneous nation-state.

One might argue that Jewish history has always contained a diasporic dimension. The word first appears in the earliest Greek translation of the Bible, where diaspora is used for the Hebrew *v'hefitz'cha* in Deuteronomy 28:64 ("The Lord will scatter you"). This itself, Michael Galchinsky observes, is a diasporic rendering, prompted by the Jewish presence throughout the Greek empire.[15] Whether myth or history, accounts of dispersal and resettling recur in ancient texts. The earliest perhaps is the story of the Tower of Babel, the third great catastrophe after the Expulsion and the Flood. (Figure 0.3.) The story enacts two forms of dispersal for the hubristic people unified in culture and language. One was a geographic scattering of population, which the people feared: "lest we be scattered abroad upon the face of the whole earth" (Gn 11:4). They did not foresee the second disruption—a confounding or loss of language, an estranging babble, which enforced acknowledgment of difference among them, as well.

Beyond biblical parable, diaspora became a mainstay of Jewish history. Ancient Babylonia, Sephardic Spain, the Mediterranean Maghreb, and Eastern European Ashkenaz are exemplary models where Jewish culture thrived as well as struggled. At the same time, for Christian cultures, the Jewish populations in their midst were managed as ghettoized strangers, content among themselves, but also symbolically cast as the exilic Wandering Jew, condemned to homelessness for refusal of Christianity. Indeed, with the French Revolution and emancipation of the Jews in 1791,

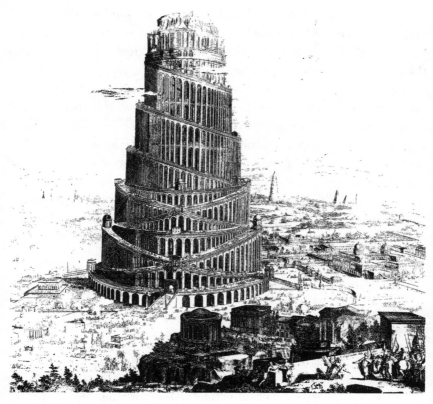

FIGURE 0.3

Athanasius Kircher, *Turris Babel*, 1679. Courtesy of Department
of Special Collections, Stanford University Libraries.

Jews shed some of their dislocated status, and cautiously joined a modern
citizenry.[16]

Emancipation provoked uneasiness on both sides. Nations with sizable
Jewish populations harbored anti-Semitic fears of Jewish power and influ-
ence. Many Jews feared that full citizenship in diaspora would lead beyond
acculturation to assimilation, absorption, and disappearance. The early
Zionist writer Ahad Ha'am (1856–1937), for example, famously cautioned
against post-Emancipation life in diaspora. The condition of the French
Jews, he wrote in 1891, "may be justly defined as <u>spiritual slavery under the
veil of outward</u> freedom. . . . At least, I have not sold my soul for emancipa-

tion."[17] The issue stirred considerable debate, as the modernizing force of Haskalah in Eastern Europe modified a culturally sequestered orthodoxy, the Jewish Bund founded in Vilna in 1897 created a Jewish proletariat, and the nationalist Zionist project gathered strength.

A compelling voice in the first decades of the twentieth century in support of Jewish life in diaspora was that of the Russian Jewish historian S. M. Dubnow (1860–1941).[18] Committed to the notion of Jews as a nation, Dubnow nevertheless promoted an ideal "diaspora nationalism" or "cultural autonomism." Jewish minority populations, he contended, while enfranchised participants in their host state, would at the same time self-govern through their community institutions and educational programs. Repudiating religion alone as the basis of the Jews' survival, Dubnow argued for cultural and social community as the guiding force. "In the Diaspora," he declared,

> we must strive, within the realms of the possible, to demand and to attain
> cultural autonomy for the majority of the [Jewish] nation. . . . In order
> to strengthen the Diaspora we will use the weapons of national struggle
> which served us for thousands of years and which are adapted to the world
> view of our time. You ask what wall shall we erect in place of the fallen
> ghetto walls? Every period has its own architecture, and the powerful vital
> instinct will unmistakably tell the people what style to use for building the
> wall of national autonomy which will replace the former religious "fence
> to the fence," and will not at the same time shut out the flow of world
> culture.[19]

For Dubnow, nationhood based on territory was a less evolved—and a more aggressive—social form than the ethical nationalism that for centuries had bound the Jews in diaspora.[20] Eventually Dubnow came to accept the need for some national center, but it was hardly the conventional Zionist model, and more in line with his own ideals: "If the Diaspora cannot live a full national life without the center in Palestine, than the latter cannot possibly exist without a national Diaspora."[21]

Diasporist consciousness, in Dubnow's model, disavows territorial interests and focuses instead on institutional forms, self-expression, and consciousness. There is no political overthrow, no revolution, no upheaval: the diasporic move is both consolidating and broadening, interpenetrating with the surrounding culture, always conscious of difference, both

inside and partially outside the prevailing hegemony. While he could not predict the contours or precise content of modern Jewish autonomy, Dubnow insisted that an emancipated diaspora would be enhanced by interaction with its national hosts.

This model, where cultural production and interaction is a hallmark of diasporic vigor, presents a particular challenge to the writing of art history, which traditionally has considered artists and their work in terms of national characteristics and schools. In that paradigm, Jewish artists are an uneasy fit. Margaret Olin and Kalman Bland have detailed the ways in which modern historiographies of art and their emphasis on national character effectively denied anything but a parochial place for Jewish art by Jews, and at best, preferred assimilated artists who excluded Jewish content or issues of identity from their work.[22] Marc Chagall's modernist pictures are one example; their riotous color and Jewish themes were long considered decorative and parochial examples of second-tier Cubism. At the same time, Martin Buber and his fellow cultural Zionists sought to develop a concept of modern Jewish art within the nationalist frame with an exhibition of Jewish artists at the Fifth Zionist Congress in 1901.[23] Inspired by Ahad Ha'am's concerns that a cultural component was essential for the Zionist project, the exhibition and subsequent ventures—the establishment of the Judische Verlag and journals such as *Ost und West*— were meant to encourage a Jewish renaissance in the visual arts. Their overarching rubric, however, was Zionist, and so matched the territorial-nationalist terms of art historical ideologies, rather than the challenges of Jewish art in diaspora.

In the pluralist spirit of twenty-first-century postmodernism, however, with its disavowal of master narratives and exclusivist canons, the diasporic paradigm may thrive, developing its art and cultural forms for a local, national, and international community, and speaking meaningfully to those several audiences and constituencies. It insists, however, on some measure of difference. Diaspora's paradox, then, is its dual essence: sameness to and difference from the host or majority culture coexists with sameness and difference within the related diasporic group. This is the challenge confronting viewers of Frederic Brenner's ambitious compilation *Diaspora,* a weighty corpus of photographs of Jews all over the world, which seems to invite us to discern some essence among them.

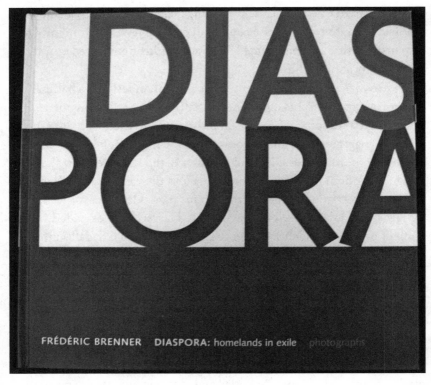

FIGURE 0.4

Frederic Brenner, *Diaspora: Homelands in Exile,* 2 vols.
(New York: Harper Collins, 2003), cover.

Our attention ricochets through an exotic parade, where most people seem like Jewish versions of their national hosts: Italian soccer players assembled in an ancient coliseum, sturdy Russian ironworkers, a gowned and turbaned woman in a whitewashed Yemeni lane, or Jewish sellers of Christian icons in St. Peter's Square.[24] In fact, its presentations of daily life and types supplies little visible similarity among Jews, and instead implies that what matters about diaspora is not the search for sameness, but the pleasures of national variety. Diasporic citizenship is a lively double consciousness, whether the currently fashionable hyphenated identity "Jewish-American," as Berel Lang has described it—or the combination with slash—"Jewish/American," as Louis Kaplan suggests.[25] And even

these two grammatical forms evoke variant possibilities: the hyphen's quiet parity, or the unsettled assertion of the slash.

Diaspora's usefulness, then, is its modification of art history's nationalist paradigm. Examining the production of art that on the one hand asserts a minority perspective, while on the other is nonsectarian and addresses a mainstream, brings into view the complexities of diasporic experience and less visible structures of hegemony. This is not simply an assertion of identity politics; it does not advocate separate spheres. What it does disclose is the messy interrelatedness and overlap of artistic production in avowedly multicultural societies.

The decade following World War I and the Russian Revolution augured well for many Jews in Eastern Europe and the Soviet Union. In 1919 the League of Nations Minority Treaties specified rights and protections for minority populations, and mandated the legitimacy of the nonhomogenous, multicultural state. The first of these treaties stipulated "total and complete protection of life and freedom of all people regardless of their birth, nationality, language, race or religion."[26]

Modern Jewish culture flourished in those years. The activities of the Yung Yiddish group and the Kultur Lige in Poland and the USSR respectively, stand as short-lived attempts to develop a diasporic Yiddish culture in Eastern Europe. But if the decade brought greater rights and modernizing acculturation for Jews in Central and Eastern Europe, it also witnessed Gentile backlash. As economic sanctions, professional limitations, and anti-Jewish violence continued, the waves of emigration dwindled as previously welcoming nations shut their gates. By the 1930s, the situation for Jews, initially promising, grew perilous as the force of fascism spread. The Shoah in Europe almost erased—but did not silence—Jewish culture in the area. In its aftermath, the richest vein of diasporic Judaism shifted to multicultural North America, where, spurred by the expansive formats of postmodernism, it continues to thrive.

Simon Dubnow acknowledged that he could not predict the forms of Jewish culture beyond the "fallen ghetto walls." The chapters in this study suggest responses to that diasporic challenge through case studies before and after the Shoah, in Eastern Europe and North America. The book begins in 1920s Poland, with photographic projects by Alter Kacyzne and Moshe Vorobeichic. A follower of S. An-sky, Kacyzne worked in theater,

film, and photography; Vorobeichic was a Bauhaus-trained photographer. Using different stylistic formats—documentary images and avant-garde montage—their photographs represent the concerns of Eastern European Jews in the first decades of the twentieth century: how to extend and consolidate the shift in Jewish society away from small-town or shtetl culture with its provincialism and its orthodoxies through the secular concerns of modernity. The images delineate not only a disappearing otherness, but also a process of social transformation. As documents of cultural change, their projects depended on interested audiences, at home and far-flung, who used the images to assuage both their nostalgia for and their ambivalence about the recent Jewish past.

Chapter 2, on images by Bruno Schulz, turns from mass circulation imagery to high art. Acclaimed as a writer in interwar (Polish) Galicia, Schulz was also a visual artist, who exhibited his drawings and etchings in Polish and Polish-Jewish salons. His pictures, like his stories, reached both Jewish and general Polish audiences, and this multiple reach shapes his diasporic success. In our own day, Schulz counts as a mainstream "modern," incurring what seem to be diasporic interventions, as the nations of Poland, Ukraine, and Israel dispute his identity and the rights to his oeuvre.

Like his stories, Schulz's pictures convey the desires and dangers of modernity through fantasy and sexual metaphor. The sadomasochistic etchings he produced in the 1920s were collected and later published as *The Booke of Idolatry* [*sic*]. Conventionally seen as Schulz's sexual confessional, the images draw on and underscore broader psychoanalytic and social metaphors of the Self. Read as expressions of modern Jewish masculinity, these scenes deploy the pleasures of erotic tableaux to force home the tensions and anxieties of diasporic difference.

Chapter 3 bridges the diasporic geographies of Eastern Europe and North America through pre–World War II photographs by Roman Vishniac and their postwar publication as *A Vanished World*. The chapter thus draws attention to visual formulations of Jewish identity before and after the Shoah. Part of the pictures' impact is the tale of their clandestine production, like secrets plucked from history. The story underscores the complexity of Vishniac's role in this enterprise, as a diasporic figure, who is part of, but also distant and even disguised from, the world of his cam-

era's eye. The pictures' postwar circulation and reception is also crucial here, for the ambivalence that animates Kacyzne's and Vorobeichic's images of Eastern European Jewish community acquires new dimensions in Vishniac's photo elegy. Inevitably framed by a horrific history, the images evoke multiple time registers of then/before and now/after, with terror and absence in-between. How, I ask in this chapter, do Vishniac's images extend the record and shape the memory of Jewish experience?

With Chapter 4, "Difference in Diaspora," attention shifts to North America, and the reformulation of gender stereotypes as markers of modern Jewish identity. The essay begins with the changing character of the Jewish Mother in the New World, and links the move from nostalgia for a *Yiddishe Mama* to assimilated dismay at the vulgar and manipulative Jewish Mother. The shift is paralleled by changing configurations of the unmarried Jewish woman from immigrant intellectual to ghetto girl to Jewish American Princess. Modeled within the Jewish community, these formulations of femininity are responsive to assimilationist pressures in the American diaspora. As stereotypes, these figures loom large in mass culture—TV, film, popular literature. Their more limited representation by Jewish artists in high culture, however, suggests a silence about what has been "too Jewish" in art criticism and history's professional frame. In their effort to escape or to critique the stereotype, incarnations of Jewish femininities by Eleanor Antin, Rhonda Lieberman, and Rebbetzin Haddassah Gross and the interrogation of Jewish masculinity in paintings by Ken Aptekar disclose the details of cultural confinements and diasporic difference.

The concluding chapter, "Diaspora Now," examines late-twentieth-century art that conveys diaspora's continuing cultural force. Works by Jewish artists R. B. Kitaj, Ben Katchor, and Vera Frenkel explore the vagaries of Jewish identity in a post-Holocaust and postmodern environment. Kitaj's paintings of the Jew as refugee-immigrant gives form to his *First Diasporist Manifesto* (1989), a text that strives, as I have suggested, to enunciate a distinctive position for the modern Jewish artist. Katchor's *Jew of New York* (1998) and Frenkel's . . . *from the Transit Bar* (1992) take another tack. Katchor presents a visual narrative in the form of a graphic novel, relying on a mass culture genre to deliver a pseudo-mythic tale of diasporic travel and resettlement, as Mordechai Immanuel Noah, the Jew of New

York, searches for a modern Ararat or Jewish homeland in the New World. Frenkel's mixed-media installation explores the pleasures and tensions of ethnic identity among an imagined community of travelers—not all Jews, but all of them emigrants from some tyranny and upheaval. What, her work asks through the travelers' stories in a railway station bar, constitutes the psyche of displacement, its social discourses and fantasies? Displacement, resettlement, the loss and potential reestablishment of home: all of these diasporic situations, I argue, are represented by Kitaj, Katchor, and Frenkel as conditions—even founding conditions—of today's multiculturalism. My argument, then, is upbeat, but not utopian—indeed, diaspora never is. Rather, I suggest throughout this study, diaspora endures not as a tragic situation, but as a challenge and an enriching dimension of modern history.

1

~~~~

## Beyond the Ghetto Walls:
## Shtetl to Nation in Photography by
## Alter Kacyzne and Moshe Vorobeichic

I begin with the Jewish culture of Ashkenaz, the vast region that stretched from modern Lithuania through Poland, Russia, and Ukraine, where Jews lived in great number from the sixteenth to the twentieth centuries. In 1797, with much of the region under Russian control, the Russian Empire declared the area a "Pale of Settlement" (map 1.1), intended to confine the Jewish population, as well as to serve as a buffer zone between the Russians and Poles. For Jewish inhabitants, however, the Pale became a supranational territory, which was a space of diasporic culture and consciousness that transcended shifting frontiers, and whose landmarks were synagogues, study centers, and rabbinical courts. Within the Pale, Ashkenazi Jews developed an extensive shtetl (small town) culture, by which is generally meant a Yiddish-speaking, provincial society, orthodox in its religious practice and traditional Jewish way of life.[1] By the 1920s, however, this shtetl culture had been transformed by half a century of modernization, secularization, and emigration to cities in Europe and America. For many Jews, this was an ambivalent undertaking: an escape from ethnic and economic oppression, but also an escape from "self" or home, and a flight from the shtetl's fixed traditions and orthodoxy.

Images of Eastern European Jews produced in the 1920s and '30s by Jewish photographers Alter Kacyzne and Moshe Vorobeichic represent this change and its ambivalence. Their work is similar in subject, but different in photographic style: pictorialist documentary in the case of Kacyzne's images, modernist photomontage in Vorobeichic's work. Both

17

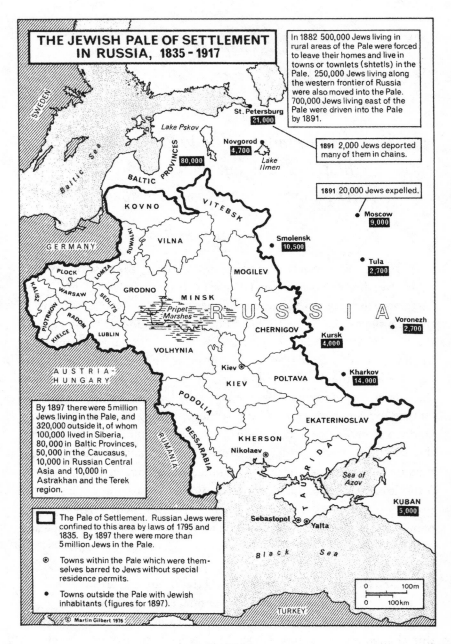

## THE JEWISH PALE OF SETTLEMENT IN RUSSIA, 1835 - 1917

In 1882 500,000 Jews living in rural areas of the Pale were forced to leave their homes and live in towns or townlets (shtetls) in the Pale. 250,000 Jews living along the western frontier of Russia were also moved into the Pale. 700,000 Jews living east of the Pale were driven into the Pale by 1891.

St. Petersburg 21,000

Lake Pskov

Novgorod 4,700

Lake Ilmen

1891  2,000 Jews deported many of them in chains.

SWEDEN

Baltic Sea

BALTIC PROVINCES 80,000

1891  20,000 Jews expelled.

Moscow 9,000

KOVNO

VITEBSK

Smolensk 10,500

SUWALKI

VILNA

GERMANY

MOGILEV

Tula 2,700

PLOCK

LOMZA

GRODNO

MINSK

KALISZ

WARSAW

SEDLITS

Pripet Marshes

R U S S I A

Voronezh 2,700

PIOTRKOW

RADOM

LUBLIN

VOLHYNIA

CHERNIGOV

Kursk 4,000

KIELCE

AUSTRIA-HUNGARY

Kiev

KIEV

POLTAVA

Kharkov 14,000

PODOLIA

By 1897 there were 5 million Jews living in the Pale, and 320,000 outside it, of whom 100,000 lived in Siberia, 80,000 in Baltic Provinces, 50,000 in the Caucasus, 10,000 in Russian Central Asia and 10,000 in Astrakhan and the Terek region.

RUMANIA

BESSARABIA

EKATERINOSLAV

KHERSON

Nikolaev

Sea of Azov

T A U R I D A

KUBAN 5,000

☐ The Pale of Settlement. Russian Jews were confined to this area by laws of 1795 and 1835. By 1897 there were more than 5 million Jews in the Pale.

⊙ Towns within the Pale which were themselves barred to Jews without special residence permits.

• Towns outside the Pale with Jewish inhabitants (figures for 1897).

Sebastopol

Yalta

B l a c k     S e a

0        100m
0        100km

© Martin Gilbert 1976

TURKEY

MAP 1.1

Pale of Settlement, *Routledge Atlas of Jewish History* (London: Routledge, 2010).

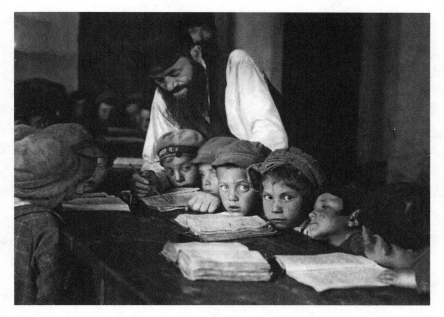

FIGURE 1.1

Alter Kacyzne, *Giving a Hint,* Lublin Kheder, 1924 photo. From the
Archives of YIVO Institute. Courtesy of the Forward Association.

photographers, however, represent a traditional society at a moment of
modernization, when the diasporic horizon of Jewish culture in Eastern
Europe was rapidly changing. We can see signs of this modernizing en-
counter in Kacyzne's much-reproduced photograph of a *kheder* (school-
room) taken in 1924 (figure 1.1). The locale is Lublin, but the obscuring
shadows in the image mask the specificities of setting and render it ge-
neric: this is any prewar kheder in the Pale. In it, little boys in caps and
side-curls sit side by side, their chins barely reaching the reading table,
while a bearded *melamed* (teacher) hovers over them and—the exception
to countless tales of teacherly impatience—kindly guides them through
the *aleph-beyz* (ABCs). The image marks an important moment in a Jewish
boy's life, as he begins the journey from childhood play to religious study
and affirmation of his place among the "people of the book." Like most
kids, their attention wanders—this is part of the picture's charm. They
exchange glances, whisper, or daydream. But two wide-eyed fellows at

the image center, their heads visually punctuated by the melamed's white sleeve, stare down the table toward us, and doing so, they activate the picture's real dynamic: the sudden intrusion of camera and photographer, of technology and modernity, into this traditional space.[2]

Although it is structured differently, the picture by Moshe Vorobeichic made in 1931 (figure 1.2) is no less a confrontation of tradition and modernity. The encounter here is hardly intimate, as the viewer looks from some distance, almost separate from the depicted space. A white-bearded old man makes his way along the pavement of an arcaded street. In fur hat and flapping overcoat, clutching two canes and his *tallis* (prayer-shawl) bag under one arm, the man is determined, purposive, but also a somewhat awkward silhouette. And though dark figures in the background suggest pedestrians and commerce, the setting is mainly characterized by the man and the arched passage: both are aged and both are picturesque. Here too the picture's air of timelessness is interrupted, not however by the subject's attention to the intruding photographer, but by the picture's modernist style, where montage shatters the cohesion and the picturesqueness of the image and flash-forwards the Jewish elder into history as a small, pale, apparitional echo at the lower left.

Despite their differences, both images subject a traditional society to the modern viewers' scrutiny. And each photographer addressed his work to an expanding Jewish diaspora: Kacyzne, to a Jewish immigrant population in North America; Vorobeichic, to an international Jewish cultural elite. Today, however, the pictures' meanings are not always easy to define. Some see them as sentimental and nostalgic, emblems of collective memory in their photographic timelessness. Recent publication of Alter Kacyzne's pictures as *Poyln, Jewish Life in the Old Country*[3] reinforces this effect, with an art book format and finely printed images—so different from their initial newspaper appearance—calling attention to the photographer's artistry. At the same time, and almost inevitably, the photographs are shrouded, or "backshadowed" to use Michael Andre Bernstein's term, by the tragic aura of the Holocaust.[4] Not only do we look at these pictures with the poignant knowledge that most of their subjects were murdered in the war that was to come, the images themselves become predictive after the fact: the people and activities—indeed, the culture—shown are doomed, and the pictures seem to forecast that destiny. This backshad-

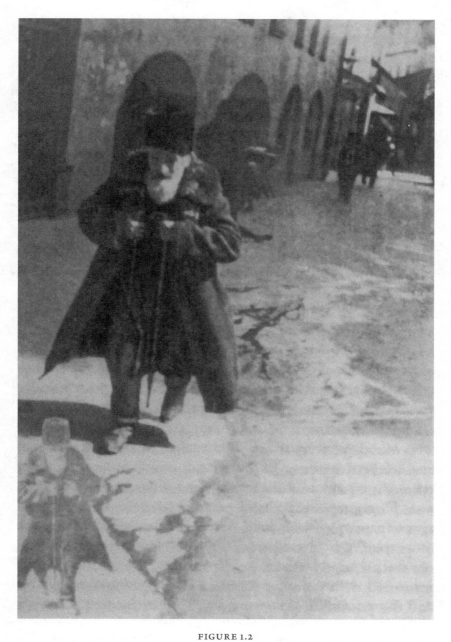

FIGURE 1.2

Moshe Vorobeichic, *The Day Is Short*, in *The Ghetto Lane in Vilna*, 1931.

owing effect began, one might say, with the New York daily *Forverts'* 1947 publication of *The Vanished World,* a photo book that included many of Kacyzne's images, and functioned as a collective *yizkher-bukh* (memorial book).[5] Of course, photographs in general seem to stop time; the future and death are held in abeyance, lurking at the edge of the frame, and given the scale of the Jewish catastrophe, some backshadowing is inevitable here. But without dismissing this postwar response, I believe these images deserve less tendentious readings that set aside the aura of impending doom and are grounded instead in the diasporic and nationalist context of those interwar years.[6]

With their ineradicable indexicality, or what John Berger refers to as their ability to quote rather than translate events,[7] photographs play a distinctive role in the preservation of historical moment and the writing of history. Indeed, as Walter Benjamin wrote in his "Theses on the Philosophy of History," for the modern historian "the true picture of the past flits by." "The past can be seized only as an image which flashes up at the instant when it can be recognized and is never seen again. . . . To articulate the past historically does not mean to recognize it 'the way it really was' (Ranke). It means to seize hold of a memory as it flashes up at a moment of danger."[8] Arguing that understanding the past is mediated through modernity's own concerns, Benjamin uses language that not only is visual and pictorial, but also mimes—with its references to flash and seizure—photography's impact and cognitive effects. Considering Kacyzne's and Vorobeichic's images today, the task for historians and viewers is to separate out the backshadowing nostalgia, to grasp the pictures' meaning for their time, and to seize the pictures' import for our own "moment of [diasporic] danger." Such preservation projects are themselves testimonies, not only to the desire to preserve a history, but also to the tensions of ongoing change.

Photographs especially—easily reproduced and recirculated—not only testify to a particular moment, they also have an extensive future life that expands the terrain of photographic historiography and memory. This phenomenon, what photo theorist Ariella Azoulay calls "the event of photography,"[9] encompasses the conditions of photographic capture—photographer, camera, image subjects—as well as viewers, which inflects

the pictures' later viewing and the histories they disclose. Unlike back-shadowing—where pictures are read through the imposition of a later history—the event of photography kindles a different sort of modern memory: the event worth photographing and how it might be deployed.

The 1920s and early 1930s augured well for the Jews of the Poland and the western Soviet Union or former Pale. As a protected minority in Poland and a recognized ethnic nationality in the USSR, the Jewish population in these regions enjoyed greater social and geographic mobility.[10] Many people left their rural villages and moved to cities, where they joined the expanding Bundist proletariat and growing Jewish middle class. Jewish art and culture flourished. Their achievements extended across literature, poetry, film, theater, music and the visual arts. In the Soviet Union, Marc Chagall, El Lissitzky, and Natan Altman infused their modernist styles with Jewish content, thereby declaring both continuity and a new expressiveness for Judaism in a revolutionary sphere. In Poland, Bruno Schulz addressed the challenges of Jewish modernization in his pictures, while Yankel Adler and others who formed the Lodz-based Yung-yidish group promoted the production of a modern Jewish art.[11]

As promising as these activities were, Jewish optimism—in all sectors—was also fraught with ambivalence. Educational and professional opportunities widened, but limitations remained. The urge to emigrate that had characterized the previous three decades continued, even as the most desired North American destinations closed their doors.[12] Zionist commitments grew at the same time, and after the Balfour Declaration of 1917, thousands of Jews emigrated to Palestine to develop a Jewish state. By that time, Jewish aid organizations such as the Hebrew Immigrant Aid Society (HIAS) and the Joint Jewish Distribution Committee (JDC) had been established to alleviate the deprivations of the poor and to enable the numbers trying to leave Europe. For Jews, then, the interwar period paradoxically saw both increased national consciousness and an intensified sense of diaspora, as the Jewish communities of Eastern Europe were consciously bound to their émigré relatives in Palestine and North America. Even if they were not planning their own departures—and many, especially on the Jewish political left, were not—family and community contact was maintained through letters and visits, and on a broader level,

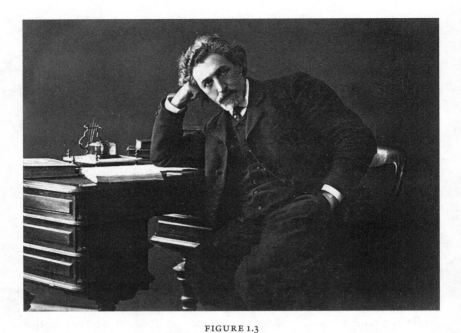

FIGURE 1.3

S. An-sky, 1903.

bolstered by cultural exchange and the international Jewish press. Ka-
cyzne's and Vorobeichic's photographs bear witness to the opportunities
and uncertainties of these decades.

There was some precedent for Kacyzne's documentary images[13] and the
meanings they evoked. The best-known is the work of writer and radical S.
An-sky (1863–1920) (figure 1.3), who in 1912 and 1913 toured the *shtetlekh*
of the former Jewish Pale with an ethnographic team that included his
young nephew Solomon Iudovin as photographer (figures 1.4, 1.5). The
expedition's three journeys were meant to collect and preserve the arti-
facts, customs, music, and images of a traditional provincial Jewish life.[14]
But An-sky also envisioned the project as the basis for Jewish renewal, an
inspirational and educational collection that would encourage a modern
Jewish future. Sponsored by Baron Naftali Horace Guenzburg and the
Historical-Ethnographic Society of St. Petersburg, the project ended with
the outbreak of the WWI, and the collected materials were presented as
a small exhibit in St Petersburg.[15]

FIGURE 1.4

Z. Kisselhof records folk melodies in Volynhia
township; photo, An-sky expedition, 1912–13.

One might see An-sky's personal trajectory from Talmudic scholar to
radical socialist to Jewish nationalist and Yiddish writer as emblematic
of the disruptive and transformative energies within Jewish communi-
ties in the later decades of the nineteenth century and early years of the
twentieth.[16] As was true of Ahad Ha'am and Simon Dubnow, neither re-
jection of Judaism nor assimilation was an option for modernizing Jews.
Acknowledging his own ambivalent path at a celebration in his honor in
St. Petersburg in 1910, An-sky described himself as having led a "broken,
severed, ruptured" life "on the borders between two worlds."[17] The ten-
sions of Jewish modernity resonate through An-sky's texts. The Yiddish
title of his best known work, *The Dybbuk* (1920), includes the phrase *Be-
tween Two Worlds* (*Tsvishn tsvey veltn [Der dibek]*)—a reference to the
realm of restless spirits in the story wandering between the living and the
dead, but also a metaphor for a new Jewish condition, poised between tra-
dition and modernity. Key figures in other An-sky tales like *Behind a Mask*

FIGURE 1.5

Jewish Museum, St. Petersburg, installation view, 1923.

(1909) or *The Sins of Youth* (1910) fill the dissenting world of the *maskilim* with a mixture of anger, excitement, and anticipation of broader horizons ahead. In this tumultuous cultural frame, the ethnographic project and its photographic component was a repository of Jewish folklore—which An-sky deemed, in part, an "Oral Torah"—meant to enable study and revitalization of a Jewish past.

Like An-sky's goals, Kacyzne's and Vorobeichic's projects were intended for widespread Jewish audiences. As self-images of a people—Jewish photographers photographing Jewish subjects for Jewish viewers—they are formulations of a Jewish social, cultural, ethnic—and implicitly national—identity, and as collections to be viewed through mass media rather than only visits to institutional sites, they describe in images what Benedict Andersen calls "imagined community"—that is, community based in national consciousness rather than fixed territory.[18] Stressing the effectiveness of print culture to the formation of that consciousness, Anderson notes George William Friedrich Hegel's characterization of reading the daily paper as a modern ritual "substitute for morning prayers."

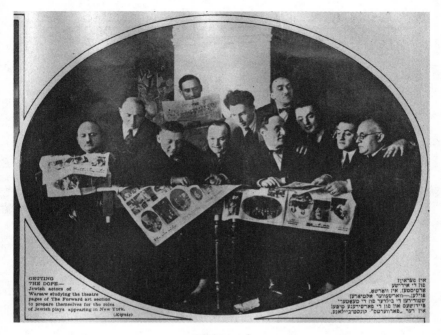

FIGURE 1.6

Menachem Kipnes, *Getting the Dope*. At the Jewish Actor's Union
in Warsaw . . . Warsaw actors study the pictures of the theater
pages and of the various types in the "Forward Art Section,"
June 6, 1926. Courtesy of the Forward Association.

"Each communicant," he writes—and the description is certainly apt for
these Jewish projects—"is well aware that the ceremony he performs is
being replicated simultaneously by thousands (or millions) of others of
whose existence he is confident, yet of whose identity he has not the slight-
est notion. . . . What more vivid figure for the secular, historically clocked,
imagined community can be envisioned?"[19]

Photography was quickly annexed to print technology; the weekly
rotogravure sections of papers like the New York *Forverts* were eagerly
anticipated and seemed to concretize the "now-ness" of press accounts
(figure 1.6). As visual presentations of a Jewish society circulated through
print media well beyond their points of origin, we might say that Kacyzne's
and Vorobeichic's photographic projects perform a cultural task, what

Homi Bhabha, in a literary context, labels "narrating-a-nation."[20] And like national epics, novels, or tales of panoramic social sweep, these collections selectively celebrate, critique, and render iconic aspects of Jewish identity and community life.[21]

The concept of nation-narration for these images is especially useful for modern Jewish diaspora because it can speak to the ambivalence that, Bhabha writes, "haunts the idea of the nation, the language of those who write of it and the lives of those who live it."[22] National consciousness, he argues, both cherishes its history and repudiates elements of its past. To accommodate this ambivalence, nation-narration is riven with polemic, it overdetermines its anxiety in stereotypes, and its emphases can be signposts of tension and disjuncture as well as strength. From a position of diaspora, with its varying degrees of assimilation and difference, the process of forming national consciousness may be even more ambivalent and complex. However uneasy their position among the Gentiles, overthrow of an imperial or occupying oppressor was not the diasporic position Jews sought.

Following WWI, Jewish self-consciousness as a diaspora people was underscored—encouraged as well as daunted—by the burgeoning nationalisms of newly constituted states of Poland, Czechoslovakia, Hungary, Rumania.[23] The tensions of diaspora loomed large. It is worth repeating Simon Dubnow's earlier invocation of Jewish national survival.

> In order to strengthen the Diaspora, we will use the weapons of national
> struggle which served us for thousands of years and which are adapted
> to the world view of our time. You ask what wall shall we erect in place
> of the fallen ghetto walls. Every period has its own architecture, and the
> powerful vital instinct will unmistakably tell the people what style to use
> for building the wall of national autonomy which will replace the former
> religious 'fence to the fence,' and will not at the same time shut out the
> flow of world culture.[24]

In many respects, the self-governing forms of the Jewish *kehilla* (community structure) and the social structures of the shtetl—schools, synagogue councils, social welfare and charitable societies, features that Dubnow deemed essential for Diasporic continuity—provided the framework for life beyond the "fallen ghetto walls." In cities like Minsk, Vilna, Warsaw, and Lvov, where the Jewish population swelled, shtetl governance

forms were augmented by a network of educational, social, and cultural institutions. By the 1920s, when Kacyzne's and Vorobeichic's pictures were made, the classic texts of modern Yiddish literature by Mendele Mocher Sforim, I. L. Peretz, Sholem Aleichem—texts in which the shtetl was already a mythic structure and the focus of considerable ambivalence—were well known to Jewish readers.[25] Further encouragement for modernization and national consciousness came through the press: Warsaw boasted more than a dozen Yiddish dailies in the same period, and a Jewish Press Photographer's Guild was established in that city in 1910.[26] Jewish art societies developed—the Yung-yidish group in Lodz, for example, or the Jewish Society for the Propagation of the Fine Arts in Warsaw.[27] The steady growth of these institutions and cultural production signaled the emergence of both a Jewish secular intelligentsia and a public that drew a provincial population into a modern and self-consciously national frame.

Alter Kacyzne and Moshe Vorobeichic were active figures in that interwar environment, although their photographic careers were rather different. Born in Vilna in a working-class family, Kacyzne apprenticed to a photographer. As an adult, he pursued a career as a novelist and playwright, but he also had a successful practice in Warsaw, photographing Jewish society and community events, and making portraits of his colleagues in Yiddish literary and theatrical circles.[28] Like the secular writers of the previous generation, Kacyzne too had become a middle-class professional who viewed the culture and society of the shtetl at some remove, and with a critical eye.[29] A devoted disciple of Peretz and An-sky—Kacyzne wrote the screenplay for the 1937 Yiddish film version of *The Dybbuk*—his admiration for An-sky's ethnographic expedition undoubtedly shaped his own documentary images, for he traveled, if not quite in An-sky's footsteps, through the provinces of Eastern Europe photographing scenes of Jewish life.

Where Ansky's expedition was born of preservationist and educational ideals, Kacyzne's efforts, largely commissions from Jewish agencies, have a somewhat different purpose: to connect and confront far-flung Jewish masses with images of their own recent history. His pictures set tableaus of social life and cultural practice in the pictorial language of documentary realism. In this genre, Kacyzne's images are not only perceived as truthful transcriptions of situations and events; they also function as visual alerts

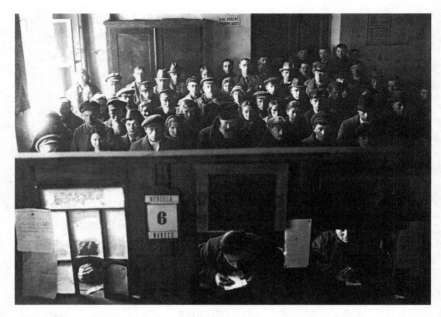

FIGURE 1.7

Alter Kacyzne, HIAS office, Poland, 1921. From the Archives of
the YIVO Institute. Courtesy of the Forward Association.

of social conditions—inequity, oppression, tragedy, as well as prosperity
and well-being. Looking at these images, the viewer is generally aligned
with the photographer, as someone separate from but nevertheless inter-
ested in the pictured sight. Through this realist syntax, photo-historian
John Tagg argues, the documentary camera establishes an affective rela-
tionship between viewer and image—it embeds the viewer as a subject-
participant in the pictured space—and doing so, animates social reality
at a moment of crisis.[30] Shot at a moment of mass population movement,
as numerous Jews left provincial towns for cities and the last great wave
of Jewish immigrants moved to America,[31] Kacyzne's pictures present a
complex program that is filled with nostalgia and idealism as well as social
comment.

In 1921, Kacyzne was commissioned by the Hebrew Immigrant Aid
Society (HIAS) to photograph Jewish immigration to the United States.[32]
The pictures' mission was clear: to detail a rescue of an impoverished

people by their more comfortable brethren in the American diaspora. Approximately one hundred images emphasize the tedious procedures of emigration—the interviews, the paperwork, and above all, the waiting. The dramatic design of this image (figure 1.7) splits the picture space into two zones: seen from above, the orderly crowd of applicants is still barred from their hoped-for future, while the camera's eye surveys the group from the position of privilege and access.

The pictured urgency and determination in these images may well have impressed Abraham Cahan, editor of the *Forverts*, the leading Yiddish daily in New York, with a circulation of over 200,000. From 1923 to 1930, Cahan commissioned Kacyzne to provide images of Eastern European Jewish life for the weekly rotogravure or "Art Section" of the paper; they appeared there as photo essays with titles like "The Principal Streets of Grodno, Poland" (December 30, 1923) or "Pictures of Jewish Life and Characters" (December 5, 1923) (figure 1.8). In an ongoing exchange of letters, Cahan and Kacyzne voiced the differences in their outlook. For Cahan, who described the photo essays as contributions from "our traveling photographer," and "our special artist photographer," and who encouraged representation of shtetl types and habits, the pictures enabled the conjoining of two diasporas—the Eastern European and the American—with the distinct impression that the pictured conditions of the old country meant it was better "over here." Kacyzne, seems to have agreed, at least in part, though he complained about the lack of variety in shtetl subjects and Cahan's lack of interest in his own ideas—both literary and pictorial—for the project.[33] His itinerary, he reminded the *Forverts* editor, was shaped by his own lecture tours and cultural projects, and as a poster for his lecture on "Literature, A National Treasure" in the background of a picture of Tshortkev (Ukraine) shows, Kacyzne actively promoted modern Jewish nationhood to old-country audiences as well.

Evidence of how a photographic event may modify with time, these tensions in Kacyzne's *Forverts* pictures are minimized in the recent publication *Poyln,* where a selection of his pictures is arranged to evoke what the editor describes as "the flow of life in Polyn." With eight sections, starting with "Approaching" and ending with "Leaving" (the HIAS photos), the book's organization effectively supplies its own narrative—one that locates the viewer as outside visitor and culminates with the idea of

FIGURE 1.8

Alter Kacyzne, Rotogravure page, *Forverts*, May 24, 1925. From the
Archives of the YIVO Institute. Courtesy of the Forward Association.

departure or flight. My selection here is meant to cut across the possibilities of a simple story or meaning and instead to call attention to recurrent themes of the original seven-year project. Grouped together in rotogravure's photo-essay design, the pictures' juxtapositions, repetitions, and combinations—single and group portraits, townscapes, domestic interior and workspaces, street and landscape scenes—delivered distinct messages as well as anecdote and data. Layouts and design clearly editorialize. Captions, some by Kacyzne but others by his editors, reinforced the essay themes. A pensive young seamstress pictured at her sewing machine, for example, is an unemployed worker, and her image is part of a group of pictures about strike and labor hardships in Bialystok in 1926. The pictures confirmed a sense of diaspora community for *Forverts* readers, and created a seemingly unmediated ethnography of a former Eastern European "home," but the recurrent rhythm of their appearance over five years delivers an ambivalent meta-narrative that is at once ideal in its picturesqueness and socially critical.

In some respects, Kacyzne's pictures reflect the genre of his studio practice, with dramatically lit close-up portraits of village workers and artisans. Often these subjects are named, giving a sense of specific history and identity to what might otherwise seem like stereotypes. The scenic pictures, on the other hand, were bound to the technological limits of the day. As handheld cameras did not arrive on the scene until the later 1920s, Kacyzne also applied studio techniques and equipment—tripods, lights, and so on—to capture what may seem to be less-managed views.[34] A shot of street-corner idlers, for example, may be a casual, unstaged moment, but even this kind of image required planning and mechanical setup.

Commemorative as well as documentary qualities appear in postcard-like images of synagogues, markets, and street scenes. Some are shown as landmarks, like the fortress synagogue of Gusyatin with its crenellated roof, crowning a hillside (figure 1.9). Meaning in such images is produced by the pictorial conventions of landscape—the romantic, the rustic, the picturesque—and by the capacity of the photograph both to generalize—or "logo-ize," as Anderson puts it—and to specify. To our eyes some two generations later, such synagogues, towns, and markets suggest a generic place; the market views could be any number of Jewish centers in the Pale, large and small, swarming with carts and horses, and figures hag-

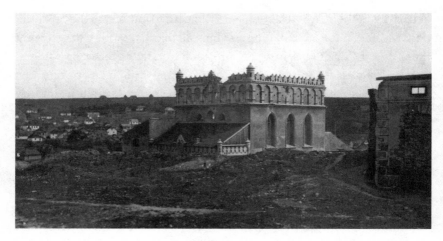

FIGURE 1.9

Alter Kacyzne, Fortress synagogue, Gusyatin, 1920s. From the Archives
of the YIVO Institute. Courtesy of the Forward Association.

gling for goods. But to immigrant readers of the *Forverts,* for whom it
was a familiar geography, it was also a world relinquished, and as much
as it triggered memory of *der heym* (home), and provoked regrets, it also
reiterated decisions to leave or to modernize. Whatever affection viewers
might feel at the sight of village streams, busy markets, wooden houses,
and synagogues was matched by the discomforting sight of muddy streets
and dilapidated houses, barefoot children in tattered clothing, bent old
men. This may be effective as nostalgia or ethnography, but it is hardly
a typical myth of national pride, or ownership. Synagogues are the only
monuments; houses are picturesque shelters, not property; the market
vistas are about exchange and barter; and in line with laws against Jewish
ownership, there is little sense of land or landedness. As cultural reportage
in the *Forverts*—that is, in an American diasporic frame—such pictures
confirmed the distance between the old-country conditions and the mo-
dernity of the new.

Other outdoor views show the disappearing traditions and village
types. As if at random—a hallmark of documentary style—Kacyzne's
camera takes in the incidents of the street (figure 1.10). A view of the Ukrai-
nian shtetl Kopychintsy shows a uniformed schoolboy and father at the

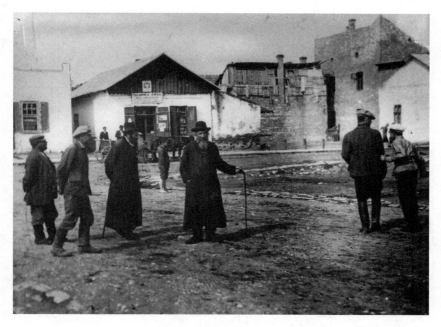

FIGURE 1.10

Alter Kacyzne, Street, Kopchintsy, 1920s. From the Archives of
the YIVO Institute. Courtesy of the Forward Association.

picture's margin, with a shoeless boy in the background amid waiting carts
and horses. The viewer's visual path to this child—a popular emblem of
rural poverty—must move through the framing figures of two older men
in the long-coated costume of orthodoxy, slow-footed on their canes, ne-
gotiating the mud.

Along with such scenes, where material discomfort and orthodoxy are
visually linked, are other traditional types: a romantically lit saddler (fig-
ure 1.11); an old man in the synagogue, enclosed in prayer and solitude; the
kheder boys beginning their study of religious texts (figure 1.1). Women
too appear as social genre. Market women embody a tradition of hard
work; bewigged religious women instruct groups of girls (figure 1.12);
elderly *bubbes* (grandmothers)—not loving mothers—nurture children
and evoke the affective space of family. As figures of traditional social
forms and orthodoxy, they too seem to fix shtetl society in an unmodern

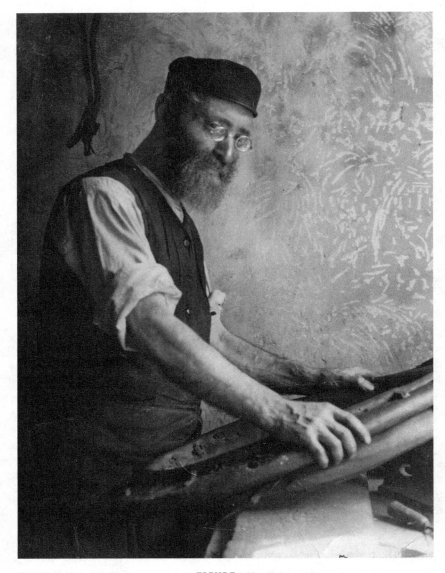

FIGURE 1.11

Alter Kacyzne, Yankev Szeranski, saddler, Volomin, 1920s. From the
Archives of the YIVO Institute. Courtesy of the Forward Association.

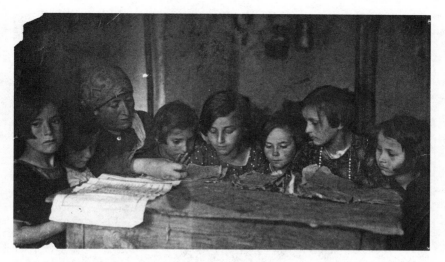

FIGURE 1.12

Alter Kacyzne, Girls' kheder, Laskarew, 1929. From the Archives
of the YIVO Institute. Courtesy of the Forward Association.

frame. And while icons of that society, they are also one pole of nation-
narration's ambivalence.

Indeed, Kacyzne's images are not a homogenous assembly of pictur-
esque types. Though they are certainly less numerous than the old-world
imagery, the social reach of his camera is underscored by images of a mod-
ern world: a team of tanners, a group of *gymnasium* teachers, striking
factory workers, and members of the socialist Jewish Bund (figure 1.13).
These pictures often frame special events or they are camera-staged group
portraits, and as such they lack the social flux and unplanned immediacy
of the street and market views. Their presence in Kacyzne's collection nev-
ertheless signals the variety of Jewish life in the region and its transforma-
tive possibilities. And taken together with the more picturesque imagery,
they suggest the social and institutional terms of a diasporic future: the
artisan becomes the industrial workforce, the orthodox scholars become
the teachers, the barefoot kids and kheder tykes form gymnastic and ath-
letic groups, street-corner idlers become the basis of the Bund.

Children abound in the pictures—impish, adorable, ragged, and piti-
able—they are a mainstay of ethnographic photography. Images of young

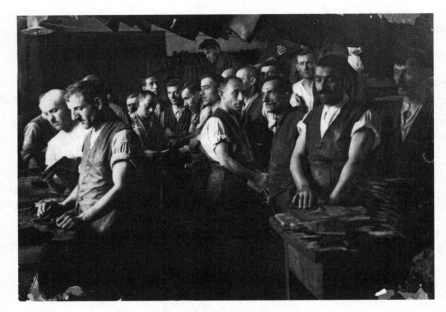

FIGURE 1.13

Alter Kacyzne, Bundist leather workers, Warsaw, 1929. From the Archives
of the YIVO Institute. Courtesy of the Forward Association.

men and women are less frequent, however, and only occasional signs of
the kind of Jewish intellectual and cultural life prominent in Kacyzne's cir-
cle. It is as if Cahan's mission for these photographic reports was bound to
the spaces, social concerns, and traditions of the laboring provincial Jew.
Imagery of family life centers on women—on bubbes, mothers, and chil-
dren rather than formal family groups. The plight of women abandoned
by émigré husbands appears in several pictures of mothers labeled as sole
support. The age difference in images like this grandmother and child
is underlined by a caption that reads "Meyer Gurfinkl's wife and grand-
daughter. Her father is in Washington. Her mother is dead" (figure 1.14).
Family, here, is fractured, dispersed, wounded by the harsh and changing
economy. Children, when not studying or peddling meager wares, are
shoeless urchins, playing in the muddy streets; on the brighter side, they
appear in the settings of social and institutional rescue: foundling homes,
sanatorium schools, summer camp.

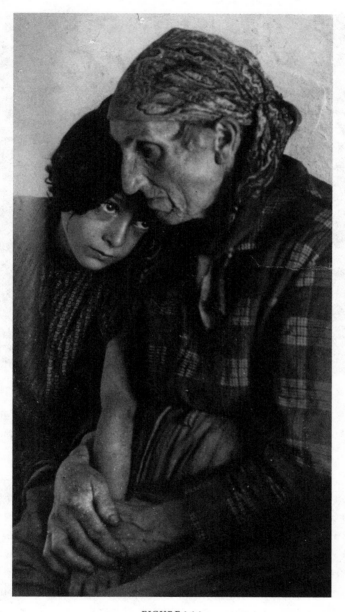

FIGURE 1.14

Alter Kacyzne, Meyer Gurfinkl's wife and granddaughter,
Karczew, 1920s. From the Archives of the YIVO
Institute. Courtesy of the Forward Association.

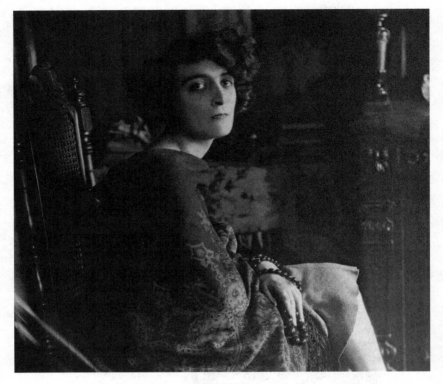

FIGURE 1.15

Alter Kacyzne, Miss Rabinowicz, the Byaler rebbe's daughter, 1927. From the Archives of the YIVO Institute. Courtesy of the Forward Association.

Given the differences between Cahan's and Kacyzne's aims—one to create a site of nostalgia and distance, the other to report on a changing society and its growing national consciousness—and Cahan's upper hand, it may not be surprising that pleasure and desire make brief appearances among these images. The dark beauty identified as "Miss Rabinowicz, the Byaler rebbe's daughter" (figure 1.15), is sultry, bejeweled, and surrounded by material luxury, a vaguely orientalized or exotic figure who could easily join the actresses and beauty queens in the *Forverts* picture page. For the most part, however, Kacyzne's photographs are remarkably decorous; physical pleasure and leisure appear as a clean living ideal, with posed group pictures of children's camps, sports teams, and clubs as representa-

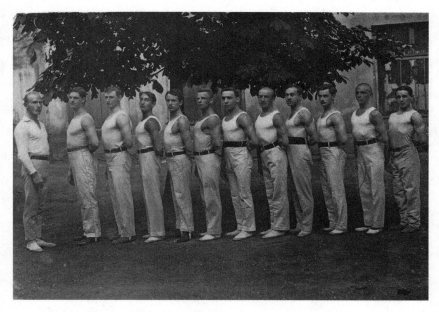

FIGURE 1.16

Alter Kacyzne, Sports club, Warsaw. From the Archives of the
YIVO Institute. Courtesy of the Forward Association.

tives of Jewish social modernity (figure 1.16). Occasionally we see Jew-
ish youth in farming communities, suggesting socialist or Zionist ideals,
and refuting notions of the landless or "nonnatural" Jew. And despite the
mixed emotions the pictures stirred for immigrants in America, the gen-
eral message was fairly clear: the alternative to traditional rural poverty
and corrupt capitalism was modern education, with progressive labor and
institutional forms. The numerous images of rustic poverty and work-
ers, the prominence of bearded elders and traditional types, the attention
to religious study and some secular education, the focus on old age and
childhood as past, present, and future—all this suggests a poor, pious, and
old-fashioned populace reshaping itself as a modern people and citizenry.

Part of the ambivalence, then, of these images as diasporic report and as
nation-narration appears in their fixing of a shtetl culture picturesque—
the mythic structure of "the Covenental Shtetl," to use David Roskies's
term—while at the same time using those terms, as Dubnow might have

prescribed, as a framework for the future. For readers of the *Forverts* in America, this was memory to be acknowledged and supplanted by what historian Ewa Morawska calls "a sweetness amidst fear and oppression"[35] the pictures emphasized difference and reframed immigrant guilt as nostalgia or relief. Even for Eastern Europe, where village landmarks, labor, learning, and prayer were a more immediate heritage, the images could underscore the temporal gap between the camera and its objects, the photograph's persistence, the viewer's modernity, and the shtetl as past. Through Kacyzne's camera, picturesque sites and social difference are documented as cultural emblems, even as the photos also point to new social formations and the vigor of modernity. These terms then are held in tension: How to modernize? How to use and transform the past? Cahan's answer, if we can call it that, was to end the series in 1929, abruptly informing Kacyzne that reader interest had waned.[36] Whatever the basis for his editorial decision, it was hardly closure on these questions; Kacyzne's images shape a mythos of modern Jewish consciousness that at once acknowledges, differentiates, and re-visions the possibility of a new diasporic home.

The ambivalent combination of tradition and modernity is very different in Moshe Vorobeichic's photographic album *The Ghetto Lane in Vilna*, published in 1931 (figure 1.17). While the picturesque Jewish quarter of Vilna might be called a "ghetto"—as neighborhood—the city was hardly a shtetl.[37] Vilna had been a center of Talmudic scholarship since the eighteenth century, when it was home to the renowned rabbi known as the Vilna Gaon. In the modern period, with Jews constituting about 40 percent of the total population,[38] the community also embraced secular achievement and scholarship. The Jewish labor organization, the Bund, was founded here in 1897, and in 1925 (the same year as the Hebrew University in Jerusalem) Di Organizatie fun der Yiddisher Vissenshaft [YIVO] was founded, dedicated to the study and promotion of Jewish history and modern Yiddish culture.[39] Like the literary construct of "the shtetl," by the 1930s, Jewish Vilna had acquired iconic status of its own as the "Jerusalem of Lithuania." The city was celebrated partly in these terms by the poet and novelist Zalman Shneour (1887–1959) in his six-part Hebrew poem "Vilna."

FIGURE 1.17

Moshe Vorobeichic, *The Ghetto Lane in Vilna* (Yidishe gas in Vilne), 1931.

Vilna, my great grandmother,
city and mother in Israel,
Jerusalem of the Exile, comforter of an ancient nation in the north!
Your patchy skull-cap, like the old synagogue's roof,
Sublime from your great-grandson's eyes when viewed from the golden tower
tops.[40]

With images that invoke youth, manhood, and old age, that meld the poor Jew's yarmulke with the synagogue roof, and that do so from sudden and strange perspectives, it is not surprising—as we shall see—that Vorobeichic sought Shneour's contribution to his project.[41]

Unlike Kacyzne, whose working-class origins led him to photography through commercial apprenticeship, Vorobeichic (1904–95), the son of a well-to-do family, studied in the Faculty of Fine Art at Stephen Batory University of Vilnius. But Vorobeichic looked beyond Vilna's traditional art milieu. From 1927 to 1929, he studied at the Bauhaus in Dessau, Germany—where his teachers included the great modernists Josef Albers, Lazlo Moholy-Nagy, and Paul Klee—and in that milieu, he adopted the vanguardist *nom-de-l'art* "Moi-Ver"—an acronym of his Yiddish name that, when read as "Me-Truth," also asserted his modernist identity and ambitions. The Vilna photographs were taken in 1929 on a trip home for Pesakh, but Dessau had already inspired him with its own double culture: vanguard art and a distinguished Jewish history. "Dessau," Vorobeichic wrote later, "was the city of Rabbi Moses Mendelssohn. One day, while I visited the library of the synagogue which bears his name, the sights I had left behind in far away Vilna came to my mind. The image of the pupil bent over his book in the old prayer house, the old man playing his fiddle in the lane, the child at his game of hopscotch."[42]

Vorobeichic's memories seem bound to a picturesque "far away Vilna," not the Jewish future of that community. As a developing avant-garde artist, he found his new and preferred cultural milieu to be Central and Western Europe, increasingly distant from the world of eastern Ashkenaz. To further his artistic goals, in 1929, he moved to Paris, a cultural capital with the bonus of a Jewish intellectual environment. A number of Eastern European Jewish artists—Chagall, Soutine, Kikoine, Kisling, Orloff, Lipschitz, Pascin, Mané-Katz[43]—worked there; the city had two

Jewish newspapers, and the intellectual community included writers like Zalman Shneour and others. The city was also a center of international modernism, where the artistic legacy of Cubism flourished and reinforced Vorobeichic's interest in the juxtapositions and fragmentation of photographic montage.

Working through the photo agency Globe-Photo, Vorobeichic—now Moi-Ver—published images in Paris magazines,[44] and with encouragement from Cubist artist Fernand Leger, he developed plans for the "Ghetto Lane." The book initiated a three-part project, featuring Vilna as a city of the past, Paris as the modern metropolis (with a preface by Leger), and a book of contrasted urban/nature images titled *Ci-Contre* (figure 1.18). But if the "ghetto lane" of Vorobeichic's title and his subjects enclose the work in a shtetl picturesque, the montaged images and bilingual captions were clearly meant for a modern, international Jewish milieu. The Swiss publisher, Verlag Orell Fussli, produced an edition of 12,500, with several bilingual formats in combinations of Hebrew, Yiddish, German, and English.[45] While hardly Kacyzne's immigrant *Forverts* audience, this too was a Jewish diaspora, one that was also ready to encounter Jewish Vilna from the outside looking in—not through documentary but through the radical forms of modernism. Shneour's introduction acknowledges both the project's modernism and its social purpose. "This Album," his essay concluded, "is not meant to satisfy the tastes of only the aesthetic few, but also the taste of the masses, to bring them in touch with the Jewish street. It shows true Jewish life and its ethnographic materials make it a handbook for everyone."[46]

Shneour affirmed the democratic spirit of the enterprise—"a handbook for everyone"—although this seems somewhat disingenuous—and he characterized the book as both ethnography and a progressive guide to "true Jewish life." Comparing Vorobeichic on Vilna to Chagall on Vitebsk—and in line with his own poetic combinations of traditional sights and startling points of view—Shneour explained the artistry of the picture's stylistic radicalism: "Vorobeichic has enlarged and accented the details not normally noticed by the hurrying passerby. With scissors he has cut out squares and circles, their narrow focus becoming especially meaningful, crammed with the contents of the Jewish lane.... The brittle,

FIGURE 1.18

Moi-Ver (Vorobeichic) photo from *Ci-Contre*, Paris, 1931.

cut-and-dried qualities so often found in photographs have been trans-
formed in the hands of a master. These pictures shape our understanding
of the Jewish lane the way a director shapes our understanding of a play."

Despite their daring high-art manner, the pictures compile a familiar
iconography: synagogues, laborers, bubbes and market women, rabbis and
old men. The book opens and closes with a smiling laborer bonded to the
elegant architecture of Vilna's great synagogue (figure 1.19). Then, in dra-
matically cropped and tilted images, the camera seems to zoom cinemati-
cally from point to point (figure 1.20). Streets are cobbled corridors seen
from odd angles, making the viewer an omniscient—but again, distant—
surveyor of these sites. Two pages showing books from the Strashun Li-
brary emblematize Vilna's scholarly culture and Jewish identity as "the
people of the book." Other pages rehearse the poverty and picturesque
types. A repeated pattern of wooden shutters encloses a seated market
woman; a cluster of hands evokes the stereotype of Jewish argument and
lively bargaining; a pile of tin and shoes labeled "The Wealth of Israel"
makes an ironic statement about Jews and money (figure 1.21); a group of
children montaged under the sheltering veil of a watchful bubbe-madonna
(like Kacyzne's picture of "Meyer Gurfinkl's wife and granddaughter") is
captioned to suggest generational contrast as "Two Worlds" (figure 1.22).

*The Ghetto Lane in Vilna* not only renders traditional sites and figures as
photographic icons, it uses a radical form of imagery to link their content
to modernity. Far more than Kacyzne's genre portraits and tableaus, the
album delivers not only a modern but also a modernist view of a tradi-
tional Jewish culture, and it does so with the skill of a former inhabitant
now moved outside. Max Weinreich's review in the *Forverts,* however,
complained about the album's emphases. Critical of what he deemed the
sentimentality of Shneour's essay, Weinreich saw a modern—though un-
realized—potential in the images. "We have here built up the synagogues
and the library with these folios, this proves that we are creative. Thus,
give us access to the treasures of the world! This is the language I feel to
be spoken by Vorobeichic's pictures. . . . I don't touch upon the question
of whether we shall succeed or not. I am talking merely of the striving for
sunshine."[47] Saying little about the pictures' style, Weinreich had other
misgivings. "If Vorobeichic wished to show that the Jewish lane is still
alive he has omitted plenty of material," he wrote, and concluded that "if

FIGURE 1.19

Moshe Vorobeichic, *Worker and Great Synagogue,*
in *The Ghetto Lane in Vilna,* 1931.

16. Streets seen from on high

.16  הסמטאות נראות יפות, מלמעלה

FIGURE 1.20

Moshe Vorobeichic, *Streets seen from on high,* in *The Ghetto Lane in Vilna 1931.*

FIGURE 1.21

Moshe Vorobeichic, *Your People Israel Is Rich,* in *The Ghetto Lane in Vilna,* 1931.

we can manage to present our idea the right way (to 'sell the idea,' as the Americans put it), then a greater interest can be expected just in that blend of old and new patterns of which we are witnesses in Jewish life of today." While he liked the mix of "old and new," Weinreich's commitment was to modern content, and he'd have been happier with a greater photographic range. But however much of modern Vilna was omitted from the album, as Maria Dmitrieva observes,[48] Paris—and later Palestine—signaled Vorobeichic's modernist future. Vilna remained a cherished past.

Even today, however, the book's format seems like a visual jolt. The fusion of traditional content and radical style in these images draws a poor, laboring, scholarly, and spiritual populace into modernist culture as pictorial fragments and artifacts. At the same time, the disruptions and juxtapositions that drive the pictures' formal success reify a distinctive identity. The fragmented figures, gestures, and objects become fetishized emblems of Jewish tradition, seized by the camera from the social clutter of the past to function as modernist icons of identity. The vanguardist view

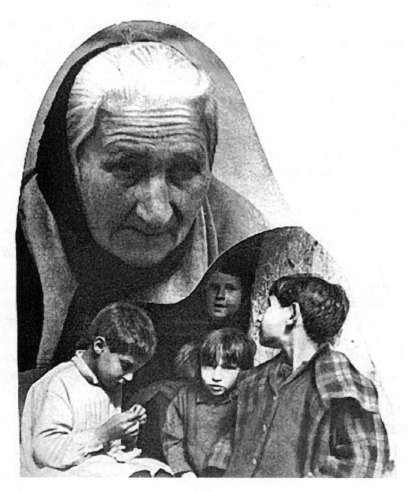

FIGURE 1.22

Moshe Vorobeichic, *Two Worlds,* in *The Ghetto Lane in Vilna,* 1931.

both mitigates nostalgia and reinforces it. This too is the ambivalence of nation-narration. Harnessing traditional Jewish culture to modernist discourse, Vorobeichic installed it in the protectorate of international modernism and so modeled yet another dimension of diaspora consciousness.

As different as are Kacyzne's and Vorobeichic's photographic strategies and audiences—one mass culture, the other high art; one emphatically proletarian, the other, stylistically at least, more bourgeois or elite—both

offer versions of a vital Jewish geography and cultural space. In distinctive ways, these representations of shtetl life and Jewish tradition play against but also to core structures of the modern nation: the poverty, piety, and difference of their laboring masses are the nation's strength and weakness, the tests of its opportunity and its tolerance. With their shared emphases and varying photographic styles, these collections mark out the sites, figures, and changing forms of an expanding Jewish diaspora.

The future of both photographers was bound to the coming catastrophe: Kacyzne was murdered by Ukrainian Nazis in Tarnopol in 1941; Vorobeichic emigrated to Israel in 1934, where, again renaming himself, this time as Moshe Raviv, he enjoyed a long artistic career.[49] Seventy years ago, the pictures may well have offered Jewish viewers moments of nostalgia and confirmation of the decision to modernize. But even with the political and social tensions of the interwar years, neither Kacyzne's nor Vorobeichic's pictures resonate simply as loss. To viewers now as then, they pose still urgent concerns of modernization, assimilation, and the status of a "distinct society" within the modern state. With less certainty and more complexity than conventional nationalism, the pictures pose both the pride and the ambivalence of modern diaspora consciousness and minority nationhood.

# 2

*Modern Artist, Modern Jew:*
*Bruno Schulz's Diasporas*

Until a recent custody battle over his murals, Bruno Schulz was best known as a Polish Jewish writer of phantasmagoric and mythic tales. The stories collected in *Cinnamon Shops* (1934) and *Sanatorium under the Sign of the Hourglass* (1937) are crafted in ornate embellished prose, and they spin out a wonder-filled vision of bourgeois life in a provincial Galician city much like Drohobycz, where Schulz lived all his life, and where he was murdered by a Nazi officer in 1942.[1] (Map 2.1, figure 2.1.) Schulz is renowned in Poland; his work is widely read, and since the late 1960s, through the restorative efforts of Jerzy Ficowski, there have been regular exhibitions of his drawings and prints.[2] But beyond those borders little close attention has been paid to Schulz's visual art, and in some ways, it is easy to see why. Even though he exhibited in Lodz, Warsaw, Cracow, and Lvov, and at times in Jewish exhibition venues,[3] his stories certainly reached the public more readily than his art. Many drawings were meant to accompany chapters of *Sanitorium under the Sign of the Hourglass,* and their status as anything other than text illustrations may not be clear. And there is also the explicit sexual content of Schulz's *The Booke* [*sic*] *of Idolatry* (1920–22), a collection of twenty-six prints that center on themes of masochism, with the artist's self-image as the primary figure of idolatrous behavior and self-abasement. For scholars and critics today, eager to celebrate Jewish art and artists, this is a far cry from the grandeur of biblical imagery or the shtetl culture pictured by Chagall.

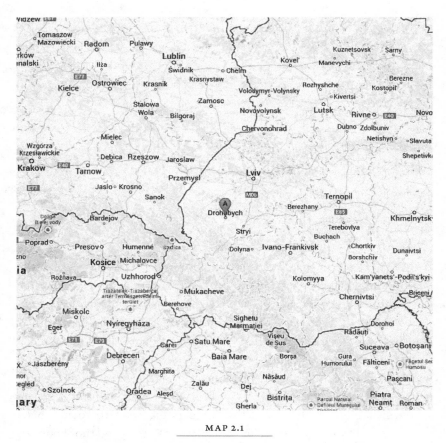

MAP 2.1

Galicia, Drohobych (Drohobycz), and environs. Google maps.

The comparison is worth exploring briefly, for like Chagall—the Jewish star in the modernist canon—Schulz is an example of a successful Jewish artist in diaspora. Like Chagall, he negotiated the multiple spaces of diasporic community: in Schulz's case, the social world of bourgeois Drohobycz, the cultural environment of the Polish avant-garde, and the life of a Polonized Jew. His bourgeois family of shopkeepers and bureaucrats (his brother Izydor was a director of a local oil refinery) spoke Polish, not Yiddish, at home. Like Chagall, Schulz drew on the familiarities of his childhood and family life in his work, and he was an active participant in the mainstream culture of his Gentile host nation. But while Jewish

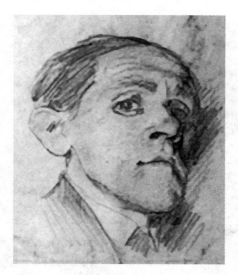

FIGURE 2.1

Bruno Schulz, *Self-Portrait,* c. 1933, Warsaw, Muzeum Literatury.

elements form a distinct current, among others, in Schulz's work, his pic-
tures offer a different vision of Jewish life than Chagall's village scenes
and allegories.

*Encounter: A Young Jew and Two Women in an Alley* (1920)—Schulz's
only extant work in oil—is one such image (figure 2.2). The scene is set
against the ruddy cube-like buildings of a hillside town. In the foreground,
a young man bows before two young women walking in the opposite
direction along a narrow split path. The figures are clearly costumed. In
the traditional black caftan and saucer-brimmed hat of Jewish orthodoxy,
*peyes* (earlocks) dangling along his cheek, the man is an exotic figure,
somewhat androgynous in his flowing black gown, but he is no less an
identifiable type than the women in their fashionable coats, rounded
cloche hats, white stockings, and pumps.[4]

They move in opposite directions; the young Jew comes forward, to-
ward the world of these modern women from which he is partially walled
off. His bow toward them is an obsequious formality, but his upturned
eyes are filled with longing and desire. Almost a parody of some strolling
dandy-*flaneur,* he is scarcely recognized by the women, who continue on

FIGURE 2.2

Bruno Schulz, *Encounter: A Young Jew and Two Women in an Alley,* 1920, Warsaw, Muzeum Literatury.

their way to town. One woman looks to her left, head tilted back as if affronted by the young man's gaze; the other looks back over her shoulder, ignoring the young man entirely, but setting up another encounter with the viewer of the picture, who is presumably on the same path. This combination of stares and glances tracks the tensions of the encounter, where, caught by the spectator's gaze, the participants enact desire, demurral, and disdain. All of this is reinforced by the picture's design. Our viewpoint is decidedly modern: we stand where the women once passed and see the Jewish stranger coming toward us. The central dividing wall is as prominent as the figures it separates; a striking orange hue, shadowed in pale green, its central placement forces us to look back and forth across the composition to comprehend the scene. The simple act of looking at the picture affirms the figures' separateness and difference.

FIGURE 2.3

Marc Chagall, *Promenade,* 1917–18, oil on canvas, the State Russian Museum, St. Petersburg. © SODRAC 2014 and ADAGP 2014, Chagall®.

The tension in this picture differs markedly from Marc Chagall's happy composition *Promenade,* painted in 1917–18 in Vitebsk, the Belarussian city where the artist was born (figure 2.3). Holding a dove in one hand and dressed in dandified black, the artist grasps the hand of Bella, his beautiful young wife, who in her claret gown floats in the air beside him, borne aloft by their love and sense of well-being. The cubistically painted facets of land and town provide a lush green carpet for the couple's picnic; the large cathedral in the center background offers a pale pink echo of Bella's gown. While clearly a portrait of the couple's happiness, Chagall's image also has broader social implications: the brightly illuminated city was a site of revolutionary political action, and Chagall, who had returned to Russia from Paris during WWI, was soon to participate in the effort to forge a radical Jewish culture there.[5] The modernity embodied in loving family life and prospering town and countryside exudes the promise of

revolutionary idealism on personal, social, and pictorial fronts. In con-
trast, Schulz's sunset encounter between the traditional Jew and modern
women presents only sexual and social anxiety. Schulz dedicated the work
to his art collector friend Stanislaw Weingarten, who owned the picture
and who with Schulz was a member in the late 1910s of a Jewish intellectual
group in Drohobycz, Kalleia (Beautiful Things).[6] The inscription on the
facing plane of the low wall in the center—*Najdrozszemie Staszkowi* (My
Dearest Staszkowi)—literally foregrounds the shared tensions of the Jew-
ish encounter with modernity.

Indeed, as a diasporic meeting ground, Schulz's picture may recall Sig-
mund Freud's account of childhood shame when, walking with his father,
the elder Freud told his own story of a youthful walk and how he silently
deferred to non-Jews who knocked his (phallic) hat into the gutter.[7] Freud
narrates a tale of formative Jewish experience passed from father to son;
Schulz depicts an adult world, and positions the spectator (the story-re-
ceiver) opposite, not with, the fawning lustful Jew. In their representa-
tions of encounter and potential mingling, however, both Freud's tale and
Schulz's picture convey a sense of Jewish otherness and anxiety in that
Eastern European diaspora.

Both Schulz and Chagall were trained professionals, poised to enjoy a
nonparochial or mainstream artistic success.[8] Schulz studied architecture
in Lvov, and for a short time in Vienna, but apart from a brief visit to Paris
in 1938, where he was too timid to explore the city or make professional
connections, he scarcely left home. In contrast to the peripatetic Chagall,
who left Russia but maintained a nostalgic ambivalence for a lost "home,"
Schulz clung to Poland; he stayed close to the centers of Warsaw and
Lvov, and formed close associations with the circle of Polish writers and
artists—StanislawWitkiewicz (aka Witkacy) of the Formist group, Witold
Gombrowicz, Zofia Nalkowska, Julian Tuwim, Debora Vogel, and oth-
ers—who constituted a mainly literary Polish avant-garde. He exhibited
with Jewish artist groups in Vilna and Cracow, but took no part in the
efforts of the *Yung-yidish* artists in Lodz to develop a distinctively Jewish
culture;[9] he looked instead to modernity's demands, accommodations,
and mythic dimensions—not its national character.

Even in this limited geography, Schulz's experience and his art was no
less diasporic than Chagall's.[10] His story, however, is tragic, not trium-

phant. Recognized in Poland for both his literature and his art, he won a prestigious Golden Laurel award from the Polish Academy of Literature in 1938. During the war, colleagues in Warsaw made every effort to save him, arranging for a false arrest and escort out of the Drohobycz ghetto to the relative security of hiding on the Aryan side of Warsaw. Fearful and unwilling to leave his family, Schulz delayed.[11] Like many imprisoned artists who made art for their captors, he survived for a time as a favorite of Nazi ghetto chief Felix Landau, making art for local institutions and decorating the children's room in Landau's apartment. Schulz's special position as a "necessary Jew," however, figured in his death. Caught in a Gestapo action on "Black Thursday" (November 19, 1942) after going out to buy bread, he was shot in the head to even the score in the dispute between Landau and another Nazi officer—each killed the other's favored Jew.

The details of Schulz's murder reinforce his status as an emblem of truncated Jewish creativity and possibility. To extend this legendary dimension, there is no grave. Schulz was buried secretly by his coworker Izydor Friedman in the Drohobycz Jewish cemetery; now covered by a modern housing project, the burial ground has left no trace.[12] Schulz is a figure of supernatural power and fantasy for writers like David Grossman, Cynthia Ozick, Phillip Roth, who in various ways yearn for his rediscovery and return.[13] One might call this yearning itself diasporic in its desire for the recuperation of loss. That Schulz, in increasingly dire circumstances, may have completed a novel titled *The Messiah,* accompanied by drawings of ancient sages, makes his symbolic status all the more powerful; the hope of finding this manuscript—Schulz's "unknown masterpiece"—and other lost material encourages a reparative fantasy.[14] Unlike Chagall's lengthy career, then, with its literal culmination in Zion, Schulz leaves us an unfinished oeuvre haunted by possibility.

The 2002 fracas over his frescoes magnifies the issues. "Who owns Schulz?" Benjamin Paloff later queried in the *Boston Review of Books.*[15] With three countries—Poland, Ukraine, and Israel—laying claim to these works, the debate itself underscores the shifting ground and uncertainties of diaspora. The frescoes' location in modern Ukraine is an accident of history. For the first half of Schulz's life, Galician Drohobycz was part of the Austro-Hungarian Empire, and after 1918, part of the newly reunited Poland. Schulz was hardly Ukrainian. He wrote and spoke Pol-

ish; he attended school and taught in Polish; his work has been collected, preserved, and exhibited in Polish national centers; and for decades it has been acclaimed with great national pride. And though he was largely "de-Juda-ized" there, the Poles have no doubt that he is one of theirs. As Maurice Nadeau writes, "Bruno Schulz, born an Austrian, lived as a Pole and died a Jew, missing the chance to become Russian."[16]

But of course, Schulz was a Jew—a Polish Jew, not a Jewish Pole—and resident in the densely populated territory of Jews that like a palimpsest hovered transcendently over and homelessly beneath the geographic borders of modern nation states. Still, whose territory is this? Is there a state to lay claim? Does Schulz's birth and death as a Jew legitimate claims to his work by the modern nation of Israel? The dilemma may not be resolvable, but the questions it raises, and in many ways the art itself, embody the tensions and predicament of diaspora, as three nations fight over his legacy.

I want to look closely at Schulz's visual art in light of these diasporic contexts and questions. He may be better known as a writer, but image making was always central to his production; it was, he declared, his first mode. "The beginnings of my drawings," he wrote to his friend, the poet and critic Stanislaw Witkiewicz, "are lost in a mythological mist. Before I could even talk, I was already covering every scrap of paper and the margins of newspapers with scribbles that attracted the attention of those around me."[17] The "mythological mist" is crucial for Schulz; it is both the origin of sensations and ideas and the place to which all understanding of experience can be traced.

Image and text were both parallel and intertwined tracks for Schulz. With little formal training as an artist—for practical reasons, he studied architecture rather than painting—he began by drawing and fantasizing over the geographies in his stamp album, then went on to produce portraits of his friends and, in the 1920s, the erotic prints of *The Booke of Idolatry*. This graphic production was followed by his stories, which typically made their first appearance as literary addenda in letters to friends. But the drawings continue—indeed, they never stop—and they are often imported to accompany his literary publications. The shifts in medium also suggest the place of the visual in Schulz's oeuvre. *Encounter,* for example, is an early picture and one of very few in oil, so that even allowing for several lost works, it is unlikely that this was a favorite mode.[18] The elabo-

rately worked *cliché verre* prints of *The Booke of Idolatry* were exhibited as individual images, but they are also gathered in albums—bound and arranged by the artist, with title and frontispiece for each version—and presented to friends in this form. The drawings that accompany the stories are less elaborate images than those seen on their own, and as partial pages in the text, they offer an intimate viewing experience. Working in this small scale, drafting stories in letters, packaging his prints in albums, it would seem that Schulz sought a close connection between the work and its audience.

Given this taste for visual intimacy, it is not surprising that self-portraits are a recurrent motif in his art, occasions for self-examination and self-presentation. There are, however, few full-length or even three-quarter-length versions, a format conventionally used by artists to declare professional identity and to comment on their mastery of its challenges. This assertive format, with the artist at his easel, is rare for Schulz. Far more common are extreme close-ups of head and face (figure 2.1). These show a lumpy-featured face above a neatly tied collar; shadows play across the forms to emphasize ungainly features—flapping ears, jutting jaw, creased forehead, raised eyebrows, and eyes looking out in consternation. Neither handsome nor welcoming, the face confronts us with a querulous and questioning man.

Schulz's head and face animate the approximately twenty-six tableaus of *The Booke of Idolatry* in grotesque and grimacing form.[19] The first plate, *Dedication* (figure 2.4), establishes the artist's presence and demeanor throughout. His bent figure appears bearing a crown on a charger as an offering to someone or something unseen. His face peers beseechingly upward, hardly daring to look directly at the object of this homage. The entreating figure fills the frame, which presses tightly upon him and so intensifies the posture of his bow. Looming out of the darkness, the dedicated Schulz is followed by more anxious supplicants, who appear as tiny misshapen figures in the background.

The team of grotesques, with Schulz as a sort of captain, recurs in the *Booke's* tableaus; they are variously labeled pilgrims or pariahs, jesters and dwarfs, and in one image, artists. They accompany the artist in scenes in which the idol-object is a long-legged nude woman lolling on her throne or where she and a companion stroll majestically with hybrid male "beasts"

FIGURE 2.4

Bruno Schulz, *Dedication,* in *The Booke of Idolatry,* 1920–22.

on a leash, or where, as in *Encounter,* she appears as a pair of fashionable women moving through darkened streets. Schulz gives these women a mythic character—captioning them as Undula, Susannah, Circe, Infanta; one site among the settings of boudoir or town square is designated Cythera, the fabled island of love. Despite their purported resemblance to women Schulz knew, they seem as generalized as their mythic names.[20] Imperious or disdainful, they are nevertheless doll-like in face and figure, except for their legs, which stand out as the fetishized object of male devotion and agent of his indignity. In the dramatic composition *A Secular Tale (I),* (figure 2.5), the Schulzian figure rising from his armchair is vehemently pushed away by the nude woman in her lofty barque, her extended leg and foot in his face. Repeatedly drawn to adore or kiss a dainty foot, the men receive only subordination and disdain. This is the case for the clothed women as well, whose fluttering skirts flag their slender white calves. Indeed, the erotic force of the glimpsed leg also appears in Schulz's

FIGURE 2.5

Bruno Schulz, *A Secular Tale*, in *The Booke of Idolatry*, 1920–22.

story "Spring," from *Sanatorium under the Sign of the Hourglass,* where the narrator muses about Bianca, the young girl he desires. "When I want to imagine her, I can only invoke one meaningless detail: the chapped skin on her knees, like a boy's; this is deeply touching and guides my thoughts into tantalizing regions of contradiction, into blissful antinomies. Everything else, above and below her knees, is transcendental and defies my imagination" (44). As telling as the gender shift recounted here, with the girl compared to a rough-tough boy, is the evocation of the source of the chapped skin: the pose of a supplicant, kneeling in prayer and obeisance. A woman's high-heeled shoe is also linked as fetish object to the author/artist's secret knowledge and mystery. In "The Age of Genius," another story from *Sanatorium,* the narrator draws out high-heeled shoes, like sacred secrets from among the dresses and ribbons in Adela the housemaid's drawer: "And lifting up with awe Adela's slim shoe, he spoke as if seduced by the lustrous eloquence of that empty shell of patent leather: 'Do you understand the horrible cynicism of this symbol on a woman's foot, the provocation of her licentious walk on such elaborate heels? How can I leave you under the sway of that symbol? God forbid that I should do it'" (25).

In their fetishized and idolatrous presence, however, the women in *The Booke of Idolatry* are not really the main object of viewer attention, for they share the scene with the shadowy but enveloping realm of male supplication and humiliation that is detailed and visually protracted through the images' design. In *The Procession* (figure 2.6), the slender, elongated woman, nude but for black stockings, is a haughty figure, but she is far less interesting than her hideous retinue. Led by a central Schulz-faced carrier of her cloak, as another Schulz-featured man kisses the ground near her foot, they are a wizened and cadaverous huddle, stretched across the composition in a variegated sequence of black darkness, linear-patterned shadow, and patches of white. The design produces a visual restlessness, a constant movement from bespectacled face, to skeletal head, to voluminous cloak, and to rising stovepipe hat, that culminates at the right with a glaring light and group of crouching men. It is as if Schulz was as fascinated by his vision of himself and his cohorts as he was by any object of desire. Again and again, the compositional force of these images returns us to the begging or devotional male form, while the woman-idol, the

FIGURE 2.6

Bruno Schulz, *The Procession,* in *The Booke of Idolatry,* 1920–22.

idolatrous signifier of some unseen power, is animated, not from within, but by her devotees and worshippers.

Other design and drawing strategies reinforce the imagery's eroticism. Furnishings and accessories, for example, serve as markers of ritual and sexuality. In *Undula the Eternal Ideal* (figure 2.7), a naked man, again vaguely Schulzian, but more adolescent than adult, prostrates himself while kissing the woman's foot, while she pins him in place with her other foot across the back of his neck. The picture's design leads the viewer's attention away from the brightly lit female figure or even her supine adorer, up to the vast openness of the divan and its ruffled pillow, whose billowing curves and central slit opening evoke genital sites of desire.

Prolonged desire is the driving force, as actual physical contact with the idolized woman in these images is rare. Occasionally, as in *Secular Tale* (figure 2.5), the woman's forceful kick in the Schulz-figure's face is a rejecting gesture that nevertheless allows contact with the phallic fe-

FIGURE 2.7

Bruno Schulz, *Undula, the Eternal Ideal,* in *The Booke of Idolatry,* 1920–22.

tish, just as the zigzag composition activates this contact's explosive force. But in general, we are shown a fantasy that, in the face of disdain—like the young Hasid in the oil painting—provokes an affective enactment of fawning adoration, crawling lust: the negative features of a stereotypical diaspora Jew.

What should we make of the artist's self-image, repeatedly shown in the throes of abject adoration and humiliation? What should we make of the explicit masochism of these visual fantasies? And what might be Jewish here? To take first the question of Schulz's self-representation: though we can only speculate about the artist's sexual life, the recurrence of pictured masochism suggests enthusiasm for such experience.[21] But given accounts of Schulz's shy demeanor, why the exhibitionary display? Only once were the images subject to censure, and that complaint was withdrawn after civic officials came to their defense.[22] In general, *The Booke of Idolatry* images were received positively by critics, who, without much elaboration aligned their style and erotic content with the traditions of Rops, Beardsley, and the grotesqueries of Goya.[23] The images come relatively early in Schulz's career—1920–22, the artist in his late twenties—the same

time as the *Encounter* painting. And like that picture, one album of the *Booke* was dedicated to Schulz's friend and later owner of *Encounter,* Stanislas Weingarten, suggesting the young men's shared erotic and cultural interests. Weingarten occasionally appears among the *Booke*'s idolaters, and two drawings dated 1919 reiterate the friends' erotic interests. One a portrait of Weingarten, the other a self-portrait of a youthful Schulz, they represent each man against a backdrop of nude pictures—compositions that would reappear in the *Booke*. Weingarten is shown at a table, leafing through an album of prints; Schulz stands at a small easel in a book-lined study, as if across the room from his friend. Weingarten appears with Schulz again in a painting labeled *Cubist Composition* (1920s), where they frame and surreptitiously watch two chic women walking through the town streets. Erotic content seems a central part of the young Schulz's pictorial repertoire.

However personally involved the artist was with such eroticism, the Schulz-featured supplicant in the images should not be seen as unmediated self-portraiture. One might see such self-representation as a form of authorial "I," like the first-person voice of Schulz's literary work, who recounts events and situations as the master of his tale, but whom it would be reductive to read simply as the author's stand-in: the stories are tales; they are not memoir. Analogously, the figure repeatedly pictured in these graphic works is hardly an omniscient narrator, for he is far more carefully wrought, more visible, and more objectified than a first-person storyteller. If anything, he is a pictured "me." Indeed, the point of view of the image is always that of the outside-spectator who is led to examine not the other characters, as in the stories, but the Schulz-figure inside the design.

Which brings me to the second question: how, if not personal disclosure, to understand these images? Beyond the immediacy—or strangeness—of a shared erotic fantasy, the pictures also suggest a cultural or diasporic experience, using eros and idolatry to evoke the tensions of Jewish difference and accommodation at that time. Staged as tableaus in prostitutional boudoir, in landscape, and in town square, with the viewer as audience—or voyeur—of this erotic genre, the pictures enlarge a theater of fantasy and private musing to a space of sociality and social metaphor.

Psychoanalytic considerations of masochism shed some light on this social metaphor. Freud's essay "The Economic Power of Masochism"

(1924) distinguishes three types of masochism—sexual, feminine, and moral—and points to the latter, moral masochism, as a behavioral norm that affects social interactions. Loosened from sexuality, where suffering is administered or overseen by a loved one—in Schulz's images, an adored woman-idol—moral masochism shapes all of the subject's relations so that suffering itself, in any form, comes to matter most. While *The Booke of Idolatry* seems to settle its imagery in the sexual mode, there are aspects of Freud's mechanics of masochism that lend these pictures a moral dimension as well. Derived from the libido and pleasure principle, moral masochism, Freud argues, works to complement or neutralize the death drive's externalized aggressive mastery or sadism. Such aggression, turned inward, seeks punishment from the superego, an internalized form of parental authority. Thus, while conscience and morality for Freud ordinarily develop through a desexualizing of the oedipal relation, in this instance, morality is resexualized and reactivates the oedipal link. Socially pervasive and psychically resexualized, moral masochism readily lends itself to representation in erotic fantasy. In these images then, Schulz's cowering masochist, a version of the obsequious bowing Jew, idolizes and subjugates himself to the superego/parental authority, which here takes the form of cultural and social authority—the Gentile culture disdainful of Jews, and especially his Jewish manhood.

Leo Bersani's discussion of masochism modifies Freud's emphasis on sexuality's "end-pleasure"—a "teleological position"—and highlights the effort to protract the pain-pleasure of arousal, extending and exploring its detail, and thereby deferring, even while excitedly anticipating, its climactic end.[24] In a similar vein, Theodor Reik's account of male masochism also extends Freud's formulation through moral masochism's three distinctive features, and its social dimension:[25] 1. the necessity and elaboration of fantasy, 2. the protraction of intensity through deferral, and 3. the demonstrative need to be witnessed or seen.

These features recur in Schulz's work. For example, in his story "The Street of Crocodiles"—as Schulz labeled the town's red-light district—deferral and protraction characterize the area's delights and disappointments. "Let us say it bluntly," the narrator declares, "the misfortune of that area is that nothing ever succeeds there, nothing can ever reach a definite conclusion. . . . It is in fact no more than a fermentation of desires, prema-

turely aroused and therefore impotent. . . . Nowhere as much as there do we feel threatened by possibilities, shaken by the nearness of fulfillment, pale and faint with the delightful rigidity of realization. And that is as far as it goes" (109). Protraction is borne out, not only in such texts and in his pictures' subject matter, but in Schulz's designs as well. Conventional S/M imagery, for example, often pictures a victim suffering physical pain, or as in Félicien Rops's *Pornocrates* (1896) (figure 2.8), a blind-folded dominatrix is led by a leashed pig, making it difficult to distinguish a sadistic from a masochistic response: the viewer can respond as the aggressive perpetrator, or enjoy identification with the pictured pain, or most likely, both.[26]

*The Booke of Idolatry* images invite us to linger in the masochistic realm, with the processes and duration of idolatry, and with less attention to the idol adored. The operative affect is rejection and humiliation, not physical pain, or even its imminent occurrence. Body contact is infrequent, and instruments of punishment, like a dominatrix's whip, are semiconcealed in shadow. Rather than the physical act, what does appear is a pictorial protraction of adoration and disdain. This not only fits Reik's masochist profile—fantasy, deferral, demonstrativeness—it also encompasses both psychic being and sociality. Indeed, Reik replaced the "moral" term in Freud's label with "social masochist" in his discussion of the syndrome.

Kaja Silverman's more recent discussion of male sexuality also explores the implications of masochistic representation, which argues that the fantasy represents a challenge to the father, to patriarchy, who even when personified by a female figure is nonetheless a phallic mother.[27] The masochistic scenario then internalizes and struggles with guilty rebellion or disobedience to patriarchal authority. Drawing on Reik's analysis, Silverman explores the cultural meanings of such representation. "The male masochist," she writes, "acts out in an insistent and exaggerated way the basic conditions of cultural subjectivity, conditions that are normally disavowed; he loudly proclaims that his meaning comes to him from the Other, prostrates himself before the gaze even as he solicits it, exhibits his castration for all to see, and revels in the sacrificial basis of the social contract. The male masochist magnifies the losses and divisions upon which cultural identity is based, refusing to be silenced or recompensed. In short he radiates a negativity inimical to the social order."[28]

FIGURE 2.8

Félicien Rops, *Pornocrates*, etching and watercolor,
1896, Félicien Rops Museum, Naumur.

FIGURE 2.9

Bruno Schulz, *Two Boys in Orthodox Garb, Two Women on a Pedestal.*

It is not difficult to recognize the rebellion or disobedience, and its concomitant guilt, in *The Booke of Idolatry*'s images. We need only link that challenge and the ambivalent social behaviors associated with it to my third question, and to the diasporic situation of Galician Jews.[29] The Jew as humiliated supplicant comes early on in Schulz's iconography, and the confrontational format of *Encounter* recurs in a drawing of the same period, where two women in evening frocks appear on a small pedestal in the town square and look disdainfully away from the approaching figures of two Hasidic boys, each dressed in the black broad-brimmed hat, caftan, and white stockings of orthodox garb (figure 2.9). Again, the boys are no less costumed than the women, but their demeanor is very different, at once modestly retiring (hands folded across chest) and eager (hands open and moving forward). They are not only exotic but also androgynous, with clean-shaven adolescent faces and short caftans that reveal their calves, as would a modern woman's coat. The blurring of gender cues feminizes

FIGURE 2.10

Bruno Schulz, illustration from "The Book,"
before 1937, *The Street of Crocodiles.*

the men—a common way to disempower their Jewish masculinity.[30] And
partnered with the town strumpets, each pair enunciates an aspect of
modernity's tension and unease. Like the street scenes by German Ex-
pressionist Emil Kirchner, in which tiny dark-suited men rush like ants
around statuesque and uber-chic women, Schulz too takes up this mod-
ernist trope and invests the masochistic eros and desire in his imagery
with the diaspora Jew's social anxiety.

The cultural tensions facing the Jews of modern Galicia run through
Schulz's literary work, in which tales of childhood wonder, adolescent
awakening, and bourgeois family life are punctuated by drawings that
iconicize characters or moments in the narrative. Two drawings in "The
Book" in *Street of Crocodiles* announce a family frame; they depict a young
mother and boy on a balcony watching an organ-grinder and other colorful

characters in the street below (figure 2.10). The primary figures in pictures, however, are the young narrator and his father—a bearded, bespectacled man with a remote expression.[31] As in *The Booke of Idolatry*, women are remote objects of sexual desire: the young Bianca of the chapped knees, Adela, the family maid, fashionable women in the street, prostitutes in boudoirs. Mother, too, on her balcony pedestal is elusive and distant.

In another drawing, where one of the familiar pair of women turns back to glance down at a large-headed, top-hatted little Schulz-man, the narrator is astonished, excited, confused—and trapped: "Somebody seems to be walking in front of me, not looking back. It is not a nurse. I know who it is! 'Mother!' I exclaim, in a voice trembling with excitement, and my mother turns her face to me and looks at me for a moment with a pleading smile. Where am I? What is happening here? What maze have I become entangled in?" (148). The account echoes a repeated trope: the young man who longs for a woman's recognition or welcoming gaze. But if the relation to mother is confusing or ambivalent, the unsettling or failure of patriarchy, on the other hand, is voiced by attention to the figure of Emperor Franz Joseph in the narrator's stamp album. Putting Franz Joseph in his place, divesting him of his iconic power, becomes, in Schulz's story, a revelatory opportunity: "How greatly diminished you have become, Franz Joseph, and your gospel or power! I looked for you in vain. At last I found you. You were among the crowd, but how small, unimportant and gray. You were marching with some others in the dust of the highway" (38–39).

Mother is hardly present, the Emperor diminished and deposed, and the constant presence of the Father, especially in the *Sanitorium* stories, is both visionary and mad. Father and Son walk together holding hands in a drawing for "Spring" (29), each figure drawn with broken nervous lines. The father is a bony-faced bearded patriarch, thoughtful and withdrawn; the son is a pretty schoolboy—grave, wide-eyed, and gangly in his sailor-collared uniform. The large-headed twosome exceed mere realism, and like so many of Schulz's drawings, move toward caricature. The most arresting image of Father Jacob appears in the story "Eddie," where the old man's illness transforms into madness or divine transport. Flying through his chamber, his flight is limited as he bumps against the ceiling. Beard and long locks streaming, he recalls, with some faint ridicule, the cloud-borne God the Father in Michelangelo's Sistine ceiling. The challenge to

patriarchy and the eroticism of these tales is clear, underscored by drawn embodiments: remote mothers, mad magician fathers, impotent aristocracy, virginal teenagers and their governesses, sensuous housemaids and promiscuous shop-girls.

Beyond the narrator's family and cohorts, the Jews in Schulz's literary and pictorial world are hardly individualized; they are part of a crowd, in keeping with their numbers in Galician cities. Neighboring the Hasidim of the town and surrounding shtetlekh, Drohobycz had a considerable Jewish bourgeoisie. In the nineteenth century, ten of the twelve local oil refineries, which served as the city's economic base, were owned by Jews, and by the 1930s, the Jewish population numbered nearly 14,000 (of a total population of 34,500).[32] So populous were they that in his *Journey to Poland* (1925), the German Jewish writer Alfred Doblin experienced the encounter with Polish *Ostjuden* as a spectacle.[33] Taking a *droshki* from the Drohobycz train station to the market square, Doblin is both fascinated and repulsed by what he sees:

> Male and female vendors, Jews, only Jews, with German names, chat and shout. Groups of peddlers in soft caps dirty clothes, talk in the square, outside the one-storey houses. Stooped old men, greasy, in dreadfully tattered caftans, raggedy trousers, burst boots, poke sticks in the garbage on the ground. One oldster has a long yellowish-white beard, a stiff hat full of holes, its brim half torn off; he keeps murmuring, playing with his thick fingers, begging. And then, emerging from the throng in the square, an elderly, very ugly, cross-eyed, unkempt woman begs. And then a younger one, holding her baby wrapped in a babushka on her breast. And then a man in a trilby, eating a big apple, chewing and simply spitting out the peel. They all murmur in Yiddish: Give me something. *Zait gezunt* (good-bye).[34]

Such encounters typify German Jewish scorn for the unmodern *Ostjude,* one dimension of the ambivalence associated with modernization and orthodox tradition. I shall consider another version of this in Roman Vishniac's photographs (see chapter 3). But Schulz, an acculturated native of the region, rarely goes this far in ethnic or class caricature. The meeting of traditional Jew–modern Gentile pictured in *Encounter* is not as grotesque as Doblin's, nor is it so emphatically rendered from an outsider's vantage point. Rather the viewer is positioned close to the meeting ground, about

to share the site and occasion of repulsion and desire. For Schulz, the Jewish relation to modernity is a far more intimate sight, elaborated through eroticism and masochistic tension. For Schulz's fictive family, living in his stories with a mixed multitude of strangers—uniformed firemen, exotic Negroes, imperial troops—the references to Jews are as Others among many, underscoring the central tensions of patriarchy, tradition, authority, and difference.[35]

Direct references to Jews appear in other stories and drawings, some intended to accompany Schulz's lost novel *The Messiah*. The adolescent Hasid reappears in assemblies of modern and traditionally dressed Jews. In their distinctive headgear—the fedoras of the modern synagogue congregants; the *yarmulkes, streimels,* and black hats of the Hasidim or orthodox Ostjuden; the *tallis*-draped heads of ancient or biblical types—these men (and they are almost entirely men) come together to greet each other, embrace, and talk. This again is public presence—an outdoor theater of Jewish men. They recall, in part, the congregational reference in "Night of the Great Season" (the time of the High Holy Days) (figure 2.11):

> groups of Jews in colored gaberdines [*sic*] and tall fur hats. These were the gentlemen of the Great Congregation, distinguished and solemn men, stroking their long well-groomed beards and holding sober and diplomatic discourse. But even in those ceremonial conversations, in the looks which they exchanged, glimmers of smiling irony could be detected. Around these groups milled the common crowd, a shapeless mob without face or individuality.
> . . . Meanwhile, the fathers of the city, members of the Great Synhedrion [*sic*], walked up and down in dignified and serious groups, and led earnest discussion in undertones. Having spread themselves over the whole extensive mountain country, they wandered in twos and threes on distant and circuitous roads. Their short dark silhouettes peopled the desert plateau.[36]

As for the images associated with the lost novel, they depict bearded men, robed like ancient sages gathered at a well or seated at outdoors at tables. The number of figures—two dozen in one drawing (figure 2.12)—denotes a significant population, and the gravity and order of their assembly implies an important reason to meet. Perhaps is it not accidental that as the times grew politically heated and dangerous for Jews, Schulz pictured ancient sages and modern Jews in discussion and debate.

FIGURE 2.11

Bruno Schulz, *Three Jews Talking*, before 1933, Warsaw, Muzeum Literatury.

Modern Jews, Hasidic and orthodox Jews, rabbinic sages: they are a distinctive diasporic company. Women and sexuality—the distant idols, the Gentile objects of desire—are absent from these images. Though we cannot know *The Messiah*'s content,[37] we can see in the pictorial work an increasing—and perhaps troubled—Jewish presence. Schulz did speak of a return to "messianic times which through all mythologies are promised and pledged to us."[38] The statement is usually understood in light of his next sentence: "My ideal is 'to mature' to childhood." But perhaps what is meant is not only celebration of a (not so innocent) childhood, but also the child's anticipation of something wondrous to come. Be it adulthood, or some future paradise, the Messiah encompasses that yearning. In his pictures and lost text—the texts we still yearn to discover—the mythic Jewish dimensions persist—idolatry, messianic redemption, and the place of Jewish men.

In what now seems a solidly Schulzian gesture, the coda to this oeuvre is eerie and mysterious. The partially uncovered, partially restored, partially dispersed frescoes painted for Nazi SS Captain Landau's chil-

FIGURE 2.12

Bruno Schulz, drawing for *The Messiah*, c. 1934 , Warsaw, Muzeum Literary.

dren's room represent a gathering of fairy-tale types: a mounted knight, a beautiful girl and boy, a peasant crone (figure 2.13). It is tempting to read some secret or subversive parable in the painted program. Who better than Schulz to cast the concerns of puzzled children and the perplexities of modern life into mythic fantasies? This was, after all, how he regaled his students at the Drohobycz gymnasium.[39] Emil Gorski, Schulz's assistant on the assignment, suggested allusions to Drohobycz citizens. "[In] the fantastic fairy-tale scenery," Gorski recalled, "the characters of kings, knights, squires had the completely 'un-Aryan' features of the faces of the people with whom Schulz lived at the time."[40] Some scholars have seen the knight figure as stand-in for the artist, though from the fragmentary evidence, the grimacing peasant seems a more likely candidate. In that

FIGURE 2.13

Bruno Schulz, Crone, fresco detail, 1942.

case, Schulz the artist/Hasid/slavish idolator/querulous man takes on yet another disguise, and again shifting the settled terms of gender, queers it this time with his own features on the kerchiefed crone. Not quite woman or man, s/he lends an uncanny presence to the scene, testing the magic of fairy-tale rescue. But this view too is uncertain; the theft and dispersal of these painted fragments has veiled their meanings and left them, like Schulz's career, forever fragmented and unwhole.

In the end—if this is an end—Schulz's position as a modern Jewish artist is as ambivalent as his modern diasporic life. The work draws on a provincial setting for images and tales of broadly mythic dimension, in which idolatrous desire and anxiety mirror the tensions of a modern Jewish diaspora. Uncertain and yearning, caught between competing social forms and traditions, the Schulzian Jewish man (there really is no Schulzian Jewish woman) strives to accommodate his unease. Similarly, Schulz's art, clearly aligned with modern European culture, addresses multiple audiences, like those nations—Poland, Ukraine, Israel—who, not seeing, or willfully ignoring, diaspora, fight to call him their own.

# 3

---

## Z'chor! Roman Vishniac's
## Photo-Eulogy of Eastern European Jews

If Bruno Schulz and his images constitute a variety of diasporic tensions, Roman Vishniac and his pictures deliver a diasporic eulogy. Vishniac's photographs of Eastern European Jews were taken in the mid to late 1930s and published several times in book form: as *Polish Jews* (1947), *A Vanished World* (1983) (figure 3.1), and *To Give Them Light* (1992). Framed by Vishniac's camera, the images give pictorial form to a society almost destroyed in the Holocaust; for Jews and non-Jews, they have become tokens of memory, emblems of a culture once thriving, now gone. The photographs have been widely acclaimed both in their published forms and in exhibitions. Jewish audiences in particular embrace them as memorial, and cued by *A Vanished World*'s title, claim nostalgic connection to the society pictured here. But the photographs are also valued as historical markers, and their combination of portrait and documentary picturing heightens their status as social evidence and archive. At the same time, even as documentary, the pictures bear a stylistic signature. The high-contrast lighting, the dark spaces and illuminated details, the dramatically framed compositions that offer special, privileged views of the past, the faces seen in stark and close-up intimacy: these features are hallmarks of Roman Vishniac's photographic style and seal the pictures' status as works of art.[1]

My own response to these images—as legacy and history, in any case—is more ambivalent, and with hindsight, seems embarrassingly clear: derived from my relation as a first generation Jewish-Canadian woman to the

FIGURE 3.1

Roman Vishniac, *A Vanished World*, 1983.

traditional, "old country" society the photographs show. To a daughter of immigrants from Ukraine and Rumania, these pictures suggest a point of identity and a final ethnography—an uncanny me/not me. The bearded *rebbes*, the market women, the mischievous children seem both familiar and strange figures of Jewish history; they establish connection and alienation, disclosure and distance, at once. Such, perhaps, are the anxieties of assimilation and diaspora consciousness.

My unease before the pictures is also provoked by the context of presentation. In book form, they offer an intimate space for cultural memory and critical review. But how to respond to the same pictures exhibited in the restored Izaaka Synagogue in Cracow, Poland, now a cultural center, but also the place where Jews in these images once prayed? Had they become icons in that setting, objects of curiosity and reverence in a space that would traditionally prohibit such display? How am I, as viewer, po-

FIGURE 3.2

Polish souvenir statuettes.

sitioned there: as a tourist? historian? cultural spectator? Of course, I am all of these, but am I also a Jewish mourner, or even a returned émigré? The critical scrutiny I mustered in private shifted. Now I resented the embrace of "Jewish culture without Jews" that flourishes in modern *Judenrein* Poland, where a paradoxical Judophilia aligns Vishniac's imagery with

popular statuettes sold at every souvenir stand (figure 3.2) and certifies such forms of difference as national stereotype.

It is a chilling elegy, and an intensely marketed one, but hardly limited to Eastern European sites and attitudes. Indeed, the most troubling aspect of Vishniac's images, part of the aura of the Holocaust that frames their presentation and packaging, is the spectatorial unease, the combination of curiosity and anxiety, such scrutiny often involves. The Holocaust, to be sure, is not directly pictured in these publications; we see no ghettos, no camps, no prisoners, no death—if indeed these are the catastrophe's representable forms. But Vishniac's pictures as they are invariably assembled are clearly meant to be seen through a Holocaust lens. This is especially true of *A Vanished World,* with a melancholic elder—prophet-like—on the cover, the book jacket shrouded in black, and a foreword by Holocaust spokesman Elie Wiesel that declares, "Our eyes see two things at once: living beings yesterday, a void today." Images such as a tallis-clad man interned in Zbasyn in 1938 (174),[2] a girl peering out from a bunk bed (175), and little girls in the shower at summer camp (56): these seem to forecast the terror ahead. We may not see what Vishniac would call the "inevitable" or "the Jewish fate," but the pictures in *A Vanished World* are linked to Holocaust history. Even the more benign pictures of Jewish artisans and country life in the later publication *To Give Them Light* (1993) seem to testify to what one critic called "the cruel calm before the Holocaust," with figures seen "on the brink of extermination."[3]

No doubt any collection of prewar European Jewish documents could elicit that response, but as with the Kacyzne pictures examined in the previous chapter, the effect is to enshroud and often limit the pictures' signification. Michael Andre Bernstein has called this sort of suggestive framing "backshadowing," a particularly bitter irony, or in Bernstein's words, "a kind of retroactive foreshadowing in which the shared knowledge of the outcome . . . is used to judge the participants . . . <u>as though they too should have known what was to come</u>."[4] In a backshadowed presentation, pictures are made predictive after the fact. Thus, the Jews in these photographs, unknowing, seem marked by their terrible future; their victimization is heightened by their not sensing the tragedy ahead, and their very character—as depicted—seems to forecast their destiny. With death retrospectively attached to the figures, the pictures become

a eulogy. They commemorate not only doomed individuals, but—as *A Vanished World* presumes more ominously—a doomed people and society

In this chapter, I consider *A Vanished World,* the best known of Vishniac's photo collections, in terms of three related issues: first, its published presentation as Holocaust eulogy; second, the image of Jews and the kind of Jewish culture that the collection enshrines; and third, their impact on or management of postwar viewer response. What interests me is the presentation of particular Jewish subjects—the orthodox and poor Jews of Poland and Rumania, labeled Ostjuden by Central European Jews—and the fixing of their images as *the* lost Jewish past. I do not challenge the pictures as historical record. These people existed, many in impoverished conditions, and most of them did not survive the war. The issue is not the pictures' authenticity as data, but rather how they are positioned as central icons of Jewish catastrophe, and the causal link of that positioning to the edifice of Jews and Judaism—poor, pious, powerless, different—that they construct.[5] Without challenging the images' aesthetic success, how does *A Vanished World* make use of the truth or reality we assume for photography to mold a particular view and understanding of Jewish history? How in telling a pictorial story do the images perform a particular historiography, and so define what scholars now call the "shape and texture of memory?"[6]

The photographs' shaping of memory begins with their public record.[7] Mara Vishniac reports her father's efforts to show his images shortly after the family arrived in the United States in January 1941, in the hope of calling official attention to the Jewish plight. Some images were shown in a 1941 exhibition titled "The Life of Man," at Teachers College, Columbia University, and with work by other Polish Jewish photographers—among them Alter Kacyzne, Menachem Kipnes—in a volume published by the *Forverts* in 1947 called *The Vanished World;* Vishniac's title is a later variant. The more ethnographically titled *Polish Jews,* with pictures exclusively by Vishniac, appeared in 1947 with an introduction by the distinguished theologian Abraham Heschel that also characterized the pictures' subjects as both abject and transcendent. In Heschel's words, the images are "the last pictorial record of the life and character of these people . . . a life abjectly poor in its material condition, and in its spiritual condition, exaltedly religious."[8] These postwar publications established a tragic viewing context that would endure or recur, but with many viewers inclined to

repress the traumatic past, or eager to assert a new American identity, the pictures moved to the margins of public memory.

*A Vanished World* appeared in 1983, twelve years after an exhibition in New York's Jewish Museum in 1971.[9] By then the context of reception had changed. The turbulence of displacement and resettlement had subsided, and with a postwar generation coming to adulthood, there was widespread readiness to review this pictorial history. Holocaust studies and cultural representations—memoirs, novels, poetry, theater, film, and to a lesser extent, visual imagery—burgeoned, along with nagging questions of what was and was not an appropriate mode of representation, what could and could not be stated or seen. The debate continues, and concern about what is transgressive, blasphemous, indecorous, or titilating is itself symptomatic of a new chapter in representational ethics. Vishniac's images, publications, and exhibitions are icons in that debate.

Vishniac's own account and the details of his project have been so often repeated, in interviews, reviews, and exhibition catalogues, that they envelop the pictures as a legend. It is very much a "story" or tale. Much of these texts ultimately appear in the caption and commentary sections of *A Vanished World,* which explain each of the photographs that follow. In this fragmented form, details like "Since the basement has no heat, Sara had to stay in bed all winter. Her father painted flowers for her, the only flowers of her childhood" (42), and the further commentary, "When I returned to the site of her home after the war, the home was no more, and there was no Sara," or "Twenty-six families lived in this basement . . . partitioned with wooden boards" (39)—such statements reinforce the pictures' pathos, their intimate appeal, and the photographer's special access to these sights.

Unpublished and preparatory texts by the photographer present other dimensions of this tale.[10] In one somewhat informal document, a personal voice and experience dominates, with anecdotes of Vishniac's childhood in Moscow, his escape as a young man from Russia to Latvia, his prewar residency in Berlin and travels in Eastern Europe; these biographical details are interspersed with traditional Hebrew prayers and personal laments. A certain awkwardness in the document, with its unexpected sequencing and emphases, reinforces the author's sense of mission and urgency. At the same time, the disjuncture and repetitions in the story, the

sudden leaps and lacunae in chronology, suggest the anxieties of trauma and its rehearsal in memory. The result is a sort of traumatized text, whose narrative voice starts, affirms, lurches, breaks off, and laments, and whose anxieties complicate or blur a precise chronology. In a sense, the same is true of the final publication—the images, captions, commentaries read as genre description, not as narration or contextual history.

Vishniac described himself as a Russian Jewish immigrant in Berlin, a biologist who fled anti-Semitism in the Soviet Union after the First World War. He claimed to have foreseen the grave danger facing Jews, and to have dedicated himself to salvaging their culture through photography. To that end, he explained, he sought "the most Jewish faces he could find."[11] He reportedly consulted with Jewish leaders in Germany, such as Berlin's Chief Rabbi Joachim Prinz and the historians Simon Dubnow and Mark Wischnitzer.[12] Dubnow, he reported, heralded the value of the photo project. But, as Jeffrey Shandler and Maya Benton point out, the project was not only a private mission.[13] Vishniac's photographs were commissioned by the Joint Distribution Committee (JDC) as part of a philanthropic campaign in support of impoverished Eastern European Jews. The JDC and HIAS, as we've seen, had undertaken such projects in 1920–21 with Alter Kaczyne's emigration photographs. Vishniac's published images combine an ethnography of religious and provincial Jews he photographed in his travels with signs of the tightening strictures of Jewish urban life. Three pictures, for example, almost sequential in the book, depict an anti-Semitic march by the Endecy [sic] party in Warsaw, a workingman on the lookout for party thugs, and his young son—ten years old at most—warning of their approach (#176, 178, 179). A well-dressed crowd, followed by solitary, threatened, and impoverished Jews: as Jewish deprivation in the late 1930s was becoming official state policy, such images interrupt the sense of timeless tradition that pervades the book.

His undertaking, Vishniac believed, was heroic and ambitious. "None of my colleagues was ready to join me," he states in the preface to *A Vanished World*. "Rather they warned me of the danger and called the project impossible." The danger was real, but the project of Jewish documentary photography had taken a new turn, as deprivation and disaster—not just preservation and social change—entered the pictorial narrative.

Vishniac's project, as he would tell later, thus became a bold adventure, with the photographer's pictures and his person (like his Jewish subjects) at risk of seizure and arrest. Here are some scenarios: Vishniac dressed as a Nazi storm trooper marching camera in hand through Berlin on *Kristallnacht*; the photographer impersonating "a local Jew" or a "Lithuanian salesman" to ensure his subjects' confidence; Vishniac imprisoned in Poland, bribing guards for return of his camera and film; Vishniac developing his images at a riverside under cover of night.

As if to belie the danger, most of the images in *A Vanished World* do not show signs of being surreptitious or even hurried. Forms are sharp, clear, and legible; compositions are striking, even organized. Nevertheless, Vishniac's claim to have taken some of these pictures clandestinely is part of their magic or "miraculousness," and it underscores their aura of trespass.[14] Concealed beneath Vishniac's scarf or coat, the camera looked through a button-hole; the shutter release wound down to his pocket, the Rolleiflex camera focused on infinity, or with lens extended allowing close-ups. In what now seems an eerie mimicry of death, Vishniac held his breath to keep the image in focus and his body still. The flyleaf of *A Vanished World* affirms this heroic strategy. "Of the 16,000 photographs he managed to take—secretly and under difficult circumstances—only 2,000 survived." In such a tale, pictures replace people as cherished survivors and agents of testimony.

The masquerade as "wandering Jew" may have facilitated the photographer's access to his subjects, but it also drew Vishniac closer to a culture he himself had fled. As a middle-class professional from a wealthy, secular Jewish family, and traveling incognito, Vishniac was both insider and outsider, part and not part of the world he photographed. One of the few images to declare his own position shows seven-year-old Mara Vishniac in 1933 standing before Berlin store facades advertising racial policies. The modernity of the setting, compared with the streets of Lublin or Kasimiercz for example, in other images in the book, is striking. In the Berlin picture, a prohibited record of anti-Semitic practice is cleverly disguised as a family snapshot. But its publication in *A Vanished World* binds these images to the Nazi terror; it brings the vanishing closer to home, and it locates Vishniac's own family in the dangerous frame. At the same time, a

Jewish photographer's disguise as a Jew in order to secretly document Jews must have been a dizzying round of identities and an ironic espionage. Indeed, the complexity of Vishniac's attitude toward his subjects—his familiarity with and distance from their culture, his guilt (as well as relief and gratitude) for surviving the war, and for "taking" some of these images by stealth—these contradictions and anxieties are rationalized and quieted by the elegiac design of *A Vanished World,* just as they seep through and overdetermine the fragmented narrative of his text.

That text characterizes the undertaking as a tragic rescue mission. "I was unable to save my people," Vishniac wrote, "only their memory." This is his recollection of a visit to Cracow: "I thought of the inevitability of the Jewish fate. Could a camera photograph feelings, emotions? On this day, I knew I was sent to do just this. It was 1938, the end of an era, the end of these people."[15] It is a poignant statement, with Vishniac wondering if the scientific instrument he would later use to record the forms of microbiology could visualize the forms of human emotion. The photographer here is not only an artist, he is a man called to duty—"I was sent to do just this"— a divine instrument of sorts. The rhetorical question "Why was I there, at that moment?"—his comment on an image of a worried-looking, elderly couple suddenly impoverished by the economic boycott—punctuates the sense of photographic mission and Vishniac's good fortune recording the scene. Tragic destiny resounds through the text, with backshadowing words like "inevitability" and "the Jewish fate" to suggest passivity, long-suffering, and Jews moving inexorably toward destruction. Apocalyptic phrases like "end of an era" and "end of these people" further tune any reading of the images to disappearance and tragedy.

The viewer/reader of *A Vanished World* thus comes to share Vishniac's position as knowing witness, with the documentary camera style reinforcing the sense of direct, unmediated view. To be sure, some figures in these pictures see the camera and several pose agreeably, but most seem caught up in the tasks and pressures of daily life. With little to interrupt the social panorama or the spectacle of a doomed society in such images, the result is a chilling, catastrophe tourism, unsettling as a eulogy prepared before the fact. And as a "last-minute look at human beings . . . just before the fury of Nazi brutality exterminated them"—these are Edward Steichen's words on the flyleaf—the images launch a fascination with a marked people in the moments before death. If we are spared the sight of atrocity and mas-

sacre, we are still possessors of an uncanny gaze, armed with prescient knowledge of these peoples' fate.

Photography, of course, is to some extent always voyeuristic; the camera captures a moment and offers protracted visual access to someone, something, or somewhere that we the viewers are not. But the decorum of looking at misery and privation framed as Holocaust destiny is especially problematic.[16] And the act of looking at these pictures, like the act of taking them, is both transgressive and compelling. As it was for Vishniac—as it is for me in the Polish synagogue, and in the privacy of my study—the viewer's relation to this Jewish society is framed by sentiment, apprehension, and morbid curiosity, and these oscillating positions charge our looking at the images with both pleasure and anxiety. Given the power of our position, there is no simple attention, no disinterested gaze that is not accompanied by anticipation and dread.

This uneasy looking may be sanctioned, however, by turning the act into commemorative ritual. In some ways, *A Vanished World* functions like the memorial books, or *yisker-bikher,* produced after the war by Jewish survivors to commemorate their destroyed communities.[17] As specific regional histories, these volumes combine ethnographic anecdotes with memorial references: pages framed in black, symbolic drawings of graves and broken branches, lists naming the dead. Like the yisker bikher, a photographic collection serves as a powerful agent of memory, allowing Jews to fulfill the commandment to remember, *z'chor:* remember the dead, and the vicissitudes of the past. And for many viewers, the feelings of nostalgia and fear, unease and curiosity, evoked by these pictures may resemble the ambivalent emotions of mourning, with its simultaneous yearning to annul and to accept a loss. Still, there is a difference between the specificities of the yisker bikher—the link to "my town," "my neighbors"—and the generalized geography and Jewish society commemorated by *A Vanished World.* Unlike the particularizing lists of place names and persons, Vishniac's still photographs function like poetic utterance or prayer; they render the image of a community as timeless essence and icon.

Let us look more closely at the Jewish society emblematically fixed by Vishniac's camera. Its members are more generally identifiable as Ostjuden, the term developed earlier in the century to designate the poor, pious, traditional Jews of Eastern Europe's cities and shtetls. The label declares its split perspective, a distancing *ost* (east), or "over there" from the designa-

tor's vantage point. The configuration was also Janus-faced. On the one hand, it celebrated the spiritual Ostjude as a positive countertype or counterforce to the assimilationist dangers of modernization, and the threat of Jews losing their center, their attachment to Torah, and giving way to the temptations of the bourgeois parvenu and the evils of capitalism; on the other hand, the more negative face was that of the Ostjude—and especially those who began to emigrate west—as ignorant and atavistic, caught in the primitive manners and habits of a ghettoized past.[18]

As early as 1906, Martin Buber, eager to affirm the cultural vitality of the Jews, formulated the positive image of the Ostjude around the figures of the Baal Shem Tov (1698–1760), founder of Hasidism, and his great-grandson, the great Hasidic rabbi, Nachman of Bratslav (1772–1810). Buber's publication of the rabbi's "tales" gave cultural legitimation in Central Europe to the image of a wise and joyous folk figure and his flock.[19] This configuration of two European Jewries—the largely German-speaking *Westjude* of Central or *Mitteleuropa* and the Yiddish speaking Ostjuden of Ashkenaz further east—was underscored by enterprises like the journal *Ost und West* founded in 1901, Buber's journal *Der Jude* (1916–24), and other publications of Der Judischer Verlag (1902) (the Jewish Press), in which the dual intellectual streams of secular Judaism met.

The representations of Ostjuden, however, were often as critical as they were celebrative. As we've seen, Bruno Schulz's painting *Encounter* (figure 2.3) uses the figure of an obsequious young Hasid to characterize the social tension, anxiety, and desire in the Jews' ambivalent meeting with modernity.[20] Even the traditional Jews pictured by Alter Kacyzne and Moshe Vorobeichic—Kacyzne, a member of Warsaw's secular Jewish intelligentsia; Vorobeichic, a bourgeois Jew from Vilna academically trained as an artist and resident in Western Europe—were seen as embodiments of a traditional past. By the mid-twenties, the figure of the Ostjude—pious, poor, and above all, unmodern—had taken hold in Western Jewish consciousness as an emblem of both atavistic authenticity and internalized otherness.

The ambivalence of this configuration—like the ambivalence of all such stereotypes developed from within—appears in a literary genre developed by Jews in search of self-legitimating origins and what David Roskies has called "a usable past."[21] The mood changes somewhat—or the

ambivalence intensifies—as the artist's vantage point moved west. Schulz in Galician Drohobycz, for example, is hardly celebrative and surely conflicted about the Jewish presence in his modern world. Further west in Prague, however, the German-speaking Kafka excitedly embraced the cultural possibilities embodied in *Ostjudische* society.[22] Caught up in Buber's presentations at Prague's Bar Kochba Society, and further enamored of a Yiddish Theater troupe from Lvov then performing in Prague, Kafka, in a 1912 lecture at Prague's Jewish Town Hall, presented the notion of what Noah Isenberg refers to as "*Sprachegemeinschaft*—an unadulterated community within the life of the language."[23] Yiddish was, Kafka declared, a repressed memory in central Europe, and a unifying cultural tie. "You will come to see the true unity of Yiddish, and so strongly that it will frighten you, yet it will no longer be fear of Yiddish but of yourselves."[24] Among the meanings of this statement is Kafka's reassurance that a Gentile host language was more to be feared by the assimilated *Westjuden* than the language—at the very least—of Ostjudische Yiddish.

By the 1920s, the image of a dual European Jewry had become a more widespread concern in central Europe. Acculturated Jewish writers like the Viennese Joseph Roth and the Berliner Alfred Doblin went to see for themselves, and in their literary accounts characterized their travels east as journeys in search of their Jewish roots and origins. This, we recall, is what Doblin saw in 1925, on his arrival in Drohobycz, the Polish-Galician town where Bruno Schulz lived and worked.[25]

Joseph Roth's *The Wandering Jews* (1925, 1937) offered a no less distanced traveler's perspective. Writing a polemic against the assimilated bourgeois Jews of Germany (of which he was one),[26] Roth berated the self-delusions of both Jewish geographies: German Jews for their unexamined renunciation of Jewish values and Eastern Jews for their naïve envy of the riches and privileges of the West. After a lengthy discussion of the possibilities of Jewish nationalism, the text compares "The Jewish Shtetl" with "Ghettoes in the West" (Vienna, Berlin, Paris). Moving through the institutions and rituals of the Eastern Jew, including a visit to a Hasidic "wonder-rabbi," Roth observes:

> Outside the rabbi's house stood a red-haired Jew, the master of ceremonies, beset on all sides. . . . His face was waxy white and shaded by a round black velvet hat. His copper-colored beard jutted into people's faces in

disorderly tufts, in places it had been worn out like an old lining and
where it did have a showing, it grew as it pleased, not subject to the design
that nature has planned for the run of beards. The Jew had small yellow
eyes under very thin, scarcely visible eyebrows; broad strong jaws that
suggested an admixture of Slavic blood; and pale, bluish lips. When he
shouted I saw his strong yellow teeth and when he pushed someone away, I
saw his powerful hand, sprinkled with red hairs.[27]

The figure appears exotic and even unattractive to the acculturated reader
in the West—strange garb, "unnatural" beard, red hair, yellow eyes and
teeth—and acknowledging this, Roth declares that "the things that hap-
pen at the court of a wonder-rabbi are at least as interesting as with your
Indian fakir."[28] For Roth, strange and poor as many of them were, these
Jews in the East were clearly in touch with an enlivening, if bizarre, spiri-
tual practice.

The pictorial discourse is similarly exotic—think Chagall, from
Vitebsk, pitching to a vanguard Western audience; it is also intimate. in
one of the best-known examples, as Maya Benton has pointed out, Her-
man Struck's and Arnold Zweig's *The East European Jewish Face* (*Der Ost-
judische Antlitz*) (1920, 1922) (figure 3.3).[29] A well-known artist, famous
for his 1906 portrait of Theodor Herzl, and later for a text on printmaking
techniques, Struck worked collaboratively with Zweig on their project.
His fifty-two images (actually made before Zweig's text) appear through
the book with rhythmic regularity, a visual counterpoint of two images
every three or four pages.

Zweig's essay is a passionate polemic about the future of modern Jewry.
Dismayed, like Roth, by German Jewish bourgeois culture and its capital-
ist values, Zweig called for Jewish renewal, chiefly through Zionism, but
not before he waxed rhapsodic about the natural spirituality and hard-
working enterprise of the orthodox Eastern European Jews. To that end,
his text attends closely to Struck's portraits, describing them in uplifting
detail. Zweig begins:

"He turns his eye away from me and into the distance," a distance that is
nothing but time. His profile leads like a waterfall into his beard, which
dissolves into spray and clouds. The nobility of his posture and his nose,
the spirituality of his pensive and furrowed brow, contrast the hard, defi-
ant ear and meet in his gaze, a gaze that neither demands nor renounces,

FIGURE 3.3

Hermann Struck, *Portrait of a Jewish Man Wearing Cap,* in *The East European Jewish Face,* 2004.

neither longs for nor laments what it is. And his gaze draws upon himself a distance about which we know that it is nothing but time.[30]

By the 1920s, the notion of the face as a signifying emblem of national identity had considerable status in visual culture; indeed, it keeps pace with the growth of modern nationalism through popular cultural forms.[31] The pseudo-science of physiognomy codified by the Swiss Johann Gaspard Lavater in the eighteenth century presented character readings through

facial features, and in the mid-nineteenth century, as population move-
ments surged across industrializing Europe, such interpretations were
applied to ethnic and national peoples as well. Vincent van Gogh, for
example, conceived his series of portraits painted in Arles in 1888 and
1889 as images of an ideal citizenry. The American photographer Edward
Curtis (1868–1952) made numerous portraits of Native Americans as erect
and dignified embodiments of the "Noble Savage" as well as a "Vanished
Race," as native populations were confined to reservations and decimated.
These emblematic figures were defined from an outside perspective, that
is, as ethnographic and ideal types bestowed upon an objectified pop-
ulation, but there were also figure types codified from within. Among
the most famous are August Sander's photographic portrait series titled
"People of the 20th Century." Formal portraits of seated or standing fig-
ures, Germans of all classes in their professional or Sunday best, the series
seems to survey an entire population. Among them are pictures of per-
secuted citizens (Figure 3.4), many of them Jews, who as well-dressed,
proper citizens are indistinguishable from their Gentile compatriots.[32]

That no clear type emerges testifies to the social breadth of Sander's
photo typology. In this sense, is it the liberal obverse of the Nazi effort
to define Aryan racial standards through physiognomic measurements.
Vishniac's photograph of his daughter Mara standing before store-win-
dow advertisements for such devices not only records the practice, it also
ironizes its nefarious claims in the face of the little girl's attractive in-
nocence. At the same time, the Nazi use of physiognomy was invoked to
condemn portraits by German Expressionist artists, as pictorial distor-
tions in their works were equated with physiological deficiency rather
than the expression of inner feeling. Lambasted as culturally degenerate,
these images were often set beside photographs of people with grotesque
birth defects to make their spurious point.[33]

The concern with faces and types was a widespread tool of ethnic and
national definition, and it invariably contained both positive and negative
examples in its repertoire. As Zweig and his colleagues devised it, the Os-
tjude was a figure of authenticity, an embodiment of an enduring and cher-
ished heritage. But within the reverence for these figures—the wise rabbi,
the hardworking artisan, the plucky boy—lurked anxiety and even guilt
about the modern Jews' future. How to sustain their affinity and identity

FIGURE 3.4

August Sander, *Victim of Persecution,* c. 1938. © Die
Photographische Sammlung/SK Stiftung Kultur-August
Sander Archiv, Cologne; SODRAC, Montral, 2014.

FIGURE 3.5

Paul Schultze-Naumberg, page from *Kunst und
Rasse* (Art and Race), Munich, 1928.

without falling victim to assimilation? How, in the face of moderniza-
tion, to prevent their vanishing? The anxieties of modernization made
the figure of the Ostjude into an ambivalent emblem of authenticity, an
image that psychically haunted—and, I would argue, still haunts—Jewish
imagination as an uncanny and recurring emblem of loss.

I turn to Freud, the great Jewish dreamer and explorer of psychic space,
to underscore the psychological depths associated with the Ostjude. Him-
self one generation away from ostjudisch orthodoxy, Freud experienced
the discomforts of his modern Jewish status in several dreams and fanta-
sies. In 1900, he writes about a dream in which a friend, identified only as
R., appears as his (Freud's) uncle and is revealed as a petty criminal and
simpleton.[34] Freud connects the dream's content to his own conflicted
professional ambitions: like his friend R., he too has been nominated to
the state ministry for professional advancement, but unlike R., he tries to
put little stock in the possibility of advancement because of "denomina-
tional considerations."[35] Freud also reports his competitiveness with R.;

he, after all, does not go groveling to the ministry, even though he believes that he is the better candidate. But the structure of this dream in which R. appears as his uncle reveals further meanings. The dream is in four parts: two thoughts, each followed by a picture—though Freud does not disclose the second sequence. The first "thought" section is one of warm affection for R. and their relation; the accompanying image—an icon, in effect—troubles him. Focusing on the picture of the man's elongated face and striking yellow beard, Freud delivers a fairly lengthy account of how beards change color with age.

> My friend R. had originally been extremely dark; but when black-haired people begin to turn grey they pay for the splendour of their youth. Hair by hair, their black beards go through an unpleasing change of colour: first they turn to a reddish brown, then to a yellowish brown, and only then to a definite grey. My friend R.'s beard was at that time passing through this stage—and so, incidentally, was my own, as I had noted with dissatisfaction. The face that I saw in the dream was at once my friend R.'s and my uncle's.[36]

Freud's beard was customary for bourgeois married men, and especially those with professional standing. But there are obvious phallic associations in this account: an external sign of masculinity and growth seems to lose its vitality. And there are also specifically Jewish links here. Orthodox Jewish men are commanded not to cut their beards or their side-curls; these become distinctive marks of identity—and at times, sites of ridicule by Gentile tormentors. Beardedness was hardly neutral ground. Freud also describes R. as "extremely dark" and one of a "black-haired people"—then (as now) designations for Jews. And by conflating the faces of R. and the unfortunate Uncle Josef, he turns the dream's composite image into that of a problematic, though beloved, old Jew. The anxiety provoked by Freud's position as ambitious modern Jew and as he expressed it in his dream is repeated in a footnote, where Freud remarks—without further comment—that Josef was only one of his five uncles, and that his interpretation eliminated the others, so that Josef—the aged Jew, the Ostjude—remains and stands alone.

I call attention to Freud's dream, and to the recurrent Ostjudische hauntings, in order to stress the enduring power of this figure and its associated way of life in modern Jewish consciousness. For better or worse,

FIGURE 3.6

Shimon Attie, *Almstadtstrasse (frühere Grenadierstrasse) Ecke Schendelgasse,
Berlin,* 1994. From the series *Writing on the Wall,* 1991–93.

the construct of the Ostjude has acquired the quality of Jewish essence,
from which assimilation or acculturation measures its place and prog-
ress. If it is this that is "lost," "disavowed," "vanished," it is also this that
in Jewish imagination (as well as in reality), remains. Indeed, the figure
has become, as Susan E. Schapiro has argued, the incarnation of a "Jew-
ish Uncanny."[37] Thus, we can follow Ostjudisch iconography through its
iterations in *Fiddler on the Roof*[38] to Shimon Attie's ghosted photographs
of Berlin's Schaunenviertel, *Writing on the Wall* (1991–93) (figure 3.6), in
which the sense of loss is once again tied to tradition, poverty, and piety.

Like these later examples, Vishniac's camera style and his books' design
editorialize well beyond documentary realism. With their dramatic con-
trasts of black and white, Vishniac's images seem to cloak their subjects
in shadow, magic, mystery, and doom. Rather than quicken memory and
keep it "alive," as photos are often thought to do, the cultural and photo-

graphic celebration of the Ostjude as Jewish essence and authenticity is accompanied by ethnographic distancing, romantic mystification, and an uneasy nostalgia that keeps these orthodox Jews—notwithstanding their current numbers in Brooklyn, in Montreal, in Jerusalem—locked in the past.

Let us consider more closely the ostjudisch society emblematically fixed by Vishniac's camera. In his preface to the 1937 edition of *The Wandering Jews,* Joseph Roth acknowledged the crisis faced even by German Jews (not just the ostjudisch "cousins from Lodz"), and cautioned, "Lest we forget that nothing in this world endures, not even a home."[39] An economic boycott of Jewish merchants and businesses in Poland, with widespread loss of jobs, produced desperate living conditions for many. Such poverty and desperation are almost the only setting and social framework of Vishniac's "vanished" world. The pictured streets of Lublin and Kasimiercz are rutted and miserable; narrow passageways and arcaded courtyards suggest mysterious spaces and decaying structures. The children in these settings are mischievous ragamuffins (106, 19); the women are market crones or weary bubbes minding children (100, 49, 40); the men are down-and-out porters or stooped elders shuffling through the snow. Occasionally, the camera shows a middle-class apartment courtyard, or Warsaw's Nalewski Street teeming with commercial life, or adolescent clusters of yeshiva students moving through the modern city, but these are rare signs of social exuberance. More prominent are pictures of unemployed and disabled men, and caftaned, bearded patriarchs leaning on canes and clutching their holy books. In these public views, life for Eastern European Jews appears as hard labor, struggle, and religious routine.

Domestic interiors are no less miserable than the public spaces. Basement rooms cluttered with furnishings are shown in tightly cropped images that accentuate physical and social claustrophobia (41). And the striking compositions, high-contrast lighting, and extreme close-up views intensify a drama of body and soul. In one, a sad-eyed little girl named Sara in the caption (for the Nazis, the generic Jewish woman's name), confined to her bed in the unheated basement, is almost engulfed by billowing bedlinen (42). This, of course, is caption information; she might just as easily be a dreamy child immersed in a fantasy garden. Still, with her fragile and waiflike demeanor, and her femininity crowned by the painted flowers on

the wall overhead, she is remarkably unlike Mara Vishniac's insouciant appearance before the Berlin shop facades. This picture also appears on the back cover of the book, where as terminal point and partner to the mournful elder on the front, it seals the pathos of the entire project.

Occasionally, linked images bring some narrative dimension to *A Vanished World*. In one sequence, the head of a pensive woman, dramatically lit and labeled "Nat Gutman's wife," looms spectrally in the darkness. The facing page shows a simple arrangement of bread and herring, her family's meager meal (29, 30). Intimate and close-up in design, the traditional formats of portrait and still life become partnered images, delivering a message of misery and gloom with iconic force. It is not until several pages later, pictorially separated from the domestic images and so reinforcing a notion of interrupted or fragmented family, that a portrait of Nat Gutman appears. Shown outdoors, away from his household, and labeled a porter and former bank cashier, Gutman meets the camera with a quizzical smile, as the camera highlights his face and his jacket's ragged tears (38). Gutman is the most distinctive secular man in the collection, and Vishniac's portrait melds individualism with ethnography to create a sense of Jewish difference, social irony, and hardship. Indeed, scarcely anyone in *A Vanished World* resembles modern citizens like Vishniac himself, or the hard-working Jewish artisans whose images were published some years later in *To Give them Light* (1992). Culled from the same photographic expedition, *A Vanished World* scarcely hints at the diversity of culture and community in Eastern European Jewish life.

The secular society of *A Vanished World* is miserable and alienated, with only occasional signs—as if to rouse the viewer by their absence—of affective family ties. A solemn grandfather and granddaughter shown together hint at a generational legacy: the passing of the "world of our fathers" to a female heir (65). But the combination of feminine youth and the patriarchal elder in this image is a disempowered partnership, and the coupling of the figures, facing but staring past each other, suggests impasse and futility.

Relief from this vulnerability and hopelessness comes in pictures of religious life. As photographic partner to the miseries of the body, spirituality in *A Vanished World* is the only coin of this realm. The book opens with an extreme close-up of a worried religious school leader (1), moves

on to children crowded over holy books (7, 8), and further on to ecstatic figures rapt in prayer and ritual (4, 5, 81, 82). Interspersed between the street scenes and domestic views, these images repeatedly remind the viewer of what ultimately defines this populace. The piety is compelling, impassioned; it is also, for many viewers, ethnographically exotic and strange. We see, in silhouette, a distinctively garbed Hasidic father leading his little boy along snowy streets (154). The camera enters the study hall of the Mukachevo Rebbe, a dimly lit space packed with fur-hatted men, the walls lined with the tattered volumes and holy books (78, 79).

Through such images, the religious rituals and habits of orthodoxy assume yet another dimension of difference, for it is here that the pictures seem most furtive, like stolen glimpses into strange places at unusual and endangered sights. The narrow arched passages, darkened chambers, the outlandishly dressed figures poring like magi over ancient Jewish texts (85, 95)—all this suggests enclosure and arcane mystery, a sort of Hasidic Gothic—to borrow the phrase of film critic J. Hoberman—with all the pleasures and terrors the Gothic implies.[40]

True to orthodox Jewish practice, the spaces of learning and prayer represented in *A Vanished World* are entirely masculine: little boys and their teachers in kheder, chanting congregants in the synagogues, the rabbisage and Talmudic scholars in the study halls. These sites of orthodox practice scrupulously exclude the feminine and the domestic, and doing so, they forge a particular kind of homo-social bonding, quite different from that of the civic groups that directed local Jewish communities. For the ardent and intensely focused men pictured here, material lack and powerlessness in the secular world is replenished through spiritual fervor and congregational ritual. Like the other accounts of Ostjuden, *A Vanished World* also calls attention to this sector of Jewish religious life, and by picturing orthodoxy as the only form of religious practice, the collection underscores both ethnographic difference and Jewish stereotype.

It is worth noting too the representation of ostjudisch masculinity. While pictures of porters abound, these men in their rags and patches are so bereft of resources beyond their brute strength, and so clearly at the bottom of the social ladder, that they hardly serve as positive models. Other men, perhaps less impoverished, are rabbinic elders and their youthful acolytes, whose learning and piety suggest wisdom and orthodox

authority. We may see that framework, as Daniel Boyarin has argued in detail, as one in which Jewish men may embody a different masculinity, through which they disdain (rather than lack) the aggressive sexuality and heroic physicality valued by Western culture.[41] As pictured by Vishniac, the men's bodies are cloaked and hidden in strange clothing; their social interaction is mysterious and cultish; their affect is addressed only to God. In these images of men crowned in fur and draped in prayer shawls, studying together or rapt in prayer, a kind of eros appears—with its energy, concentration, and release. Only here in *A Vanished World*—the least validated site within the modern secular nation—are we shown a community of effective men.

Vishniac's photographs have become tokens of nostalgia, objects of veneration, as well as texts of mourning and loss. They also remain markers of difference. In them, cultural identity is standardized, drenched in melodrama and pathos, and driven into stereotype. This is precisely how one of the images was used—or misused—in a Dutch Nazi wartime publication, as evidence of Jewish barbarism and inferiority.[42] Emphasizing exhaustion and defeat, the helpless and the strange, *A Vanished World* presents a curiously costumed and pathetic people, a people without potency or agency, at ease only in study and prayer, too different and too emasculated to survive. By presenting that people and their world emblematically as a site of misery and orthodox spirituality, Vishniac's images reiterate a familiar Christian trope: the Jew as exotic other and eternal sufferer.

In the best sense, and like the yisker-bikher, this image of "a vanished world" may seek to rectify what Maurice Blanchot called the Shoah's eternally "open, umarked grave,"[43] and to supply an absent tombstone for the dead. But the suggestion that this society *is* the world that has vanished obscures the complexity and variety of Jewish culture—then and now— and it harnesses Jewish identity to a mythic and putatively annihilated past. Confining Jews as emblems of weakened misery and spiritual ritual, the pictures enshrine only those conditions. And by setting Jewish culture within the conditions of catastrophe, the images seem to function as an eerie Holocaust Sublime,[44] forecasting that end as inevitability.

Beneath the pictorial elegy and the heroic legend of Vishniac's project, however, there is an other-than-Holocaust dimension to the pictures' enduring impact. That is the unabated ambivalence which the images, as os-

tjudisch ethnography, invoke. Ironically, the Shoah framework displaces that anxiety into moral certainties of genocidal loss. But the earlier loss, produced by modernization, assimilation, and its ambivalences, remains. For diasporic Jews, who continue to fashion our own forms of accultur-ated community, the mythic memory of premodern Jewish life carries a haunting melancholy, as if this is the Jewish imaginary that we cannot put to rest. The photographic achievement of *A Vanished World* rests on the psychic as well as historical depth of its fascinations. Looking at Vishniac's beautiful and elegiac images, the challenge for the viewer is not to narrow the shape of Jewish memory or too firmly fix the loss.

# Difference in Diaspora:
## The Yiddishe Mama, *the Jewish Mother,*
## *the Jewish Princess, and Their Men*

The *Yiddishe Mama* and her younger sister the Jewish Mother are beloved and derided stereotypes in America, and the shift in character from one configuration to the other, from Mama to Mother, tells a diaspora history.[1] With this chapter, attention turns from Jewish visual culture in Eastern Europe, home to the world's largest Jewish population before 1939, to North America, where the greatest number of world Jewry currently resides. Jewish immigrants to the United States arrived in waves, mainly between the late 1880s and 1924, when strict entry quotas were imposed. The immigrants' goal was to "be American," to leave behind the Old World and its traditions, and to find a place in a nation that promised well-being and social possibility.

In the early twentieth century, another Jewish diaspora framed its identity. Aided by the Yiddish American press and the cultural forms of popular music, photography, radio, and film, America's Jews produced their own stereotypes, which embodied their progress and achievement in the new world. This chapter thus has a double focus. I begin with visual formulations of Jewish men and women in the first half of the twentieth century, not simply to campaign against stereotype, but rather to track the vicissitudes of self-made Jewish identity. From this perspective, the Yiddishe Mama and members of her family not only reveal the terms of assimilationist desire, they also demonstrate how the deployment of self-stereotype in popular culture effectively maps and manages the terms of diaspora success.[2] The discussion then moves to contemporary imagery,

My Yiddishe Momme ★ Sophie Tucker    **mono**

MY YIDDISHE MOMME
SOPHIE TUCKER

Mercury

MERCURY

FIGURE 4.1

Sophie Tucker, *My Yiddishe Momme* album cover
1961. Courtesy EIL.com & 991.com.

noting the place of modern Jewish art in American high culture, and the
varied deployment of Jewish gender stereotypes as cultural critique.

Despite her putative Eastern European birthplace, the Yiddishe Mama
is an American invention, first incarnated by Jack Yellin and Lew Pollack
in their 1925 song of that name. In both Yiddish and English, the lyrics
and melody are suffused with nostalgia for a mother left behind as Jewish
immigrants moved to America. "My Yiddishe Mama," the English lyrics
go, "I miss her more than ever now," as the song longs for the gentle figure
of plenitude, forgiveness, and above all, self-sacrifice. Abjuring material

wealth or public fashion, the song says, she was a "gift from God" (*a sheyne matone geshenkt fun Got*) who filled the home with beauty and light and was enriched by her "baby's smile."[3] But the Yiddishe Mama is distanced from the singer by her age as well as geography.[4] As sung by her adult off-spring, the lyric pictures a woman old and gray, her brow wrinkled; more a loving bubbe than mama, she is part of a world accessed only through memory.[5] The words use nostalgia, with its usual sweetening, to ease the anxiety and ambivalence of Yiddish-speaking Jews about their break with "mother" and a familiar past.[6]

"My Yiddishe Mama" was a hit in the mid-1920s—a date that coincides with the closing of United States immigration policies for Eastern European Jews, thus sealing the distance of memory's geography.[7] It was sung and recorded by the Jewish chanteuse Sophie Tucker (figure 4.1), and her performance solidified the Mama's matronly guise. Hardly gentle or sweet in character—as "the last of the Red-Hot Mamas," her performances were filled with sexual innuendo—Tucker was a stout and sturdy figure, who vocally, and to some extent visually, configured the subject of her song in a nostalgically idealized past. And there, conveniently, that Mama remained: a cherished memory, rarely making the trip into modernity that her immigrant children undertook.

By mid-century, however, the Yiddishe Mama had been replaced by the Jewish Mother, a far less lovable figure. In novels like Dan Greenburg's *How to be a Jewish Mother* (1964), Bruce Jay Friedman's *A Mother's Kisses* (1966), and most famously, Philip Roth's *Portnoy's Complaint* (1969), Jewish writers inverted her saintly character, and characterized her as vulgar, overbearing, and grotesque, and all too close at hand. Mass cultural products elaborated the image. In countless greeting cards she appears as a bulky matron (no cuddling bubbe), tastelessly overdressed, bedecked with jewels and other signs of her husband's success, shrill and demanding, proffering not love but greed, not a nourishing plenitude, but oral suffocation ("eat! eat!") and unassuageable guilt. Most egregiously presented in Woody Allen's short film "Oedipus Wrecks" in *New York Stories* (1989) (figure 4.2), the Jewish Mother, like an inverse Madonna of the Assumption, berates her son from heaven, and tells the world—or at least all of New York—about his desire and preference for Gentile girls.

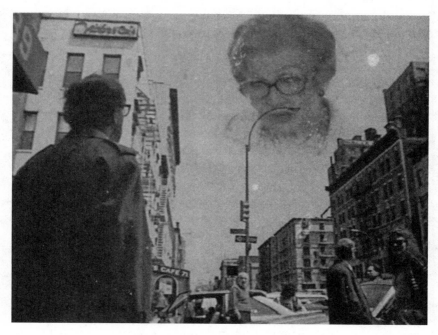

FIGURE 4.2

Woody Allen, still from "Oedipus Wrecks," *New York Stories*, 1989, Touchstone Pictures.

What has happened here? What history has produced this drastic revision of ethnic motherhood? Moving from immigrant nostalgia for an idealized past, the Yiddishe Mama is denied the class mobility and modernization of a new world, and is transformed instead into a Jewish Mother, a ranting figure of ridicule, not reverence. Such revision is unique; no other culture has produced such a negative maternal stereotype.

The Jewish Mother, however, shares the cultural stage with other family stereotypes, all of them North-American born, and all Jewish internalizations of older anti-Semitic stereotypes. The Jewish Mother's daughter, the Jewish American Princess (acronymically known as the JAP) is a mini-version of her mother; her son, the Jewish Prince, struggles to loosen her consuming embrace. As husbands and fathers, however, Jewish men are peripheral figures in the family scenario. In part, they continue a diasporic

struggle, one we've seen in previous chapters in the masochism of the Schulz-men and the spiritualized eros of the Ostjuden, where Jewish men are traditionally seen as failing modernity's demand for the aggressive masculinity of a "Muscle Jew."[8] Enjoying the benefits of capitalist success in North America—again, the Jews as greedy money-men—the Jewish man is often hidden behind the trophy presences of his Jewish Mother wife and JAP daughter—that is, if he has not left the fold and partnered with a Gentile. His peripheral place in the imaging of the modern Jewish family mirrors the absent (though still patriarchal) father of the bourgeois Gentile family and its antecedent, the Christian Holy Family, and so paradoxically demonstrates the Jewish father's acculturated success.

Fundamental to the discourses of globalization, nationalism, citizenship, and diaspora, the stereotype, as George Mosse and other scholars remind us, is a useful category for analysis, and not simply a derogatory slur.[9] Rather, these constructs are essentialized tropes whose presence seems to explain the social complexities of lived experience. Stereotypical figures come readily to mind—they appear "natural"—in the face of deep emotions; they help manage and soothe feelings of love, hate, fear, anger, pity, and so on. As such, stereotypes embody the paradox of modern nations: an ideal of social homogeneity belied by the realities of diverse peoples living together. The situation is no less complex even when diversity is a declared national ideal, as it is in North American democracies.[10] As an exaggerated sign of difference, the stereotype marks the frontiers of diasporic citizenship. When stereotypes are seen as constructs rather than fixtures of character, the task of understanding them is, as historian Ritchie Robertson put it, to "inquire not directly into [a particular] history but into [a particular historical] imaginary."[11]

The stereotype may often attach to a specific feature or body part—a Jewish nose, a Nordic blonde—that signals the dimension of difference, and their effectiveness often appeals to the senses.[12] The sense of hearing conjures stereotypes of voice: class-marked as shrill, coarse, or ugly; gender-marked by pitch and timbre; ethnically marked by grammar and accent. Stereotypes of smell abound: many peoples are designated "smelly" as a gut response to their difference, and taste (or what they eat) reinforces the visceral charge. Like smell and taste, touch presumes an intimate relation to the stereotype's form. Visual stereotypes, however, may function

FIGURE 4.3

Jacob Epstein, "The Orthodox Jewess," in Hutchins Hapgood,
*The Spirit of the Ghetto* (New York: Funk and Wagnalls, 1902).

best at some distance, needing a space through which to focus, especially
when they embody a figural gestalt or whole. The stereotype may attract or
repel—indeed, it may do both—promising sensual pleasure or abjection
and disgust. As an index of tensions or pressures, it is worth noting which
senses are brought into play with any given stereotype.

The stereotype's success depends on easy recognition of relatively fixed
forms; like any commodity, it relies on repeated appearances and circula-
tion through technological and mass distribution—in print, radio, film,
television, Internet media. It is not surprising that with the development of

printing technologies and a mass press in the nineteenth century, images of ethnic stereotypes enjoyed great popularity. Featuring specific types in full-length genre portraits, graphic series such as *Les français peint par eux-mêmes* (1840–42), offered a figurative panorama of cultural difference, and as visual anthropology, shaped stereotypical features and biases. Foreign types were depicted for their ethnic charm and exoticism, fascinatingly different from the image makers and their audience. Photography amplified the genre. Within a short time, as increasingly diverse societies sought to demarcate the visible boundaries of normative behavior, propriety, and citizenship, outsiders such as criminals, the insane, the poor, and local ethnic minorities like the Jews were depicted as well.[13]

Hutchins Hapgood's popular ethnographic study of immigrant Jews, *The Spirit of the Ghetto* (1902), appeared as the numbers of Jewish newcomers swelled. Jacob Epstein's illustrations for the book are vignettes of picturesque types. One section is devoted to "The Old and New Woman,"[14] and the cast of characters contrasts old-fashioned shtetl types and younger women with modern—if still foreign—ideals. An elderly "Orthodox Jewess" (figure 4.3) is described as Yiddish speaking, "drab and plain in appearance," with "no practical authority" except for her husband and rabbi—in many ways, this was a misunderstanding of women's place in shtetl society. Young unmarried women, an educated minority, are labeled "Intensely Serious" and "A Russian Girl Student" (figure 4.4). With "many virtues called masculine," Hapgood notes, "[they] are simple and straightforward and intensely serious, and do not 'bank' in any way on the fact that they are women."[15]

What's missing in calling attention to Hapgood's study of the immigrant Jew is the already acculturated figure promoted in *The American Jewess*.[16] Edited by Rosa Sonneschein (figure 4.5), Hungarian-born bourgeois wife of a St. Louis rabbi, whose elegance couldn't have been further from Hapgood's East Side types, the eight volumes of this English-language publication spoke out against gender inequities in Jewish tradition and community, even as it encouraged its readers to adopt the domestic and social behaviors of the Gentile bourgeoisie. Hapgood's Eastern European immigrant types, in contrast, were intellectual, serious, and vaguely subversive in their nonfemininity; they hardly fit the American paradigm. Hapgood's text reinforces that cultural distance: "They lack the subtle

FIGURE 4.4

Jacob Epstein, "A Russian Girl-Student," in Hutchins Hapgood,
*The Spirit of the Ghetto* (New York: Funk and Wagnalls, 1902).

FIGURE 4.5

Rosa Sonneschein, editor of *The American Jewess.*

charm of the American woman, who is full of feminine desires, compli-
cated flirtatiousness; who in her dress and personal appearance seeks the
plastic epigram [*sic*], and in her talk and relation to the world an indirect
suggestive delicacy. They are poor in physical estate; many work or have
worked; even the comparatively educated among them, in the sweatshops,
are undernourished and lack the physical well-being and consequent tem-
peramental buoyancy which are comforting qualities of the well-bred
American woman."[17] The text's comparison provides a template of what
the Jewish woman must become if she is to be successfully American. Ref-
erence to work is tied only to sweatshop labor and poor health—despite
the practice of Eastern European Jewish women who often worked outside
the markets and factories, in business and entrepreneurial roles.[18] But
although the vignettes were produced by a Jewish artist, Epstein (1880–
1959), the American-born son of Polish immigrants, the point of view and
the cast of characters may be seen as the ethnographic creation of a non-
Jewish writer looking in on an outsider community.

By the 1920s, the older Jewish woman had become a Yiddishe Mama,
whose old-country sweetness evoked both nostalgia and guilt. In the
next decade, however, that construct began to change. From the thir-

FIGURE 4.6

Gertrude Berg on the set of CBS's *The Goldbergs*, 1949–52.

ties through the fifties, Gertrude Berg's Molly Goldberg (figure 4.6) car-
ried the presence of Yiddishe Mama-hood through radio and television.
Much the way the bourgeois Gentile wife embodied the "angel of the
household," the Jewish woman or immigrant daughter, fired by the desire
to assimilate, abandoned a public sphere and withdrew to her place in
the American home.[19] But Molly Goldberg's irrepressibility was telling.
Shouting "Yoohoo, Mrs Bloooom . . ." from the liminal space of her apart-
ment window, her energies burst the confines of home as she voiced opin-
ions on just about everything. Barely contained by domesticity and her
mangled Yinglish, she famously "mixed in." Her husband, Jake, deemed
this meddling, but Molly saw it as her mission to improve the world. The
designation—mixing in—may indeed describe the social busybody, but it
also calls attention to the challenge of social mixture and diversity. Molly
may have struggled to epitomize the diasporic maxim of "Jew in the home,
[American] in the street," but her potential excess suggests the repressive
force of the stereotype, and heralds a more problematic metamorphosis
to come.[20]

Gertrude Berg's Molly persisted into the postwar 1950s, but she was
losing ground, as a new generation, the Jewish immigrants' grandchil-
dren, relished assimilation's success. Recast and reformulated, the Yid-
dishe Mama's abiding love and *heymish* (homey) wisdom turned into the
Jewish Mother's suffocating affections and charmless vulgarity.[21] At the
same time, the Jewish Princess appeared to extend her mother's crass
character. She too had undergone a transformation, and as she adopted
Hapgood's "indirect suggestive delicacy," she became a caricature of nar-
cissistic beauty and materialistic ambitions. Making her appearance in
Herman Wouk's middle-brow novel *Marjorie Morningstar* (1955), followed
by Brenda Patimkin in Philip Roth's *Goodbye, Columbus* (1959), these mid-
century stereotypes signal the tensions of diasporic assimilation: ambiva-
lence within the Jewish community, as postwar baby boomers asserted
their full participation in American culture.

Though most scholars agree that the stereotype is marshaled from
within, feminist historians differ somewhat in accounts of this critical
shift. Paula Hyman argues that Jewish men experienced a more dras-
tic change in the move to modernity—from the old-country, and more
ostjudisch, ideal of study and spirituality to the acculturated values of

entrepreneurship and material success—and so, she suggests, they displaced their frustration onto their wives. Jewish practice and moral education became the province of Jewish women (like the Gentile ideal), who, already responsible for household matters, moved readily into modern domesticity.[22] Joyce Antler describes the monstrous Jewish Mother as engineered through the comedy of the male Jewish *tummlers* (comedians) in the Catskills summer resorts, the postwar locus of Jewish immigrant leisure in America.[23] That configuration was followed, in the 1950s, by the novels of Greenberg, Friedman, and Roth. Riv-Ellen Prell and Martha Ravits go further, and see the elaboration of the Jewish Mother–Jewish Princess as a backlash phenomenon by Jewish men against the wave of modern feminism in the 1960s.[24] The misogynist virulence of the stereotypes, they argue, with the emphasis on suffocating or castrating love from the Mother, or frigidity and narcissistic materialism from the Princess, emblematizes the Jewish man's rage at Jewish women for trying to obstruct their assimilationist desire,[25] or for not acquiescently miming the Gentile wife. The tacit—and rather optimistic—explanation is to assume the presence of a will to adjust and accommodate, whereby the cultural anxieties that provoke the stereotype die down and disappear in acculturated success. What's left out is the inevitable tensions of difference that are inherent to life in diaspora, as well as the ways that stereotype replays and exaggerates the host culture's ideals.

Another dimension of the Jewish Mother–JAP stereotypes—in addition to their ironic mimicry of the Gentile bourgeois family—is their inversion of Christian gender ideals. Christian paradigms and iconographies play a crucial role, not only because these values infuse the consciousness of Western societies, but also because Christian icons and gender configurations hover behind even the most secular of modern pictorial types.[26] Christian art elaborated a reverential iconography of Motherhood—centuries of Madonnas and Holy Families, followed by secularized forms of happy mothers in the eighteenth and nineteenth centuries.[27] We need only look to the emphasis on loving domesticity in French nineteenth-century painting—Renoir's *Mme Charpentier and Her Children,* for example (figure 4.7), or numerous Mother-Child images to find the secular versions of the Madonna and Child, with the bourgeois father—who, like Joseph, is always a subordinate or peripheral figure in

FIGURE 4.7

Auguste Renoir, *Mme Charpentier and Her Children*, 1878.
New York, Metropolitan Museum of Art/Art Resource.

Holy Family pictures—usually absent from the scene. Indeed, the mother
figure as a Madonna, promising eternal love and forgiveness, is so deeply
stamped in Western cultural consciousness that any satire, critique, or
inversion of the paradigm, as in Max Ernst's painting of 1926, *The Virgin
Spanking the Infant Jesus in Front of Three Witnesses* (figure 4.8), appears
shocking, even blasphemous. Like the verbal twists of jokes, it is the rever-
sal of the holy figure's idealized behavior that supplies the shock. As signi-
fiers of assimilation and difference, the stereotypes of Jewish Mother and
Jewish Princess perform their own blasphemy as they too invert or distort
the benevolence, selflessness, forgiveness, and chastity of the cherished
Christian type. The Jewish Mother is precisely what the Madonna is not:
unforgiving, possessive, castrating, domineering, noisy, and protesting.
And the JAP, for all of her treasured virginity, is frigid, materialistic, and
self-involved.

FIGURE 4.8

Max Ernst, *The Virgin Spanking the Infant Jesus in Front of Three Witnesses; Andre Breton, Paul Eluard, and the Painter,* oil on canvas, 1926, Museum Ludwig, Cologne.

If the Jewish Mother–Princess types touch a cultural nerve in their inversion of the Madonna and Motherhood, they are made plausible— if not palatable—through misogynist humor and satire. This has long been a convention for stereotypes and caricatures, from the centuries' old, topsy-turvy world of jesters and the *carnivalesque* to the we/other world of modern ethnic humor. In *Jokes and Their Relation to the Unconscious*,[28] Freud links the comic linguistic formulation not only to the psychological workings of the unconscious, but also to a social mission: to bring together and mark the difference between social figures and groups. In a text full of Jewish jokes, the first one he cites is about a lottery agent who is treated "famillionairely" by the wealthy Rothschild. Evoking a patronizing en- counter between classes, the joke's witty verbal condensation suggests the shared outsider-ness of both men, as Jews.[29] But Freud acknowledges a purpose for jokes beyond immediate pleasure; they have the power to ex- pose as well as to deliver aggression and hostility. "In the case of aggressive purposes," he writes, the joke proffers pleasure "in order to turn the third person, who was indifferent to begin with into a co-hater or co-despiser, and creates for the enemy a host of opponents where at first there was only one."[30] The application of the joke-at-someone's-expense to the effects of stereotypes is simple: functioning as a joke, the stereotype first delivers pleasure and goes on, as it persists in the culture, to sanction continued derision of a targeted group.[31] Whether framed in terms of class, ethnicity, or gender, humor works well at the intersection of a social divide.

It is rarely, however, the fare of high art. At its most avant-garde or sub- versive in the modern period, humor and satire have stayed in the domains of mass culture—in caricature, parody, in the worlds of the fairground, the carnival, cabaret, and film, rather than the museum or concert hall. When mass culture does invade high art—and it is always experienced as an invasion of the impure, as with collage, Dada, and Pop Art—formula- tions of visual humor like stereotype and parody find their place.

Eleanor Antin is one of the first American artists to explore Jewish gen- der and ethnic identity through humor and parody. Born in 1940, a daugh- ter of Polish Jewish immigrants, Antin began exhibiting in the 1960s, not long after the formulation of the Jewish Mother–Jewish Princess stereo- types. Among preceding generations of the American vanguard, Jewish artists gave little sign of their ethnic identity.[32] Jewishness figures more

for Dec.10th and 11th, the days I spent in Washington on business.

MAP CODE

Bored

Calm

Civilized Conversational

Agitated

Argumentative

Hysterical

Provocative

S                                    Story Onset

FIGURE 4.9

Eleanor Antin, *Domestic Peace* (detail), 1971–72, seventeen
handwritten text pages on graph paper. Courtesy Ronal
Feldman Fine Arts, New York/www.feldmangallery.com.

REPRESENTED DURATION: 150 min.

me

mother

Dec. 9,

(Save for a cheerful relaxed day) Why do you get bugged when David
talks about Ted Kennedy? You act as if David is guilty of leaving
someone in the river to drown. If Kennedy hadn't done it David
wouldn't be able to talk about it, right? Look, I didn't say I
wouldn't vote for him. If a body or two in your closet is
sufficient evidence to disqualify a man from being president who
would we ever have to vote for? When they asked Truman on his
80ᵗʰ birthday if he had any regrets he said "One, that I didn't
marry earlier."

FIGURE 4.10

Eleanor Antin, *Domestic Peace* (detail), 1971–72, seventeen
handwritten text pages on graph paper. Courtesy Ronal
Feldman Fine Arts, New York, www.feldmangallery.com.

openly in Antin's work, and has increased, in recent years, with films like
*The Man without a World* (1991) and the installation *Vilna Nights* (1993),
both of which relate to Holocaust and cultural loss. In the early work,
however, as Lisa Bloom points out,[33] Antin's representations of women
have been annexed to feminist issues, rather than Jewish concerns.

*Domestic Peace* (1971–72) (figures 4.9, 4.10), is a seventeen-page text
that measures mother-daughter frictions during the daughter's visit home.
Hardly image-bound, the work avoids conventional figuration, with type-
written text and penciled lines used to represent the mother-daughter
interaction, thereby jettisoning the sentimentality of mother-child imag-
ery. Explicit references to Jews are unstated, but the text offers an ironic

critique of a Jewish mother, at the same time avoiding the caricature or grotesque. With narration turned into data, it is the interaction of the two characters, rather than the essential nature of either one, that counts. The selection of topics for discussion during the visit—family anecdotes, buying furniture, political choices—are both provocative and benign, but they convey the tensions of the mother-daughter bond. Antin wrote: "Though my mother insists upon her claim to the familial she is not at all interested in my actual life, but rather what she considers an appropriate life. . . . By madly ransacking my life for all the details that suited my mother's theory of appropriateness and by carefully suppressing almost all the others, I was able to offer her an image of myself that produced in her a 'feeling of closeness.'"[34]

The desired "closeness" is quantified by the work's visual design; discussions are measured by the length and agitation of graphed marks, and these signify disagreements and moods from boredom to hysteria. Antin alludes to a longed-for candor and intimacy, even as she registers its impossibility. At the same time, there is a sense of the daughter's upper hand. The artist's project is to construct an illusion, a pleasing-to-the-mother image of herself, but the mother, also a construction here, is the measured and judged object of the daughter's—and viewer's—scrutiny. Characterized as a survival strategy, the pseudo-scientific tone of the piece belies the aggression and anxiety of the undertaking.

Any adult daughter will recognize the difficulties presented in *Domestic Peace*. This is the fraught emotionality—with little sentimentality—of mother and child, now both adults. In her account of Jewish content in Antin's work, Lisa Bloom suggests that the tensions documented in *Domestic Peace,* while not stated overtly, are those of the bourgeois Jewish family.[35] And indeed, in the daughter's representation and repudiation of the mother's stereotypical ideals, the reluctant Jewish Princess refuses to conform. At the same time, the graphed encounters of *Domestic Peace* report no simple stasis in the relationship, but rather a range of ambivalent feelings. Antin, in later interviews, declared the importance of her mother's influence: her left-wing politics, her brief acting career in the Polish Yiddish theater, her intellectual and cultural allegiances. From her mother she learned that "being an artist was the greatest thing in the

FIGURE 4.11

Eleanor Antin, *Carving: A Traditional Sculpture,* 1972. Collection
of the Art Institute of Chicago. Courtesy Ronald Feldman
Fine Arts, New York, www.feldmangallery.com.

world. I don't think she really believed it, but I didn't know that. I adored
her and believed everything she said."[36] Despite its liminal Jewish content,
*Domestic Peace* is a rare example of resistant Mother-Daughter identities.
Doing so, it tries to assume another kind of power, one that negotiates
identification and emulation, rather than objectification and differentia-
tion through derision or the grotesque.

Carving, A Traditional Sculpture, 1972 (figure 4.11), proffers a reformula-
tion of the body as a cultural critique: a one-hundred-image photo-docu-
mentation of the artist's effort to lose twenty pounds. Feminist orthodoxy
of that period discredited representation of the female body, asserting that
such images inevitably fall victim to the voyeuristic pleasures associated
with the traditional nude. *Carving* refutes that injunction through an es-

FIGURE 4.12

Hannah Wilke, *Venus Pareve*, 1982–84, painted plaster of Paris.
Jewish Museum, New York/Art resource/VAGA.

pecially objectifying visual mode that mimes the photography of medical
or institutional record. Frontal and flat-footed, the figure assumes none
of the gestures of figural seduction or bodily grace. The posture refuses
the tilts and turns of classical sculpture, and substitutes reportorial data
of the body, photographically moving its forms along an axis of real and
ideal. Like *Domestic Peace,* a tongue-in-cheek mimicry of scientific study,
the work proffers nakedness as a performative construction, and does not
return the conventional pleasures of the nude.

   *Carving* was an admired feminist icon, and Lisa Bloom's insightful ac-
count links it to issues of ethnic identity as well.[37] Short-legged, wide-
hipped, and full-breasted—Antin, Bloom suggests, represents a Jewish
body in these images, if not essentialized, then at least somewhat geneti-
cally formed. A decade later, Hannah Wilke's self-portrait torsos as *Venus
Pareve* (1982–94) (figure 4.12) (*pareve* is the term for neutral food, neither
milk nor meat, in Jewish dietary law) could play with the racial and specta-
torial limits of the goddess figure. Painted in saturated jewel-tones—red,

green, black, brown, lavender, and the like—the plaster figures ironically shift the idealizing terms of white marble and as compelling Venus-of-colors intensify the beauty of the nude female form.[38]

If, like many of her colleagues, Antin appears more feminist than Jewish in her early work, her ethnic identity nevertheless lurks at a subliminal level. "As a Jew, I'm an outsider," she asserts. "As a woman, I'm an outsider. . . . And then I'm an artist, the perfect outsider."[39] Linking these three—Jew, woman, artist—Antin moves the notion of the Jew from a historical and negotiated diasporic position to an existential condition, the creative outsider, tinged with romance and tragedy. In line with her feminist outlook, Antin subsequently enacted gender stereotypes as the Indian maiden, the Egyptian Queen, the nurse, the ballerina. In *Man without a World* (1990) and *Vilna Nights* (1993), however, one a film, the other a video installation, she refers to Eastern European Jewish life before the Holocaust. These dramas evoke a world of disappearance and catastrophe, rather than the vital Yiddish society, full of possibility, of Antin's mother's youth. They signal a distinctive ambivalence faced by Antin's generation: the avoidance of explicit Jewish content other than Holocaust references—an approach that maroons Jewish content in the psychic imaginary of loss.

That avoidance was roundly challenged by the exhibition *Too Jewish, Challenging Traditional Identities,* curated by Norman Kleeblatt at New York's Jewish Museum in 1996. The show was a breakthrough event, as it audaciously opened the question of Jewish stereotype at the level of high culture. This was art that suited the postmodern enthusiasm for identity politics and minority cultural representation. But *Too Jewish* confronted art world exclusions with humor and parody rather than indignation, and like Jewish jokes, flaunted the déclassé character of the comic mode.

The Jewish Mother, however, was barely in evidence. Instead, the Jewish Princess was the preferred object of derision, and usually outside the family frame. Rhonda Lieberman's still-life installations and catalogue essays launched trenchant critiques of Jewish femininity and Princess-ness. Objects of Jewish ritual are annexed here to the logo-trappings of worldly chic. *Chanel Chanukah* (1991) (figure 4.13), a collaborative work with Cary Leibowitz, mocks the patina of designer goods and labels with its glittering fake leather bag, sinuous chain of Chanukah *gelt,* and cheap menorah with Chanel lipsticks as candles. It may be no accident that Chanukah

FIGURE 4.13

Rhonda Lieberman, Cary Leibowitz, *Chanel Chanukah,*
1991. Courtesy Invisible Exports Gallery, New York.

celebrates a miracle of survival under powerful enemies (Maccabean Jews against the Romans)—an ancient resistance to capture and assimilation, rendered ironic in this work. The blasphemous combinations also call attention to a gendered stereotype, for the values of the purse owner, the Jewish Princess, are relentlessly materialistic and ultimately devalue the holiday's ideal. The humor of the work lies in its near miss—the near miss of the Jewish Princess's desire—with its clear seams of difference and hybridity. Playing at the social border between taste and tastelessness, these object-amalgams entice with the wit of the Duchampian ready-made and poke fun at all sides of the joke: the fashionable framework of acceptance, the unattainable chic, the bargain knockoff, and the search for authenticity that is the Jewish Princess's tireless quest. The seams of juxtaposition in *Chanel Chanukah* underscore the costuming of assimilation and diaspora's unfixed identities.

Lieberman's projects repeatedly take on this point. At a retreat for Jewish artists and critics held in a luxurious Protestant church–owned lodge in rural Connecticut,[40] Lieberman performed the Jewish Princess. With

a Bloomingdale's shopping bag at her side, she opened the proceedings by thanking the organizers for bringing the group to such beautiful surroundings. "It's soooo Ralph Lauren," she breathed, invoking the fictions of high WASP success by Jewish fashion designer Lauren (né Lipschutz). Her comment immediately denaturalized the environment, designated it a constructed fantasy, and like the deracinated Jew at some distance from nature—that is, like Lauren/Lipschutz—draped it in in a mantle of assimilationist desire.

Lieberman's critique of Jewish gender ideals extends to her writing as well. Two essays on "Jewish Barbie" explore the yearnings of the popular icon created by Ruth Handler, the Jewish owner of Mattel toys.[41] "Who but a Jew," Lieberman wrote, "is best at packaging unwhiny blonde fantasy figures?" Her analysis reviews the standard features of this goyish ideal—slim thighs, anorexic body, pert nose, and straight blonde hair—as well as the exclusionary social mechanisms of the doll's success. Even as Barbies-of-color entered the market, the essay points to the absence of a Jewish Barbie, and underscores a Jewish desire to disappear into the mainstream, paradoxically risking either failure or self-erasure. Eager to straighten her hair and nose, unable to celebrate her own dark, aquiline features, Jewish Barbie is unimaginable and unimaged except as the Princess grotesque.

Lieberman, however, does try to imagine her. To that end she invokes—via Nietzsche, Deleuze, and others—a practice of "legitimate misreading" by "nomad rogue readers" who, in her words, "can make monsters out of what we read through the distorting lens of strange and new desire, spawning conjunctions, the metabolic products of reading as contamination, rather than reproducing codes faded by familiarity and thus sterilized into pre-packaged 'identities' and stuff we've already known and labeled."[42] Lieberman's effort to fantasize Jewish Barbie and the range of philosophical partners she summons to the task suggests how far the imagination must venture in order to create a viable new Jewish identity, how well beyond past limits and ideals. Terms like misreading, rogue, distorting, strange, contamination: all these reiterate and excite, as they hammer home what every feminist knows—the dangers and risks of new ideals, the monsters of uncharted identity. Like Donna Haraway's feminist woman-as-cyborg,[43] Lieberman's imagined Jewish Barbie seems to

inhabit a parallel universe, among us but not yet at home in this world. And, like Haraway's essay, Lieberman's text is also a call to think beyond the stereotype in the reformulation of identity and self.

And what of the Jewish Man, so marginal as father in the model Holy Family that he seems absent from the family relationship? His appearances in the *Too Jewish* show addressed the assimilationist habits of name changing and nose straightening, along with concern for Jewish masculinity. Freud's bullied father in the shtetl, his orthodox hat in the gutter, did not—in Freud's account—measure up to Western standards of virile masculinity, but neither, as Daniel Boyarin argues—did he take an interest in the aggressive manliness of the Gentiles—a quality Boyarin designates as *goyim naches* (Gentile pleasure).[44] In that refusal, what has been read as the father's "feminine weakness" might also be seen as imperviousness to or disdain for the thuggish habits of the Gentile, while the son's response— humiliated by his father's vulnerability—marks the modern designation of traditional Jewish masculinity as shameful stereotype.

Eager to modernize, twentieth-century Jews produced a counterstereotype, the "Muscle Jew" (*Muskeljude*), whose physical prowess certified manliness and linked him to the machismo of Western Christian cultures.[45] In *The Spirit of the Ghetto*, the first chapter, "The Old and the New," describes three types: the Old Man, the Boy, and the Intellectuals. The Old Man remains "the patriarchal Jew devoted to the law and prayer," and the Boy is "shrewd-faced ... with ... melancholy eyes" facing the "contrary" directions and influences of orthodoxy, Americanness, and socialism.[46] The intellectuals—mainly Russian Jewish immigrants—are, in author Hapgood's words, "the anarchists, the socialists, the editors, the writers; some of the scholars, poets, playwrights and actors of the quarter." Among them is *Forverts* editor Abraham Cahan,[47] whose novel *Yekl* is praised for its "unpleasant" realities and accompanied by Epstein's illustration of Yekl as womanizer, a brutish type eager to make his way with the "sweat-shop girl" in the modern American world (figure 4.14).

The Muscle Jew aped the machismo of Western men, but his performative masculinity was not a complete success. "The Jewish male," Daniel Iskowitz writes, "was American but foreign; white but racially other; consuming but non-productive ... an inauthentic participant in heterosexu-

FIGURE 4.14

Jacob Epstein, "Yekl," in Hutchins Hapgood, *The Spirit of the Ghetto* (New York: Funk and Wagnalls, 1902).

ality, and inauthentically within the walls of high culture. . . . The Jewish male was imagined to be a secret perversion of the genuine article.[48] Daniel Boyarin, however, offers a counterposition to the tyranny of Western machismo, suggesting that the eros of premodern rabbinic Judaism offers an alternative to Muscle Jew masculinity and another way of being a Jewish man. Eager to reclaim the manly possibilities of the Jew as "eroticized sissy," Boyarin writes, "Jewish culture demystifies European gender ideologies by reversing their terms, which is not a liberatory process in itself but can be mobilized—strategically for liberation. . . . The modern Jewish abandonment of our sissy heritage has been a noxious force in modern Jewish culture, an ill wind that has brought no one good."[49]

The proposition is both provocative and thrilling, for it confronts the reader with both the difficulty and the excitement of imagining a different eros. Picturing it may restate both dimensions. Ken Aptekar's Jewish subjects, however, take on the conundrum of Jewish masculinity as well as issues of assimilation. With subjects drawn from Old Masters or other museum works, Aptekar's painted images are surfaced with glass panels that in turn carry sandblasted text. Like carefully composed anecdotes, these literary messages are carefully placed so as to interact symbiotically with the host imagery beneath. Thus the text not only carries a commentary—Midrashic style, on the surface, in a different register or font—it highlights a traditional Jewish intertextual enterprise of interrogation and dialogue. The result is a picture with multiple "voices" or sights, in which the image is primary, but where words also comment, explain, and, unlike a caption, refuse to resolve.

*I Hate the Name Kenneth* (1996) (figure 4.15) turns to ethnic stereotypes to spell out the challenge to Jewish identity and manliness. The title announces a diasporic journey, and the source paintings, all turn-of-the-century portraits by the nineteenth-century Jewish Hungarian artist Isidor Kauffman, show two Eastern European Jewish men (one a rabbi) and two youths. Aptekar paints these as framed images—pictures inside his picture, in somber grays and browns—thereby distancing the viewers from his subjects' original identities. The men appear costumed; they wear the signs of their ethnicity and ritual practice as old-country Jewish men. The text reads:

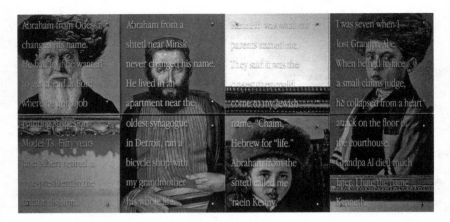

FIGURE 4.15

Ken Aptekar, *I Hate the Name Kenneth*, 1996.  Courtesy of the artist.

Abraham from Odessa changed his name. He had to if he wanted to get ahead at Ford where he got a job painting stripes on Model Ts. Fifty years later Albert retired, a vice-president in the tractor division.

Abraham from a shtetl near Minsk never changed his name. He lived in an apartment near the oldest synagogue in Detroit, ran a bicycle shop with my grandmother his whole life.

Kenneth was what my parents named me. They said it was the closest they could come to my Jewish name, "Chaim." Hebrew for "life." Abraham from the shtetl called me "mein Kenny."

I was seven when I lost my Grandpa Abe. When he had to face a small claims judge, he collapsed from a heart attack on the floor of the court-house. Grandpa Al died much later. I hate the name Kenneth.

Aptekar's small story personalizes the ethnic stereotypes and their history. In vertical alignment across each figure, the text identifies two grandfathers and two phases of the young boy's life. And the tale, like the imagery, resonates with nostalgia, ambivalence, and loss. Leaving home, Odessa or the shtetl near Minsk, somewhere the grandparents shift into the masculinities of the modern world, and shape the artist's diasporic identity as Kenneth/Chaim. We are told of, but do not see, their new-world identities, and despite the assertive presence of the Young Boy in his tallis, the sideways pose of this Chaim closes the visual narrative, as if part of the grandfathers' past. The painting thus leaves the matter of change

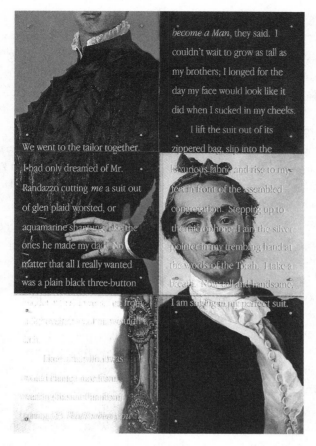

*become a Man*, they said. I couldn't wait to grow as tall as my brothers; I longed for the day my face would look like it did when I sucked in my cheeks. I lift the suit out of its zippered bag, slip into the luxurious fabric and rise to my feet in front of the assembled congregation. Stepping up to the microphone, I aim the silver pointer in my trembling hand at the words of the Torah. I take a breath. Now tall and handsome, I am singing in my perfect suit.

We went to the tailor together. I had only dreamed of Mr. Randazzo cutting *me* a suit out of glen plaid worsted, or aquamarine shantung like the ones he made my dad. No matter that all I really wanted was a plain black three-button

FIGURE 4.16

Ken Aptekar, *We Went to the Tailor*, 1995. Courtesy of the artist.

and assimilation spoken—"I hate the name Kenneth"—but problematic and unresolved.

Aptekar's *We Went to the Tailor Together* (1995) combines personal history with reconsideration of the Jewish man and masculine stereotype (figure 4.16). Richly painted in black, white, and ochre, the partial image of two men—fragmented, like surviving antiquities—is derived from works by the sixteenth-century Italian painter Il Bronzino and the eighteenth-century Spanish painter Luis Melendez. To the modern viewer, these are striking if somewhat dandified figures. Each man assumes an

elegant, assertive pose, touched with vanity—or perhaps disdain. Who is not drawn to the prideful stance, the exquisite hand, the dark sensual features of the face? With the flowing knot atop his head extending the white froth of his blouse, the clothes are simply gorgeous. All this finery draws us through the details of the figures' bearing, spelling out the components of the Jewish Man as handsome object of desire.

From underwear advertising to the gym-fit body, modern popular culture has relicensed the spectacle of masculinity as object of a desiring and adoring gaze. While they are hardly Muskeljuden, the men in Aptekar's picture enact this pleasure. Their slim bodies are so decorated with exuberant finery as to suggest a different kind of man, somewhat dandified with his frills and his seductive stare, but hardly emasculated. One might argue that with source figures drawn from Italy and Spain, Aptekar has found a Sephardic model for his masculine ideal. Clearly different from the shtetl types, they are an exotic and little-seen Jewish masculinity.

The text extends and modernizes this fantasy. It recalls the thoughts of a Jewish youth dressing for his *bar mitzvah,* the religious ceremony in which he will become a Jewish man. Carefully placed phrases reinforce the preparation's solemnity: "We went to the tailor together" is emblazoned across the quilted torso and introduces the shared dimension of the dressing ritual. The same panel keeps us deep in the fabric—glen plaid worsted, aquamarine shantung—and ends with youthful desire: "all I really wanted . . ." From there, we shift upwards to the declaration, "become a Man," and down again to handsome and thoughtful manhood.

> We went to the tailor together. I had only dreamed of Mr. Randazzo cutting me a suit out of glen plaid worsted, or aquamarine shantung, like the ones he made my dad. No matter that all I really wanted was a plain black three-button model with side vents, cut from a lightweight wool that wouldn't itch.
>
> I knew that who I was would change more from wearing the suit than from turning 13. That's when you become a Man, they said. I couldn't wait to grow as tall as my brothers; I longed for the day my face would look like it did when I sucked in my cheeks.
>
> I lift the suit out of its zippered bag, slip into the luxurious fabric, and rise to my feet in front of the assembled congregation. Stepping up to the microphone, I aim the silver pointer in my trembling hand at the words of the Torah. I take a breath. Now tall and handsome, I am singing in my perfect suit.

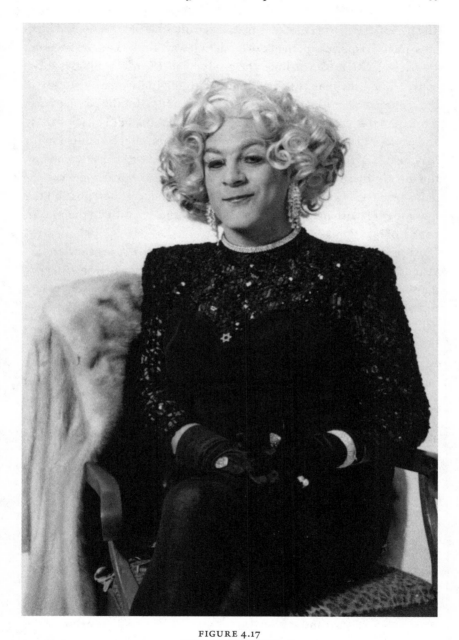

FIGURE 4.17

Amichai Lau-Lavie, *Rebbetzin Hadassah Gross*. Photo
Keith Gemerk. Courtesy Storahtelling, Inc.

The personal voice of Aptekar's texts intensifies his pictures' embeddedness in the diasporic experience of modern Jewry. The voice and viewpoint are packed with mixed feelings and excitement. The text combines social convention—the making of the suit—with the individual's emotion in the solemn male initiation into Jewish community. But the picture offers more than the forms of ritual. It conjures trepidation, self-consciousness, and pride, and a male figure draped in worsted and silk, embodied in the dark beauty of the painted men. Joined to the trembling bar-mitzvah boy, the men in these paintings are neither the modern Muscle Jew nor the pious yeshiva *bokher* (young man). Rather, they suggest new possibilities for modern Jewish men, proud in their status and beautiful in their incarnation of Jewish masculinity.

At present, in the second decade of the twenty-first century, the revisioning of Jewish masculinity, like Boyarin's call for a new Jewish eros, may be most effectively realized through a queering of Jewish gender representation. The Jewish Mother may have been set aside for a younger generation of Jewish artists, but she did not go far. With her appearances in performance venues and on the Internet, Amichai Lau-Lavie's *Rebbetzin Hadassah Gross* takes the grotesqueries of the Jewish Mother to a new Queer cultural space. Calling herself a "Soul Trainer" who is "older than Moses, younger than Spring," and elaborately overdressed (figure 4.17), the blonde-wigged and heavily made up Rebbetzin offers wisdom about modern Jewish practice. She writes on her web blog, in the form of "A Hasidic Parable," about "naked" Truth and why she wears "couture." "Truth followed this advise [*sic*] and decked himself out in Parable's gay clothes. And lo and behold! People no longer shunned him but welcomed him heartily. Since that time Truth and Parable are to be seen as inseparable companions, esteemed and loved by all."[50]

The character's name and title invoke a gendered scheme. "Hadassah," after all, is a Jewish woman's name, but it is also widely recognized as the name of the bourgeois Jewish women's organization dedicated to charity and good works. The surname "Gross" means large (in Yiddish) and may refer to her stature and her girth; in today's adolescent vernacular, it is also signifies revulsion and excess. And "Rebbetzin" is the honorific for a rabbi's wife. The rabbi dispenses advice and wisdom, but this rebbetzin reverses the role—and presumably much else—as she notes the sexual

potency of her seven deceased husbands and thus insistently reintroduces sexual pleasure into the Jewish feminine domain. Though she upholds the general principles of Jewish law and tradition—Lau-Lavie does not renounce his Orthodox upbringing—her wisdom is both irreverent and probing, linked to Judaic traditions of study, interpretation of meaning, and arguing with God. And her desire is lovingly delivered to "my dear *kinderlakh* [children]," echoing the sweet Yiddishe Mama with little of a Jewish Mother's hectoring complaint.

The Rebbetzin's radical gender intervention is not only her comedic character—and the transgressiveness of Jewish female comedians[51]—but also the Jewish Queer sensibility she sets before us. Working in drag—a practice of queering stereotype—allows Lau-Lavie, as historian David Shneer notes, "to avoid the dichotomy of sameness and difference."[52] With Queer Performance, the excessiveness of stereotype reframes itself as a parodic site of inquiry and possibility. Indeed, as the Rebbetzin declares about celebrating Pesach, "Together, we will cross the sea of reeds and *nahrishkeit* [foolishness] into a desert of possibilities, once again, matza in hand!"[53] It is, then, not Hadassah's counsel that is transgressive, but her persona and visual mode of being. By invoking the dictates and taboos of Jewish law, the Rebbetzin tumbles the usual forms of female stereotype, and in her own Queer Drag Queen difference proposes a refreshed access to Jewish thought and being.

In their play with stereotypes, all of these artists—Antin, Lieberman, Aptekar, and Lau-Lavie—challenge and invigorate the Rebbetzin's "desert of possibilities." Antin pushes at the confinements of Jewish Mother–Daughter—though, as for many of her generation, Jewishness is a whispered subtext. Through her campy exaggerations of JAP identities, Lieberman, a generation younger, audaciously forges another route to reimagine and re-vision Jewish feminine ideals. Aptekar's images, on the other hand, continue to enjoy some masculine privilege, even as they offer a new kind of attention to Jewish manhood. The persistence of pleasure and desire in his pictures, his use of familiar ritual infused with the contradictions of individual experience, pry apart the diasporic stereotypes' confining space. These works also benefit from the social and cultural openness of gay and lesbian sexualities, which dislodge the rigid boundaries of Western machismo. Thus, rather than ridicule the figures they

present, the combined pleasure of paint, figure, and voice in Aptekar's pictures allows viewers—and especially Jewish men—to remember and to reconsider the modes and varieties of Jewish masculinity. And it is in that putatively more open and essentially Queer-ed arena that Lau-Lavie's Hadassah Gross may thrive.

As Jewish artists, Antin, Lieberman, Aptekar, and Lau-Lavie work in the multiple spaces of an American diaspora, appealing to and changing the contours of the avant-garde's audience. Their success is not parochial, but enacted in the mixed communities of the culture as a whole. In their art's embodiment of Jewish concerns in a variety of gendered configurations, we may see the border lines of assimilation and the continuing challenge of diasporic change.

# Diasporic Values in Contemporary Art:
# R. B. Kitaj, Ben Katchor, Vera Frenkel

The Diasporist feels uneasy, alert to his new freedom, groundless,
even foreign—until or unless he feels very much at home.

—R. B. Kitaj, *First Diasporist Manifesto*

Exile is always the beginning of narrative—and Diaspora
is the place where people talk.

—Sidra DeKoven Ezrahi, *Booking Passage*

I begin this chapter and conclude this book with a challenge posed in
these epigraphs on Jewish life and art in diaspora. In his *First Diasporist Manifesto* (1989), the painter R. B. Kitaj declares diaspora's fundamental ambivalence. It encompasses both the exhilaration and anxiety of being unfettered—free of convention and proscriptive ties—as well as uneasiness in that "groundless" state. The discomfort passes, Kitaj suggests, when the Diasporist recognizes that this state can also be "home." Aphoristic in style, the *Manifesto* proclaims displacement as a central condition of modernity and modern art. "Diasporist painting, which I just made up," Kitaj wrote, "is enacted under peculiar historical and personal freedoms, stresses, dislocation, rupture and momentum. The Diasporist lives and paints in two or more societies at once."[1] Diasporism, then, is deemed a characteristic of modern artists generally. "In my time," he states, "half the painters of the great schools of Paris, New York and London were not

born in their host countries."[2] Kitaj saw a real advantage to this condi-
tion for the artist. "As a painter, I've come to detect something like moral
power or destiny, living in more than one society, wrapped about in art,
in its histories and antitheses."[3] But however broad the *Manifesto*'s claims,
and however eager the artist was to see it as a modern condition, Kitaj's
Diasporism is clearly Jewish. "Diasporic painting," he wrote, "is unfold-
ing commentary on its life-source, the contemplation of a transience, a
Midrash . . . in paint. . . . These circumstantial allusions form themselves
into secular Responsa or reactions to one's transient restlessness, un-at-
homeness, groundlessness."[4]

Writing a decade later, literary scholar Sidra DeKoven Ezrahi also
evokes modern diaspora's creative possibilities. If exile begins a tale, she
argues, a history to be told and handed on, then diaspora—a long-endur-
ing exile—augments and elaborates that story. Less a space of alienation,
though the tensions of difference always remain, it is an important site of
a modern Jewish aesthetic, in Ezrahi's terms, an "imaginative theatre,"
the place or condition where "people talk." Prompted by Philip Roth's
novel *Operation Shylock* (1993), she describes diaspora as a site of cultural
fiction and imaginative play, a "masked ball" of performativity that, pre-
cisely because of its unrealized fantasy of return, encourages qualities of
dream and possibility often repressed in the ideological confines of mod-
ern Israel. For Roth, Ezrahi observes, and we might add for Kitaj as well,
"Diasporism has taken on a new cultural agenda . . . [as] the foundation of
a new Jewish aesthetics."[5]

We may see features of this "new Jewish aesthetic" in work by R. B. Kitaj
(1932–2007, born in Cleveland), Ben Katchor (born 1951 in Brooklyn, New
York), and Vera Frenkel (born 1938 in Bratislava, Czechoslovakia): three
Jewish artists who work mainly in the United States and Canada, and
exhibit their art in mainstream international art venues. While hardly the
only subject in Kitaj's extensive oeuvre, *The Jewish Rider* (1984–85) (figure
5.1) and *Rain* (1990–2004) (figure 5.4) are two among many pictures by
the artist dealing with diaspora, displacement, and foreignness. Katchor's
graphic novel, *The Jew of New York* (1999) (figure 5.5) tells an illustrated tale
of immigration, intercultural relationships, and searching for home. Fren-
kel's installation work . . . *from the Transit Bar* (1992) (figure 5.8) provides a
temporary refuge for a community of travelers telling their tales of home.

FIGURE 5.1

R. B. Kitaj, *The Jewish Rider*, 1984–85. © The Estate of R. B.
Kitaj. Courtesy Marlborough Gallery, New York.

All of these works deal with journeying and fantasized adventure, but—
especially when seen through a Jewish lens—all also deal with upheaval
and uncertainty. Their similarities and differences illuminate the ways
in which diasporic culture may reach multiple audiences and assert the
multiple subjectivities that, in W. E. B. Du Bois's phrase, is the hallmark
of diaspora's "double consciousness."

A similar doubling characterizes the production of modern Jewish art.
Just as the Jewish citizen in diaspora carries multiple identities, so mod-
ern Jewish art in diaspora is a heterogeneous entity. Not merely a local

phenomenon, nor an insider's art, it is instead a flexible cultural weave, combining Jewish elements with the cultural features of the national host or international matrix. Thus, unlike the effort of contemporary Israeli art to distinguish itself among national cultures, diasporic art has very a different project: to push at or interrogate national cultural limits and to embrace or transmit its fluidities.

R. B. Kitaj's diasporic identity began with his childhood. Raised in Midwest Cleveland, the adopted son of a Viennese Jewish immigrant father whose name he took, Kitaj lived the expatriate artist's life first in Vienna and then London. His best-known work, *The Jewish Rider* pictures a middle-aged gentleman on a passenger train, soberly lost in thought despite his brightly colored surroundings. Ever eager to attach his work to mainstream art history, Kitaj derived his passenger from the equestrian knight of *The Polish Rider,* a painting formerly attributed to Rembrandt in the Frick Collection in New York. The Jewish dandy in the train—the model was Jewish British art historian Michael Podro[6]—retains the proud posture of the Polish hero on horseback, though his mount is squashed beneath him, and its protruding greenish head and white tail turn him into a strange hybrid. Unlike the misty hills surrounding Rembrandt's steed, Kitaj's train moves through an ominous landscape, where a chimney, visible through the window, sends its smoke up to the Cross on a hill. Kitaj breaks the figure, train setting, and window view into wildly colored, loosely brushed segments, and in this excited sea of color, the balding head and face is a somber spot of dullish-gray, downshifting the demeanor of the Jewish man from the dashing confidence of the Polish knight. To underscore the sense of confinement, a steep and narrow blood-red corridor at the right edge of the image tunnels back to the stick-figure conductor—a uniformed authority—arms also akimbo, waving a weapon-like baton. We observe this scene as if standing to one side, pausing in the passage between compartment and corridor. But there is no refuge beside this passenger. The vivid zone of fragments also threatens to slide apart. Its painted restlessness loosens the figure's form, attention lodges in the blood-red trousers, and it requires effort to see the whole coherently. In this charged and dislocating combination of color, space, and mood, the Polish Jewish Rider—unlike the self-assured equestrian figure—travels to some unknown destiny.

FIGURE 5.2

R. B. Kitaj, *Cecil Court, London, WC 2 (The Refugees)*. © The Estate
of R. B. Kitaj. Courtesy Marlborough Gallery, New York.

While living in London for four decades and feeling his difference as
an American Jew in Britain,[7] Kitaj's diasporist identity was reinforced
by his need to address a catastrophic Jewish history and by his desire to
bind his work to some larger community. Diaspora provided this larger
"theater . . . where human artistic instinct comes into play."[8] *Cecil Court,
London, WC2 (The Refugees)* (1983–84) (figure 5.2), a wildly colored scene,
shows the London street famous for secondhand book stores. Indeed,
what better setting for refugees—secondhand citizens—than the space
of secondhand books, themselves, by definition, instruments of diaspora?

Reminiscent of Otto Dix's *Pragerstrasse* of 1920 filled with grotesque Berlin residents and veterans of WWI, Kitaj's stagelike promenade is lined with lit shop fronts and peopled by refugees. The artist lies on a couch in the foreground, like a patient in analysis, and figures from his life—fallen men and women, flower vendors, streetwalking strumpets—loom large in the space beyond. The theatrical presentation is also fitting, for Kitaj claimed his design was inspired by the traveling Yiddish Theater Troupe that had so impressed Kafka. For Kafka, the interaction with the troupe and its director brought new admiration for the Yiddish culture of Ashkenaz;[9] it is that world, perhaps, almost destroyed, that seeks refuge in Cecil Court. Thus, while there is much that is celebrative in Kitaj's work, and in his advice to artists to live "diasporically," the diasporic imagery in pictures like this and others like *Germania (The Tunnel)* (1985) or *The Jewish School (Drawing a Golem)* (1980) alludes to specifically Jewish experience and is fraught with expressions of disquiet, dislocation, disruption, and fear.

Some scholars put a positive spin on Kitaj's Diasporism. Andrew Benjamin sees in the Wandering Jew/Jewish Rider not a punitive homelessness, but more existentially—or theologically, like the Jewish God—a people unfixed, always in the process of becoming.[10] Janet Wolff argues that the layered allusions and unresolved meanings in Kitaj's work—problematic features for many of his critics—are an effective pictorial homology to the condition of diaspora itself. The signs of diaspora, Wolff concludes, "emerge in silence, mobilized . . . by the play of images and their open-ended and often contradictory connotations."[11] Juliet Steyn and John Lynch also consider the pictures' diasporism a deep dimension of Jewishness, while other scholars—Andrew Benjamin, Giles Peaker—deem the critical emphasis on the past too limited (they do not say too pessimistic or tragic) a reading.[12] Benjamin, in particular, argues in some detail that notwithstanding the imagery of trains, smoking chimneys, railroad tracks, watchtowers, Kitaj's pictures of Jewish travelers are "futural"—they are en route to somewhere; though not the doomed Wandering Jew, they escape and avoid that Christian icon and journey on to somewhere new.[13] Even this futural mode, however, has the tension of critical rescue: to my mind, the earlier pictures seem bound to an afflicted past, while the futural, of necessity, seems both anxiously desired and unknown.

FIGURE 5.3

R. B. Kitaj, *London School of Diasporists*, 1988–2004. © The Estate
of R. B. Kitaj. Courtesy Marlborough Gallery, New York.

Such approaches to these diasporist pictures or to diasporism generally,
are still bound to the distressing condition of nomadism or exile. Despite
invocations in Kitaj's pictures of great Jewish diasporists like Walter Ben-
jamin, Franz Kafka, Philip Roth, and notwithstanding the moral-critical
edge that Kitaj believed is diaspora's claim, it is the plight—not the pur-
pose—of the Wandering Jew/Jewish Rider, the smoking chimneys of con-
centrations camps, the anxieties and uncertainties of diasporic emigration
that he depicts here, not the positive potential of diaspora's imaginative
theater.

Kitaj's shock at his status in Britain—Janet Wolff characterizes it as
that of "unwelcome boarder"—signaled for him that his comfort in that
double diaspora—as a Jew and an American—was illusory. *The London
School of Diasporists* (1988–2004) (figure 5.3), a painting begun in London
and finished in Los Angeles, may announce a "school," but it also suggests
an exodus and ending. Five figures, all Jewish painters in London, are
stretched across a stage-like foreground and against the deep blue forms
of a modernist house in the background. Lucian Freud, Frank Auerbach,
and Sandra Fisher, spectral figures in slashes of white, sit, stand in salute,

and exit to the right respectively, while a nude Kitaj brandishes his brush at the left, and a red-clad Leon Kossoff leads the group out at the picture's right edge. The blue background structure with its emphatic horizontal geometries also reads like ghostly passing trains, and reinforces the spectral quality of the figures squeezed across the narrow foreground. If this is a school—and Kitaj named the painting many years after it was begun[14]—it is a school seen only as it disperses.

Kitaj's diasporism, however, takes on another inflection after the artist moved home. Bitterly blaming critics for the reception of the Tate exhibition and shattered by the sudden death of his wife shortly thereafter, Kitaj returned to the United States in 1994; he lived and worked in Los Angeles until his death in 2007, shortly after the appearance of his even more aphoristic *Second Diasporist Manifesto*.[15] "I love being in my own country in my last years," he wrote early on. "My country is the American Diaspora of the Jews" (Kitaj, 2007, #59). The text this time is emphatically Jewish in its organization and concerns, and opens with the declaration: "Jews are my Tahiti, my Giverny, my Dada, my String Theory, my Lost Horizon." The Second Manifesto is written as 615 propositions, one more than philosopher Emil Fackenheim's addition to the traditional 613 commandments that "the authentic Jew of today is forbidden to hand Hitler yet another, posthumous victory." To this the artist adds, "As I make to die, here's *my 615th*: EASEL PAINTINGS ARE NOT IDOLS, so JEWISH ART IS OK to do without consulting your Rabbi, so do it! It's good and universal!" (Kitaj, 2007, #61).

Although the document ends with this ringing revision of the Second Commandment, that is not its main preoccupation. Rather the statements read like diaristic musings and jottings, like the Jewish artist thinking aloud and making notes to himself. Packed with references and allusions to art history and Western culture in general, Kitaj naturalizes an odd company of Jews and Gentiles: "A great sage, contemporary of Chardin, Rabbi Nahman of Bratslav (from the Ukraine of my grandparents)" (Kitaj, 2007, #46). Citing these and other figures, the text is a guide to the challenges of making a modern Jewish art. And in this task, Kitaj remained a diasporist, paying little attention to art from Israel. Jewish art, his text maintains, is a modern phenomenon, bound to modernism, but at the

same time, it is montagist—fragmentary—and filled with the materials of a shattered history. Jewish art, he wrote, "makes the unified work of art a sort of idolatry" (Kitaj, 2007, #397). There is a tacit analogy here between the unified work of art and the (fictive) unified nation, but the reference to idolatry takes the statement further to suggest that only the fragmented, the partial, or the incomplete can stand as art or as aesthetic possibility; to strive for unity is a creative presumption, and an idolatry that challenges or competes with God. This position, of course, is not new; such issues recur almost continuously from the twelfth-century writings of Maimonides to those of Abraham Kook, chief rabbi of Jerusalem in the early twentieth century.[16] But Kitaj's effort is distinguished by its constant search for and interrogation of the possibilities of Jewish art. Among the "Ten Commandments" boxed off in the text and titled "How to Do a Jewish Painting Art," the first states with generous imprecision, "Be some kind of Jew"; the ninth declares: "Pay attention to Host Kulchur [*sic*] in the Diasporist, Giotto to Matisse to now" (Kitaj, 2007, #400). The jargoned spelling demystifies the host culture and takes it down a peg, enabling more access and intimacy in this domain.

After his return to America, Kitaj's paintings also show a shift in their Jewish concerns, away from Holocaust displacements and, like the *Second Manifesto,* closer to Jewish theology and cultural history. Disruption and the Holocaust are no longer central metaphors in Kitaj's allegorical world. The pictorial cast of Jewish characters—iconic Torah figures, Enlightenment rabbis, modern culture heroes, and Sandra (his late wife) as *Shekhina,* the eternal (and never tragic) Jewish feminine—such figures appear in myriad combinations, side by side with their famous Gentile contemporaries. A semi-masqueraded self-portraiture recurs, ebullient and audacious in its partnerings and appropriations—Cézanne, Freud, Kafka, Matisse, Whistler—Kitaj assembles his own imaginative pantheon; he discourses and pictures in that company.

*Rain* (1990–2004) (figure 5.4), a painting worked on intermittently over fifteen years, as if to mark the transition from one home to another, declares in vivid color the persistence of some diasporic paranoia. A chunky figure in a blood-red overcoat trudges through an indeterminate space, bearing, as if in rescue or like a St. Christopher, a multiple-headed, blue-

FIGURE 5.4

R. B. Kitaj, *Rain*, 1990–2004. © The Estate of R. B. Kitaj.
Courtesy Marlborough Gallery, New York.

clad creature on its back. The carried figure wraps blue-trousered legs around the red torso and the two necks sprout four faces, one sad-eyed and mournful, another almost sheer scribble. Huge and bulbous in their frame, together they lean into driving red and blue lines of rain, determinedly making their way forward.

The pictured situation may be what Andrew Benjamin calls "futural," but Kitaj describes the figures as "Jews in trouble (as usual), fleeing London for Los Angeles," and adds the comment from Jacques Derrida: "'I always adopted a stance to provoke them, to expel me again.'"[17] With the artist at home, but again prepared to run, diaspora here has become a more personal and militant stance, though Kitaj seemed to find strength and pleasure in his critical misfortune, as if it helps to define precisely what kind of Jewish artist he is. Rather than unwitting victim, he has become both Jew and artist as provocateur, pulling artist and Jew closer together to continue the heroic posture of the modernist avant-garde. At the same time, the Los Angeles diasporist assumed a place in an illustrious history. With his last major exhibition at Marlborough Gallery in 2005, titled *How to Reach 72 in a Jewish Art,* Kitaj claimed, in old age, the position of celebrative—and wary—Jew.

As unique objects of high culture, exhibited in museums and galleries, Kitaj's pictures reach a broader community through art books and photo reproductions. Ben Katchor's work, however, appears first as comic strips in newspapers, a medium that fosters Benedict Anderson's "imagined community" and effectively conjoins segments of diaspora's far-flung geography.[18] Nationally syndicated, Katchor's strips have been a regular feature of the weekly English edition of the Jewish *Forward,* a natural site given the paper's history and its own diasporic purpose. Once the most widely read Yiddish daily in America, with the declared mission of Americanizing its readers, the paper now draws on an acculturated but self-consciously Jewish American readership, for which it reports and reinforces the continuing vitality of diasporic Jewish life. But in addition to his Jewish constituency, Katchor, who teaches at New York's School of Visual Arts, and whose Guggenheim and MacArthur fellowships certify his place in the American mainstream art world, also publishes his strips in book form. These include *The Beauty Supply District* (2000); *Julius Knipl,*

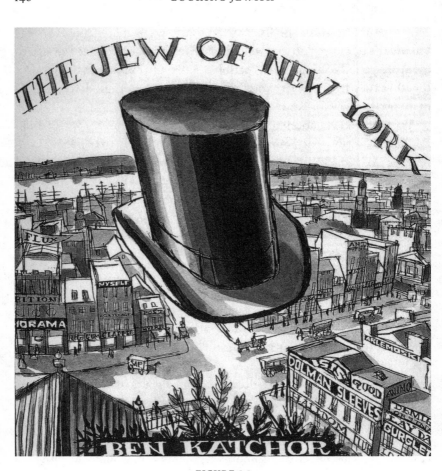

FIGURE 5.5

Ben Katchor, *The Jew of New York*, 1999. Courtesy Random House, New York.

*Real Estate Photographer* (1996); *Cheap Novelties: The Pleasures of Urban Decay* (1991). The titles are high-art parodies: they play on beauty and its commercial supply, on photography of properties not landmarks, on the joys of vulgar novelties, not artistic innovation or aesthetic delight. In *Hotel and Farm* (2008), for example, the action takes place in settings bound to a particular Jewish irony: the Jew as perpetual (hotel) guest and so never at home, and the farm, the landedness from which most diasporic Jews were for centuries excluded (and which served a founding principle

FIGURE 5.6

Ben Katchor, "Yosl Feinbrot," *The Jew of New York*,
1999. Courtesy Random House, New York.

of modern Zionism). Additional ironies reside in the twentieth-century history of American Jews, many of whom took to hotel ownership or vacationing in the Catskills countryside. Katchor uses humor to create a critical aesthetic layering; it sets the viewer/reader in a framework that is not unlike a diasporist's double consciousness. This is true as well in *The Jew of New York* (1999, figure 5.5), which is designed to resemble a nineteenth-century history, with special endpapers, introductory pages, book flaps, and bookmarks. As a highly stylized volume, it moves the tale from its cheap journalistic origins into the realm of the art book and a more sophisticated commerce and readership.

Katchor's strips habitually depict the adventures of Jewish men engaged in small-time commercial enterprise in the urban world—for Jews, and now for many others, a classic dimension of immigrant experience.

*The Jew of New York* combines notions of Jewish immigration and diaspora with the mythic frameworks of America as a promised land. Within this overarching rubric, the storytelling is kaleidoscopic; Katchor plays fast and loose with any easy-to-follow sequence or narrative. A dizzying cast of male characters appear and reappear, and despite their distinctive Jewish monikers—Enoch Letushim, Yosl Feynbrot, Nathan Kishon, Isaac Azarael—they are not easy to tell apart. Angular and stiff in contour, the figures are rather like manikins (figure 5.6, 5.7), and they enact their drama through puppetlike gesture and pose. This produces a primitive quality appropriate to comic-strip mode, and as a repudiation of high-art figure styles, it invokes popular print traditions and broadsides.[19] But the drawing style is also an expressive strategy, for the physiognomic awkwardness of the characters brings them close to caricature and—in line with satire's pact between artist and knowing audience—reinforces the viewer's critical awareness and sense of parody.

This is also borne out by the graphic design of the page. *The Jew of New York* stays close to its newspaper format, with regular frames and only occasional interruptions of important symbolic forms, settings, and chapter breaks (figure 5.8). From frame to frame, however, close-ups, panoramas, and perspectives leap about like cinematic jump-cuts or montage, disrupting the ease of narrative sequence and refusing to draw a single point of view. For a graphic novel, moreover, the text is remarkably wordy and visually dense. Like the verbal hijinks of Katchor's radio shows,[20] the characters deliver lengthy speeches, and large blocks of text tell the story in a sophisticated literary style that belies the figures' woodenness. But it is this very "mismatch"—the puppet-like figures, the perspectival jumpiness, the witty text—that produces our own omniscient or specially informed presence and the story's sardonic tone.

The historical tale is well-researched: Katchor's knowledge of United States and Jewish history is evident in this drama that pairs myths of bustling entrepreneurial energy in early-nineteenth-century New York with Jewish immigration and search for a Promised Land. Jonathan Sarna has described the desire for linked mythologies as almost a Jewish American propensity. "Among America's ethnic and religious groups," Sarna writes, "only one, the Jews, has linked itself to so many of the nation's founding myths," a habit that says less about real history than it does "about Ameri-

FIGURE 5.7

Ben Katchor, "Francis Oriole," *The Jew of New York,*
1999. Courtesy Random House, New York.

can Jews, their loyalties, and their insecurities."[21] *The Jew of New York*
derives its narrative from a project of Mordecai Manuel Noah (1785–1851),
a playwright, newspaper editor, and politician whom the *Jewish Encyclopedia* describes as the "most influential Jew in the United States in the early
nineteenth-century." Noah sought to establish a Jewish homeland called
Ararat on Grand Island in the Niagara River, just north (and now a suburb) of Buffalo. The area has long been the subject of land-claim disputes
between Tuscarora Iroquois and suburban homeowners. In Katchor's
narrative, Jews and Indians (to use the term of stereotype) are paired as
dispossessed partners. Reviving nineteenth-century accounts of Native
Americans as the Ten Lost Tribes (a mythic population who have been
repeatedly "discovered" in unexplored geographies), the combination offers some telling couplings or binary stereotypes:

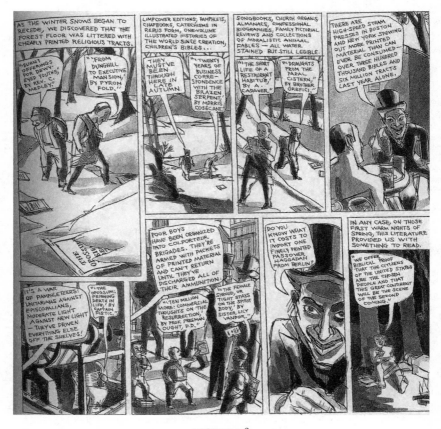

FIGURE 5.8

Ben Katchor, *The Jew of New York*, page 23, 1999.
Courtesy Random House, New York.

1. Jews seen as a sophisticated people detached from nature, un-
   landed and unnatural, while Indians are seen as simple primitives
   embedded in nature, the "natural man."
2. Jews seen as traditionally entrepreneurial and mercantile, while
   Indians are imagined living entirely in a subsistence or natural
   economy;[22]
3. Jews, often ghettoized in Europe, and thought to be in perpetual
   search for their home and promised land, while Native people,
   their land wrested from them by European colonizers, live
   ghettoized on reserves.

With such conceptual alignments as subtext, Katchor intertwines diasporic Jews and ghettoized Indians, not only through the Lost Tribes myth and Grand Island project, but also through his characters' adventures. Nathan Kishon, the disgraced *shoichet* (butcher) lives au naturel as a trapper, marketing muskrat skins; he also plans to tame nature by carbonating Lake Erie, and so to ease the *grepsing* (burping) of New York digestive tracts. Like most of the story's characters, Kishon shuttles between city and nearby frontier. If it is hard to keep track of plot details with this crowded cast and their restless diasporic to-and-fro-ing, what surfaces is the always moving population and the shifting identities that these Jews acquire.

On one narrative level, however, the play's the thing in Katchor's diasporic theater. The story opens with plans for a dramatic staging of Manuel Noah's project as *The Jew of New York*, and the characters are costumed in diving suits, togas, business suits, and buckskins—to fit the mythic terms of their mission. One of the commercial ploys in the story (along with Kishon's muskrat trade and the sale of Kabbala-symbol-printed handkerchiefs) is more costume illusion: the manufacture of a flesh-colored body stocking to disguise the nakedness of the play's star, the aging diva Ms. Patella, really the only woman in the story. Katchor's tales describe the seedy or marginal worlds of men; women, if they do appear, as here, are incidental objects of desire. But more important than Ms. Patella's body is the body stocking's commercial potential, and significantly, it widens the masquerade, as identities are made, enacted and circumstantially defined. As the top-hat of the title page (figure 5.5) suggests at the outset, New York's Jew is an airborne figure: a *luftmensch* perhaps, borne by the wind, his bourgeois identity hovers—not yet settled—over his diasporic home.

If Katchor's restless characters are forever seeking their place in an American land of promise and opportunity, the diaspora of Vera Frenkel's installation . . . *from the Transit Bar* (1992) evokes an indeterminate geography. Born in Czechoslovakia, Frenkel emigrated as a teenager with her family from England to Canada, where the national rhetoric proclaimed not promised land but protected colony, and now, not a melting pot but a diverse social mosaic. For the *Transit Bar,* Frenkel collected a diverse group of participants to stand for the world's dislocated and diasporic populations. As an installation constructed in 1992 for *Dokumenta ix* at Kassel, Germany (figure 5.9), the work has since then been shown in gallery and

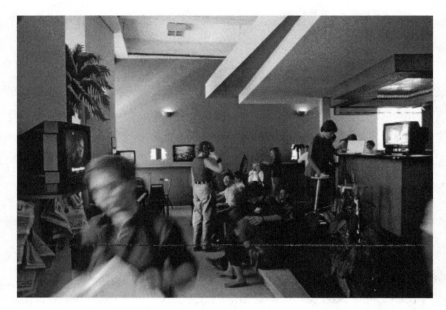

FIGURE 5.9

Vera Frenkel, . . . *from the Transit Bar,* six-channel video installation
and functional piano bar, *documenta IX,* Kassel, 1992, partial view, bar
in action. Courtesy the artist. Photo: Dieter Schwerdtle, Kassel.

museum settings in Toronto, Ottawa, Tokyo, Stockholm, and Warsaw.
Notwithstanding these high-art settings and audiences, . . . *from the Transit
Bar* has considerable popular appeal. The gallery space is transformed into
a railway bar; café tables and newspapers on racks are available; drinks
can be ordered from a handsome barman or, on occasion, from the artist
playing bartender. Wall cutouts reveal glimpses of other abandoned and
longed-for spaces: stacks of old-fashioned suitcases and topcoats clutter a
left-luggage room; another opens onto a palm-treed paradise. The vaguely
art deco decor and the melodies coming from the player piano suggest a
1930s glamour and cosmopolitanism, but in a more contemporary vein,
and thus undermining any fixed time period.

TV monitors scattered about play a forty-minute loop of interviews.
The fifteen respondents sit, as we do, at a train bar or in a railway club car
(figure 5.10). They are a diverse company of eight men and seven women,

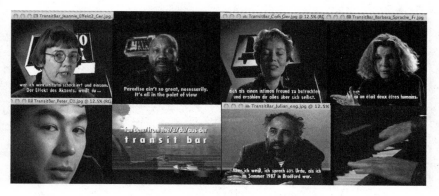

FIGURE 5.10

Vera Frenkel, *. . . from the Transit Bar,* six-channel video-disk
installation and functional piano bar, 1992; video stills editing
composite showing seven of the fifteen on-camera narrators, title
page, and hands of the piano-player. Photo: Courtesy the artist.

young adults to middle-aged, old enough to have some past and to tell
us, as fellow travelers, about their journeys, displacements, and homes.
In their video presence, the interviewees are positioned as survivors and
witnesses through a form of portraiture rendered emblematic and stylis-
tically transparent by television reportage and the formats of Holocaust
testimony. The videotape plays in several languages: subtitled in French,
English, and German, and spoken in Polish and Yiddish, the languages
of the artist's grandparents. Indeed, sound—as Jean Gagnon has noted
in calling the bar a space of orality and address, a "space to say"[23]—is
crucial here: the room is filled with audio fragments in shifting national
tongues, romantic tunes from the piano (always some sort of "You must
remember this . . .") are punctuated by the background noise of passing
trains. Not quite cacophony, but appropriate to the bar's conviviality, and
set in the perpetual present of transience, its sounds confound the future
with the past.

   *. . . from the Transit Bar* can also be visited through another work by
Frenkel, the *Body Missing* project that began as a separate installation in
Linz, Austria, later set up in London's Freud Museum, and also located
on the internet at www.yorku.ca/BodyMissing. In this global setting, a

Vera Frenkel, hand-drawn "Rough site map" for web version of *Body Missing* (www.yorku.ca/BodyMissing/barspace/site_map.html). Courtesy the artist.

space of representation as well as communication, the bar appears in fragments, with glimpses of the setting, the personnel, the interviewees, and other visitors. The *Site Map* (figure 5.11) is a cartographic drawing of great elegance, beautiful as artifact, but like many diasporic journeys, it charts a somewhat baffling terrain.

Access here, of course, is enormous, as easy as an electronic click, but as with any diaspora, always partial, depending, as the text warns, on where you sit and what's around you. Hunting through the frames of the website reminds us that the journey, like the writing of history, always offers a particular and situational view.

Everyone is an equal traveler in the *Transit Bar*. Mass culture codes of leisure and romance, familiar to most Western audiences, entice us into an interactive space of nostalgia and fantasy. To enter the bar be-

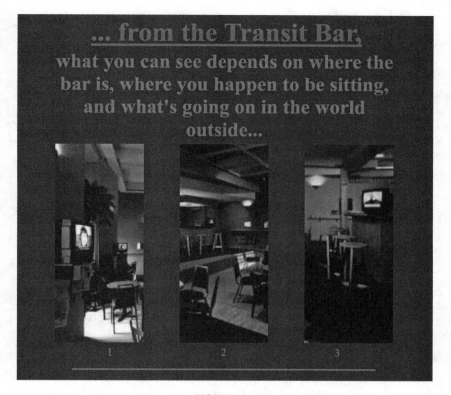

FIGURE 5.12

Vera Frenkel, *"What you can see depends on where the bar is, where you happen to be sitting and what's going on in the world outside . . . ,"* still frame from web version of Frenkel's six-channel photo-video-text installation, *Body Missing*, resituating the Transit Bar fictively at the Offenes Kulturhaus, Linz, as gateway to consideration of Hitler's *Sonderauftrag Linz* and his planned museum there for the stolen art (www.yorku.ca/BodyMissing /barspace/Bar1a.html). Courtesy the artist.

gins a journey of encounter and discovery, as the visitor enjoys the bar's voyeuristic disclosures, its transient society, its sense of possibility. Even the title, with its opening ellipsis and prepositional *from*, suggests a prior or already ongoing existence, lack of fixity, an open site, a message relay. If bars are ideal spaces in which to speak, to pour out one's story to an ever-listening barman or companion, this bar design, décor, music, and

pictures urge us to remember and imagine. Citing Paul Ricoueur's notion of "a pre-narrative quality," Gagnon notes Frenkel's tendency to work at this liminal level, where the desire for story effectively draws us into the game.[24] Thus, the bar creates a place for us—it even allows for solitude and loneliness—as the visitor spins her own narrative fantasy, weaving together filaments from the environment, personal history, and cultural recollection, and shares the bar's community history.

I am reminded by Gagnon's characterization of the desire for story and by the visitors' sense of being in a special company of Italo Calvino's *The Castle of Crossed Destinies*, in which weary travelers—are there any other kind?—each journeying alone, find refuge in a castle and later in a local tavern.[25] Calvino's travelers have lost the capacity to speak—Babel, once again—and so they tell their tales through a crudely drawn pack of tarot cards. Each story is then recorded by the narrator through the sequence of emblems the cards lay out. "We thought we understood that, with the card, he wanted to say 'I' and that he was preparing to tell his story."[26] With titles such as "The Tale of the Ingrate and His Punishment," and "Two Tales of Seeking and Losing," Calvino's narratives are moralized parables, a positioning of characters derived from the narrator's voice. The *Transit Bar* functions differently, for in that space the parable is less fixed. The viewer actively joins the travelers and participates (however modestly), while the overlapping and shifting languages, the visual cues of left luggage, palm trees, and bar furnishings, the mixture of sights, texts, sounds, and other people in this performative space, create an exciting and potentially self-disclosing environment.

This is not to overlook the tension and foreboding stirred by Frenkel's setting and its travelers' tales. The *Bar*, after all, is neither a safe harbor nor more than temporary shelter. Irit Rogoff and others astutely discuss the *Transit Bar*'s capacity to evoke traumatic memory and a tragic past.[27] The glimpses of stacked luggage, the sound of shuttling trains evoking Nazi prisoner transports, forced expulsions, and running for refuge to a fantasized natural Paradise—also glimpsed in the palms: this may be the predicament of Jews for much of our history, but by now it is a widespread refugee experience. So are the allusions in the video texts, whose words sound the ethnic expressiveness of M/other tongue translated into the

authoritative, printed script of Euro-American power. But what makes ... *from the Transit Bar* particularly effective is the mix of its experience. If there is painful history here, as well as a shuddering *Schadenfreude,* there is also promise and well-being. Which part is illusory? Which is real? The erotic space of the bar, the use of nostalgia to draw us as participants into the subject community, and only then, amid that pleasure, to awaken uneasy associations of home, travel, and flight: all this enables multiple participants, multiple subject positions, and reconsideration of one's own geography along a broad emotional continuum. From Holocaust refugees to more recent emigrants and travelers, the visitors in or ... *from the Transit Bar* are another diaspora pondering their relation to home.

With these examples of three artists' works, I want to suggest some main contours of diasporic art. Essential qualities are an appeal to widespread and multiple audiences, and with that, the positing of multiple subjectivities. If, as Anderson describes it, modern print culture was essential for the development of national consciousness, then popular access to far-flung community is similarly crucial to diaspora's cultural forms. To be sure, these artists' first-line audiences are a cultural elite, visitors to museums and galleries. Still, in an age of mechanical and digital reproduction, this work reaches beyond an actual audience toward a virtual diaspora.

The instantiation of multiple subjectivities may be more difficult to define. Certainly, it must be capacious enough to allow for every artist claiming to be Jewish. Here again, the issue is self-recognition, not style. The formal or stylistic modes, like the languages of host cultures, will earmark the acculturative agility of diasporic success. But closer to the terms of a diasporic aesthetic is its tendency to allegory.[28] For the diasporist, there is always something "more" at stake, some more complex need or terrain to inhabit—again, some palimpsest-like environment in which to thrive. The layered references in this art signal the urge to allegory, to insist—no matter how realistic its report—on symbolic allusions to past lives and histories in a hyper-charged present, to the multiple dimensions of here and now. Despite their differences of medium and style, all three artists—Kitaj, Katchor, and Frenkel—work in an allegorical mode. The recurrent personae and fragments in Kitaj's compositions function as a symbolic syntax that is at the same time filled with restless energy and

association. Katchor's tales of land and landedness are sagas of cultural restlessness; Frenkel's bar gathers refugees whose tales are spun for other chance visitors.

In the works discussed here, Kitaj, Katchor, and Frenkel bind key features of their art to diaspora's labile character, its play with several viewpoints, its meandering and mutable borders rather than fixed cultural frames, and its aesthetic appeal to many types of viewer, whether knowing participant or critical spectator. Even Kitaj's disparate cultural company attests to the shared reluctance to separate their audience into national or ethnic groups; they propose instead new affinities as well as displacements. Such positions allow for diaspora's simultaneity, for the pleasures of diasporic imagination, as well as the tensions embedded in the more exilic galut. They imply a different notion of diaspora, not a choice between separatism or assimilation, but instead as a more negotiated and changing space-between. Kitaj phrased this newness and uncharted territory: "If I say: 'Jewish Art' to people, even dear friends, Jewish or not, it's like saying 'The world is round' in 1491. Each new painting of mine sails off where there be monsters" (Kitaj, 2007, #1). The "monsters" may well be the new and unassimilable contours of diasporic art. Similarly, Katchor's Jewish American saga and Frenkel's electronic barroom are probing frameworks for diasporic identities, old and new. Like all allegories, they complicate and extend the directness of their subject matter. Doing so, they call attention to the exhilarating, uncertain, and always negotiated status of community and home.

# NOTES

## INTRODUCTION

1. R. B. Kitaj, *First Diasporist Manifesto* (New York: Thames and Hudson, 1989), 19.

2. Ibid., 19.

3. Kitaj salutes the opportunities of modern diasporist production. As self-proclaimed Diasporist, he set himself in good artistic company: Picasso, Cezanne, Kafka, among others. Ibid., 25.

4. Ibid., 21, 25.

5. Kitaj, *The Second Diasporist Manifesto* (New Haven, Conn.: Yale University Press, 2007).

6. The source picture by Isaak Jouderville (1612–145/48) is *Young Man in a Turban* (1631), in the collection of Windsor Castle, UK.

7. Personal communication from Ken Aptekar, Aug. 17, 2004.

8. Norman Kleeblatt, ed., *Too Jewish? Challenging Traditional Identities* (New York: Jewish Museum; New Brunswick, N.J.: Rutgers University Press, 1996).

9. On this issue, see Margaret Olin, "C[lement] Hardesh [Greenberg] and Company," in *Too Jewish*, 39–59. The question of modernist "purity" became a critical touchstone in the later critique of Greenberg's writings. For a recent overview of the issue, see Charles Reeve, "Balls and Strikes," review of Alice Goldfarb Marquis, *Art Czar: The Rise and Fall of Clement Greenberg, London Review of Books*, April 5, 2007, 27–28. The first study that attempts to escape the blood-and-soil confines of the nationalist position is Avram Kampf's *Chagall to Kitaj: Jewish Experience in 20th Century Art* (London: Lund Humphries, 1990), which frames its analysis in terms of Jewish experience.

10. Among the many texts on diaspora, James Clifford's essay "Diasporas," *Cultural Anthropology* 9 (1993): 302–38 is an invaluable guide to modern diasporic issues and contradictions. Much of my own understanding of diaspora aligns with Clifford's account. Other key texts are: Daniel Boyarin and Jonathan Boyarin, "Diaspora: Generation and the Ground of Jewish Identity," *Critical Inquiry* 19 (1993): 693–825; Arnold Eisen, *Galut: Modern Jewish Reflection on Homelessness and Homecoming* (Bloomington: Indiana University Press, 1986); Nicholas Mirzoeff, "The Multiple Viewpoint: Diasporic Visual Cultures," and Stuart Hall, "Cultural Identity and Diaspora," in *Diaspora and Visual Culture*,

*Representing Africans and Jews,* ed. Nicholas Mirzoeff (London: Routledge, 2000), 1–19 and 21–33; Howard Sacher, *Diaspora: An Inquiry into the Contemporary Jewish World* (New York: Harper & Row, 1985); William Safran, "Diasporas in Modern Societies: Myths of Homeland and Return," *Diaspora* 1 (1991): 83–99; Khachig Tölölyan, "Rethinking Diaspora(s): Stateless Power in the Transnational Moment," *Diaspora* 5 (1996): 3–36. For an excellent review of the Jewish historiography of diaspora, see Todd M. Endelman, "The Legitimization of the Diaspora Experience in Recent Jewish Historiography," *Modern Judaism* 11, no. 2 (May 1991): 195–209.

11. Safran, "Diasporas in Modern Societies," 83–84.

12. For the contentious discussion of the relationship of the state of Israel and modern Jewish diaspora, see Alan Arkush, "From Diaspora Nationalism to Radical Diasporism," *Modern Judaism* 29, no. 3 (2009): 326–50; Boyarin and Boyarin, "Diaspora"; and Michael Galchinsky, "Scattered Seeds: A Dialogue of Diasporas," in *Insider/Outside: American Jews and Multiculturalism,* ed. David Biale, Michael Galchinsky, and Susannah Heschel (Berkeley: University of California Press, 1998), 185–214.

13. Clifford, "Diasporas," 305, 315–21.

14. In *The Souls of Black Folks* (1903), Du Bois wrote of "a world which yields [the American Negro] no true self-consciousness, but only lets him see himself through the revelation of the other world. It is a peculiar sensation, this double-consciousness, this sense of always looking at one's self through the eyes of others, of measuring one's soul by the tape of a world that looks on in amused contempt and pity. One ever feels his two-ness,—an American, a Negro; two souls, two thoughts, two unreconciled strivings; two warring ideals in one dark body, whose dogged strength alone keeps it from being torn asunder" (ch.

1). See too, Paul Gilroy, *The Black Atlantic: Modernity and Double Consciousness* (Cambridge, Mass.: Harvard University Press, 1993).

15. The text dates from around 250 BCE. For a stimulating discussion of diaspora, its traditional Jewish and more current multicultural and postcolonial meanings, see Galchinsky, "Scattered Seeds," 194.

16. French Jews were emancipated by the French Revolution in 1791. In 1804, this was extended by Napoleon to Jews in French imperial territories.

17. Ahad Ha'am [Asher Zvi Hirsch Ginsberg], "Slavery in Freedom" (1891), in *Selected Essays,* trans. Leon Simon (Philadelphia: Jewish Publication Society of America, 1948), 171–94, this 177, 193 (emphasis in original).

18. Dubnow's ten-volume *Weltgeschichte des Judischen Volkes* (Berlin: Judischer Verlag,) translated from the Russian, was published in Berlin 1925–29. Within an extensive bibliography, the ideas of both Dubnow and Ahad Ha'am are most easily accessed in Simon Dubnow, *Nationalism and History: Essays on Old and New Judaism* (Cleveland: World Publishing, 1961); Ahad Ha'am, *Essays, Letters, Memoirs* (Oxford: East and West Library, 1946); Ahad Ha'am, *Selected Essays.* For contemporary discussion of their ideas, I have relied on Stephen Zipperstein, *Elusive Prophet: Ahad Ha'am and the Origins of Zionism* (Berkeley: University of California Press, 1993), and Sophie Dubnov-Erlich, *The Life and Work of S. M. Dubnov: Diaspora Nationalism and Jewish History,* ed. Jeffrey Shandler, trans. Judith Vowles (Bloomington: Indiana University Press, 1991).

19. Dubnow, "The Affirmation of the Diaspora" (1909), in *Nationalism and History,* 186–87.

20. Dubnow, "Third Letter: The Ethics of Nationalism," in *Nationalism and History,* 124–30. Dubnow debated his position in

a famous essay exchange with Ahad Ha'am, who also rejected the Zionists' "negation of diaspora"—*shelilat ha-galut*—but who called nonetheless for a "spiritual centre" in Palestine as essential for modern Jewish national identity. Ahad Ha'am, "Nationalists and the Diaspora" [*Shelilat hagalut*, 1909], in *Essays, Letters, Memoirs*, 213–21.

21. Dubnow, "Affirmation," 187. For a recent discussion of Dubnow's diasporism and its relation to contemporary Israel, see Arkush, "From National Diasporism."

22. Margaret Olin, *The Nation without Art: Examining Modern Discourses on Jewish Art* (Lincoln: University of Nebraska Press, 2001); Kalman Bland, *The Artless Jew: Medieval and Modern Affirmations and Denials of the Visual* (Princeton, N.J.: Princeton University Press, 2000). The phenomenon of Jewish artists whose work was deemed "too Jewish" because of its content is the premise of Norman Kleeblatt's groundbreaking show *Too Jewish? Challenging Traditional Identities* at New York's Jewish Museum in 1996. See also ch. 4 in this study.

23. Like several German-Jewish intellectuals of the period, Buber had studied art history as a young man. For Buber's activities and the 1901 exhibition, see Gilya Gerda Schmidt, *The Art and Artists of the Fifth Zionist Congress, 1901* (Syracuse, N.Y.: Syracuse University Press, 2003), and the exhibition catalogue by Emily D. Bilski, ed., *Berlin Metropolis: Jews and the New Culture, 1890–1918* (Berkeley: University of California Press, 1999), especially the essay by Inka Betz, "Jewish Renaissance–Jewish Modernism," 164–87.

24. Frederic Brenner, *Diaspora: Homelands in Exile*, 2 vols. (New York: Harper Collins Publishers, 2003). The first volume comprises textual responses to individual photographs by an array of contemporary scholars and writers, including Andre Aciman, Jacques Derrida, and George Steiner. The compilation includes the earlier photograph collection by Brenner, *Jews, America: A Representation* (New York: Abrams, 1996).

25. Berel Lang, "Hyphenated-Jews and the Anxiety of Identity," *Jewish Social Studies: History, Culture, Society*, n.s. 12, no.1 (Fall 2005): 1–15, and Louis Kaplan, "Slashing toward Diaspora: On Frederic Brenner's *jews/america/ a representation*," in *American Exposures: Photography and Community in the Twentieth Century* (Minneapolis: University of Minnesota Press, 2005), 131–54.

26. Polish Minority Treaty, article 2, also known at the Little Treaty of Versailles, June 1919, http://en.wikipedia.org/wiki/Little_Treaty_of_Versailles, accessed April 2011.

## 1. BEYOND THE GHETTO WALLS

1. "Ashkenazi" is the term used to designate the Jews of Central and Eastern Europe, and particularly those who lived in Poland and the Russian Pale.

2. For a lively account of the rituals and social practices of the shtetl kheder, see Yekhiel Shtern, "A Kheder in Tyszowce (Tishevits)," in *East European Jews in Two Worlds: Studies from the YIVO Annual*, ed. Deborah Dash Moore (Evanston, Ill.: Northwestern University Press, 1990), 51–70. For an essay on interwar photographs of children as historical texts, see Roberta Newman, "Change and Continuity: Photographs of Jewish Children in Interwar Eastern Europe," *YIVO Annual* (1991): 101–23.

3. Alter Kacyzne, *Poyln: Jewish Life in the Old Country*, ed. Marek Web (New York: Metropolitan Books, Henry Holt, 1999).

4. Michael Andre Bernstein, *Foregone Conclusions: Against Apocalyptic History* (Berkeley: University of California Press, 1994), 16.

5. The collection includes images by Kacyzne, Roman Vishniac, Menachem

Kipnis, and others. Raphael R. Abramovitch, ed., *The Vanished World* [Der farshvundene velt] (New York: Forward Association, 1947).

6. For the possibilities for Jewish minority populations in newly constituted Eastern European states after WWI, see Mark Levene, "Nationalism and Alternatives in the International Arena: The Jewish Question at Paris, 1919," *Journal of Contemporary History* 28 (1993): 511–31.

7. John Berger and Jean Mohr, *Another Way of Telling* (New York: Pantheon Books, 1982), 96.

8. Walter Benjamin, "Theses on the Philosophy of History," V, VI, 265, in *Illuminations* (New York: Schocken Books, 1968).

9. Ariella Azoulay, "Photography," *Mafte'akh* 2 (2011): 65–79.

10. I have relied on Ezra Mendelsohn's comprehensive study *The Jews of East Central Europe Between the World Wars* (Bloomington: Indiana University Press, 1983).

11. The group published three editions of a journal also titled *Yung-yidish;* a planned fourth volume did not appear. The group also planned to exhibit jointly with avant-garde Polish groups. For Yungyidish, see Jerzy Malinowski, "The 'Yung Yiddish" Group and Jewish Modern Art in Poland, 1918–1923," *Polin* 6 (1991): 223–30, and Marek Bartelik, "The Young Yiddish Group," in *Early Polish Modern Art: Unity in Multiplicity* (Manchester: Manchester University Press, 2005), 125–59.

12. With the Immigration Act of 1924 (also known as the Johnson-Reed Act), the United States tightened set quotas for Southern and Eastern European immigrants.

13. For an account of Jewish photographers in Poland, see Lucjan Dobroszycki and Barbara Kirshenblatt-Gimblett, *Image before My Eyes: A Photographic History of Jewish Life in Poland, 1864–1939* (New York: Schocken Books, 1977), 1–38.

14. The Historical and Ethnographic Society of St. Petersburg was founded in 1908. The report on An-sky's project was published as *The Jewish Ethnographic Program* (1914). For excerpts from An-sky's preface and some of the questionnaire used by the field workers, see David G. Roskies, "Introduction," in S. An-sky, *The Dybbuk and Other Writings* (New York: Schocken Books, 1992), xi–xxxvi.

15. The institution closed in 1930, and the collection divided between the Soviet Government Museum of Ethnography (ritual objects) and the Institute of Proletarian Culture (archives) in Kiev. In 1938, a portion of the archives was sent to the Jewish Museum in Odessa, but their post–WWII location is unknown. See "S. An-sky," *Jewish Heritage Online Magazine,* www.jhom .com/personalities/ansky/index.htm, accessed January 2007. For a recent publication on the photographs, see Eugene Avrutin, et al., *Photographing the Jewish Nation: Pictures from S. An-sky's Ethnographic Expeditions* (Waltham, Mass.: Brandeis University Press, 2009).

16. Roskies, "Introduction."

17. Quoted in Lucy S. Dawidowicz, ed., *The Golden Tradition: Jewish Life and Thought in Eastern Europe* (London: Jason Aronson, 1989), 305. Indeed, in contrast to his early rebelliousness, An-sky's devotion to his people is striking after his return to the fold; one result was the ethnographic project; another was his relief efforts on behalf of Jewish victims of pogroms that killed thousands during WWI.

18. Benedict Anderson, *Imagined Communities, Reflections on the Origin and Spread of Nationalism* (London: Verso, 1991).

19. Ibid., 35.

20. Homi K. Bhabha, "Introduction: Narrating a Nation," in *Nation and Narration,* ed. Homi K. Bhabha (London: Routledge, 1990), 1–7. See also "DissemiNation: Time, and the Margins of the Modern

Nation," 139–70, in Bhabha's *The Location of Culture* (London: Routledge, 1994).

21. Both Dan Miron, *A Traveler Disguised: The Rise of Modern Yiddish Fiction in the Nineteenth Century* (1973; Syracuse, N.Y., Syracuse University Press, 1996) and David G. Roskies, *The Jewish Search for a Usable Past* (Bloomington: Indiana University Press, 1999) note the ambivalences of turn-of-the-century Yiddish literature, which thus follows Bhabha's model of nation-narration in its amalgam of cultural celebration and critique.

22. Bhabha, "Introduction," 1.

23. For these variations, see Ezra Mendelson, "The Jewries of Interwar Poland," in *Hostages of Modernization: Studies on Modern Anti-Semitism, 1870–1933/39*, ed. Herbert A. Strauss, ed., 2 vols. (Berlin: Walter de Gruyter, 1993), 989–95.

24. "The Affirmation of the Diaspora" (1909), Dubnow's reply to Ahad Ha'am's "Negation of the Diaspora," in *Nationalism and History*, 186–87.

25. For the history of modern Yiddish literature, and its relation to the modernizing of Eastern European Jews, see the superb studies by Miron, *A Traveler Disguised*; Roskies, *Jewish Search*; and David G. Roskies, *A Bridge of Longing: The Lost Art of Yiddish Storytelling* (Cambridge, Mass.: Harvard University Press, 1995.)

26. For photography in the Yiddish press see Dobroszycki and Kirshenblatt-Gimblett, *Image before My Eyes*, 20–31.

27. Malinowski, "The *Yung Yiddish* Group."

28. For an overview of Kacyzne's life, see Marek Web, "Introduction" in *Polyn*, x–xxiii.

29. For discussion of the authorial account of the shtetl as outsider or visitor, see Miron, *A Traveler Disguised*, and Roskies, "The Shtetl in Jewish Collective Memory," in *Jewish Search*, 41–66.

30. John Tagg, "The Plane of Decent Seeing," in *The Disciplinary Frame* (Minneapolis: University of Minnesota Press,

2009), ch. 3. Tagg's detailed account sets the origin of the term and practice of "documentary" (as opposed to "document") in 1932 with the writings of British photographer John Grierson and the projects of the WPA photographers, led by Roy Stryker. Tagg's argument insists on the historicizing agency or intentionality of the documentary (though he distinguishes it from "propaganda"), as the stabilizing purpose of the State. For a contrasting view of the FSA documentary, with the emphasis on community disintegration, theorized through Jean-Luc Nancy, see Louis Kaplan, *American Exposures*. In the present context, and to my mind, Kacyzne's pictures for the *Forverts* aptly fit Tagg's model, though with a less sinister institutional power behind the scenes.

31. The 1924 Johnson-Reed Act or National Origins Act superseded the 1921 Emergency Quota Act. Immigrants from European countries were limited in numbers to 2 percent of resident immigrants from each country, based on statistics of 1890. For depopulation of the shtetls in and move to urban centers, see Zvi Gitelman, *A Century of Ambivalence: The Jews of Russia and the Soviet Union, 1881 to the Present* (New York: Schocken Books, 1988), 122–32.

32. Founded in 1902 in New York, HIAS established an office in Warsaw in 1920, an important point of departure for many Jews of the Pale, and especially those from provincial towns and villages. See Mark Wischnitzer, *Visas to Freedom: The History of HIAS* (Cleveland: World Publishing, 1956).

33. Web, "Introduction," xix–xx. In letters to Cahan about his photo commissions (often complaining about payment and costs), Kacyzne raised the issue of subject matter—the inclusion of orthodox types and the appeal to workers through proletarian imagery. My thanks to Roberta Newman, New York, for generously sharing her research on Kacyzne's letters with me.

34. The 1924 Ermanox was succeeded by the first Leicas in 1926.

35. Ewa Morawska's essay "Changing Images of the Old Country in the Development of Ethnic Identity among East European Immigrants, 1880s–1930s: A Comparison of Jewish and Slavic Representations," in *YIVO Annual 21: Going Home*, ed. Jack Kugelmass (Evanston, Ill.: Northwestern University Press and YIVO Institute for Jewish Research, 1993), 273–341, this, 308, is a remarkable study of the shift in American Jewish perception and image of Old Country in the Jewish press and popular culture—literature, film, theater. She does not discuss pictorial images, however.

36. Letter from Cahan to Kacyzne, May 30, 1930, YIVO Archives. I thank Marek Web for bringing this document to my attention. Morawska's study of the Jewish press, "Changing Images," confirms the tendency to set a more America-focused framework for a prospering Jewish future before Jewish readers.

37. Until the Nazi period, enforced ghettos did not exist in Poland or Russia, though until 1917. Jews in Russia were, confined to the large territory of the Russian Pale of Settlement.

38. Nancy Schoenburg and Stuart Schoenburg, *Lithuanian Jewish Communities* (New York: Garland Publishers, 1991), 354.

39. For the history of Jewish Vilna, see Henri Minzceles, *Vilna, Wilno, Vilnius* (Paris: Editions La Decouverte, 1993).

40. Zalman Shneour, "Vilna," trans. Angus R. Shamal and William Levy, in William Levy, "Hanging Out with Zalman," www.semantikon.com/features, accessed April 2005. The poem was in the monthly *Miklat* (New York, 1920).

41. Active as a writer and journalist in Vilna from 1904 to 1907, Shneour lived in Paris from 1923 until the German invasion in 1940.

42. Vorobeichic, quoted from Maya Raviv's unpublished manuscript, in Marina Dmitrieva, "Di Wilna-Fotocollagen von Moshe Vorobeichic," in *Judische Kultur(en) in Neuen Europa, Wilna 1918–1939*, ed. Marina Dmitrieva and Heidemarie Petersen (Wiesbaden: Harrassowitz Verlag, 2004), 69–84, this 74–75. Dmitrieva's essay is a thorough account of the book's origins and modernist style.

43. Kenneth E. Silver and Romy Golan, *The Circle of Montparnasse: Jewish Artists in Paris, 1905–1945* (New York: Universe Books, 1985).

44. *Bauhaus Photography* (Cambridge, Mass.: MIT Press, 1985), 352.

45. Dmitrieva, "Die Wilna-Fotocollagen," note 2. Publisher Emil Schaefer proposed the project for his press, Orell Fussli Verlag, after seeing an exhibition of Vorobeichic's images at the 16th Zionist Congress in 1929.

46. Zalman Shneour, Introduction, in Vorobeichic, *Ghetto Lane in Vilna* (1931), n.p.

47. Max Weinreich, *Forverts,* September 20, 1931, English translation by Renne Brun, http://wsrv.clas.virginia.edu/~ds8s/wilna /wilna_gh.txt, accessed November 10, 2006.

48. Dmitrieva, "Die Wilna-Fotocollagen."

49. His photographic and design work emphasized the vigor and idealism of the Zionist ideal. Later in life, he moved to Safed, and devoted himself to paintings of ecstatic Hasidim.

## 2. MODERN ARTIST, MODERN JEW

1. *Cinnamon Shops* is published in English as *The Street of Crocodiles*. I refer to the following editions throughout: *The Street of Crocodiles,* trans. Celina Wieniewska (New York: Penguin Books, 1977), and *Sanatorium under the Sign of the Hourglass,* trans.

NOTES TO PAGES 53–59

Celina Wieniewska (Boston, Houghton Mifflin, 1978).

2. Since his discovery of Schulz's writing in 1942, Jerzy Ficowski (1924–2006) was the primary and most reliable source of Schulz scholarship. My own discussion follows Ficowski's scrupulous research and documentation. For Ficowski's account of his fascination with Schulz, see ch. 1, "I Found the Authentic (In Place of a Prologue)," in *Regions of the Great Heresy; Bruno Schulz—A Biographical Portrait,* trans. and ed. Theodosia Robertson (New York: W. W. Norton, 2003), 25–31.

3. For Schulz's exhibitions, see Ficowski, *Regions,* 210–15.

4. The young man's hat and caftan also resembles the garb of Catholic clergy. The similarity may remind us that ironically, in Poland at least, the orthodox Hasid and Catholic priest seemed not so different on sight.

5. For Chagall's activities as artist and arts administrator in revolutionary Russia, see *Marc Chagall, Early Works from Russian Collections,* ed. Susan Tumarkin Goodman (New York: Jewish Museum, April 29–October 14, 2001).

6. Looted from Weingarten's collection during the war (Weingarten died in the Lodz ghetto), the picture surfaced at auction in Lodz. Ficowski, *Regions,* 151, 209.

7. Sigmund Freud, *The Interpretation of Dreams,* Penguin Freud Library 4 (London: Penguin Books, 1991), 286. Daniel Boyarin discusses Jacob Freud's behavior in this incident not as humiliation, but as a reversal of such feelings, with the father stooping to recover his hat with a feeling of disdain for *goyim-nakhes,* the (macho) pleasures enjoyed by the Gentiles. Daniel Boyarin, *Unheroic Conduct: The Rise of Heterosexuality and the Invention of the Jewish Man,* (Berkeley: University of California Press, 1997), 33–38.

8. Chagall studied with Yehudah Pen (one of the few Jews schooled at the Imperial Art Academy in St. Petersburg) at his private art school in Vitebsk; in 1908 he studied with Leon Bakst in St. Petersburg, and then went to Paris in 1910, where he absorbed the avant-garde forms of Cubist modernism. Caught by the war shortly after his return to Russia in 1914, he remained there for eight years, and worked actively to spearhead the development of a revolutionary Jewish modernism.

9. The Yung-yidish group of writers and artists was active in Lodz from 1918 to 1923. See Malinowski, "The *Yung Yiddish* Group," 223–30; Bartelik, "The Young Yiddish Group."

10. Chagall left Russia in 1922 and, apart from the seven years spent in the United States (1941–48), he made his home in France, where he died in 1985.

11. For the efforts by friends to rescue Schulz, see Ficowski, *Regions,* 134, 137.

12. Ibid., 226.

13. David Grossman, *See Under: LOVE,* trans. Betsy Rosenberg, Picador ed. (London: Pan Books, 1991); Cynthia Ozick, *The Messiah of Stockholm* (New York: Vintage Books, 1988); Philip Roth, *The Prague Orgy* (New York: Vintage International 1996). Ozick's and Grossman's novels might be said to take the form of legend—the Picador edition of Grossman's book features a Schulz drawing on its cover. Only Roth uses the Schulz figure as an elusive and sardonically masked object of desire in his novella, and in his interview with Isaac Bashevis Singer, he plays out the terrible irony of the surviving Yiddish writer (Singer) and the murdered Polonized one (Schulz). See Roth, "Conversation in New York with Isaac Bashevis Singer about Bruno Schulz," in *Shop Talk, A Writer and His Colleagues and Their Work* (New York: Vintage International, 2001), 78–89. Henryk Grynberg's remarkable collection of short stories

detailing the disappearance and murder of Jews by Nazi and Soviet regimes focuses, in its title story, on the terror in Schulz's home environment: *Drohobycz, Drohobycz and Other Stories,* trans. Alicia Nitecki (New York: Penguin Books, 2002).

14. "Letter: Bruno Schulz's Wall Paintings, *New York Review of Books,* May 23, 2002. For a detailed list of lost works and Ficowski's efforts to locate them, see *Regions,* ch. 11, "Works Preserved and Lost," 141–53, and ch. 12, "Awaiting *Messiah*—A Postscript," 155–62. For a demythologizing account of Schulz, see Jaroslaw Anders, "The Prisoner of Myth," *New Republic* 227, no. 22 (Nov. 25, 2002): 33–41.

15. Benjamin Paloff, "Who Owns Bruno Schulz?" *Boston Review,* December 2004–January 2005. On discussion of the theft and ownership of Schulz's mural, see Ficowski, *Regions,* 168–72; Yad Vashem, The Holocaust Martyrs' and Heroes' Remembrance Authority, "Press Release: Regarding the Sketches by Bruno Schulz," www .yadvashem.org/about_yad/press_release /temp_index_press_release.html 2001; Nacha Cattan, "Murals' Grab by Memorial Stirs a Debate in Arts World," *Forward,* July 13, 2001, 1; "Letter: Bruno Schulz's Frescoes," *New York Review of Books,* Nov. 29, 2001; and "Letter: Bruno Schulz's Wall Paintings." Benjamin Geissler and 108 others, "Open Letter Endorsing the Foundation of an International Bruno Schulz Centre," September 18, 2008, www.bruno .sculz.prv.pl.

16. "Bruno Schulz, né Autrichien, a vécu Polonais et est mort Juif, manquant l'occasion à deviner Russe." Maurice Nadeau, "Bruno Schulz (1892–1942)," in Centre Georges Pompidou, *Présences polonaises: Witkiewicz, constructivisme, les Contemporains: l'art vivant autour du Musée de Lodz, Centre Georges Pompidou, 23 juin–26 septembre 1903* (Paris: Le Centre, 1983), 106.

17. Bruno Schulz, *Letters and Drawings of Bruno Schulz,* ed. Jerzy Ficowski, trans.

Walter Arndt (New York: Harper & Row, 1998), 110, published originally as Witkiewicz's "Interview with Bruno Schulz," *Tygodnik Illustrowany,* no. 17 (1935).

18. Ficowski cites at least six others, with mythological titles such as "The Slaying of the Dragon." *Regions,* 151.

19. According to Ficowski, Schulz produced the images over a two year period, from 1920–22. He worked in a *clichés-verre* process. The technique involves drawing through a coated glass plate to produce an image that functions as a photonegative and is printed on light-sensitive paper. *Regions,* 210. Schulz wrote, "The procedure is like photo-printing. The cost is considerable—so is the labor. . . . It is not a technique for mass reproduction." *Letters,* 73. The edition size is not known. The first Polish edition of the album collection was published in 1988. *Regions,* 152.

20. Ficowski claims that they resemble women of the Drohobycz, and were often recognized as such. *Regions,* 91–92. Lacking photographic or portrait comparisons, however, it is difficult to see this kind of specific characterization.

21. Unmarried (though once engaged to Jozefina Szelinska, a writer and translator), he had several affairs and intimate friendships with women in his artistic circle, among them writers Debora Vogel and Zofia Nalkowska. Ficowski, *Regions,* 111–13, 214.

22. In 1928, a government official vacationing at Truskawiec, where Schulz was exhibiting work, labeled them pornographic and demanded that exhibition's close. Both the mayor of Drohobycz and the owner of the Truskawiec resort supported the exhibition and denied the request. Ficowski, *Regions,* 212.

23. Without probing the meanings of Schulz's erotic imagery, a positive review of his work in 1922 by Adolf Bienenstock in the Lvov daily *Chwila* briefly made the connection to Goya and Rops, and declared the "fantastic-erotic" an emotional stimulus for

the spectator that was readily associated with an aesthetic sensibility. A 1929 review by Artur Lauterbach in the same paper made similar connections, and considered the erotic content as public heresies of a sensitive soul. The writer Stanislaw Witkiewicz in 1935 again linked the work to a Goya-Rops tradition. Somewhat cryptically, Ficowski ties the erotic energy of the work to the artist's creative task. All quoted in Ficowski, "Quelque mots sur *Le Livre idolatre*," in Schulz, *Le Livre Idolatre* (Warsaw: Interpress [1988]), 9, 13, 45.

24. Leo Bersani, *The Freudian Body: Psychoanalysis and Art* (New York: Columbia University Press, 1986).

25. Theodor Reik, *Masochism in Modern Man* (New York: Grove Press, 1941).

26. This is most evident in the images collected for the exhibition *Phantom der Lust: Visionen des Masochism in der Kunst*, ed. Peter Weibel (Graz: Neue Galerie am Landesmuseum Joanneum, 2003). Schulz's imagery was included in the show, along with a host of high and mass media pictures. A companion volume of essays by thirty-seven scholars (*Phantom of Desire: Visions of Masochism, Essays and Texts*) provides a useful overview of the history and critical discussion of masochism. For the problem of pictorial distinction between the two poles of this binary, see the review of the exhibition, by Barry Schwabsky, "An Esthetics of Masochism?," *Art in America* 92, no. 4 (2004): 66–69.

27. Silverman relies on Freud's account of masochistic fantasy in "A Child Is Being Beaten" (1918).

28. Kaja Silverman, *Male Subjectivity at the Margins* (New York: Routledge, 1992), 206.

29. In her account of Schulz's drawings, Ewa Kurylyk relates the work to Leopold Sacher-Masoch's novel *Venus in Furs* (1870); her comments link the masochism to general social concerns of the period— "Drohobyczan masculinities" or a collective post-imperial crisis of civilization, and not to the situation or stereotypes of Jews. "The Caterpillar Car, or Bruno Schulz's Drive into the Future of the Past," in *The Drawings of Bruno Schulz*, ed. Jerzy Ficowski (Evanston, Ill.: Northwestern University Press, 1990), 31–43, this 33–34.

30. For the feminized Jew as a modern anti-Semitic construct, see Sander Gilman, *The Jew's Body* (New York: Routledge, 1991), and Boyarin, *Unheroic Conduct*, 151–86.

31. Though beginning the first published collection, *Cinnamon Shops/Street of Crocodiles* is not necessarily Schulz's earliest story. There is no creative chronology that can be fixed to the publication of his texts, perhaps like the elusive playing with time that serves as another trope of his tale.

32. "Drohobycz," in *Encyclopedia of Jewish Life Before and During the Holocaust*, vol. 1, ed. Shmuel Spector (New York: New York University Press, 2001), 333–34.

33. Alfred Doblin, "The Petroleum District" (1925), in *Journey to Poland*, trans. Joachim Neugroschel (New York: Paragon House, 1991), 174–80. He lent the area a hellish dimension in the chapter's epigraph: "The mountains are covered with flames."

34. Ibid., 177–78.

35. There is relatively little critical discussion of Jewish references in or the Jewish character of Schulz's work. Drawing on his letters and especially the motif of the Book in the stories, some scholars suggest a Jewish framework in his general philosophical outlook and creative ideas, and several have related his literary subjects and motifs to Kabbalah. See Jan Blonski, "On the Jewish Sources of Bruno Schulz," *Cross Currents* 12 (1993): 54–68; Bozena Shallcross, "'Fragments of a Broken Mirror': Bruno Schulz's Recontextualization of the Kabbalah," *East European Politics and Societies* 2 (1997): 270–81. Shallcross refers to the studies by Polish scholar Wladyslaw Panas in Schulz and Kabbalah, as well as the intellectual interest in Kabbalah studies in prewar Poland. Shallcross, 274n15.

36. Schulz, *Street*, 134.

37. Ficowski suggestively outlines the presumed content—four linked illustrated tales, in ch. 12, "Awaiting *Messiah*—a Postscript," *Regions,* 153–62.

38. Quoted in ibid., 157.

39. Ibid., 49.

40. Quoted in ibid., 166.

### 3. z'chor! roman vishniac's photo-eulogy of eastern european jews

1. Josef Grosz, pointed out the pictures' artistic status in "Dr. Vishniac's Great Document," *British Journal of Photography* 30 (March 1984): 332–34.

2. Numbers in parenthesis indicate plate number in *A Vanished World.* The Vishniac Archive has refused permission to reproduce the images discussed in this chapter. Readers may readily find the pictures on numerous Internet websites. I thank Mara Vishniac Kohn for her careful reading of and corrections to an earlier version of my text.

3. *Newsweek,* March 22, 1993, 68.

4. Bernstein, *Foregone Conclusions,* 16.

5. Other photo books develop the topos of "the last Jews of . . ." as romantic elegies of disappearance and loss. See Aviva Weintraub, "An American in Poland: Photography and the Jews of Eastern and Central Europe," *Jewish Folklore and Ethnology Review* 15, no. 1 (1993): 14–17.

6. Geoffrey H. Hartman, "Darkness Visible," in *Holocaust Remembrance: The Shapes of Memory,* ed. Geoffrey H. Hartman (Cambridge, Mass.: Blackwell, 1994), 1–22, and James E. Young, *The Texture of Memory: Holocaust Memorials and Meaning* (New Haven, Conn.: Yale University Press, 1993).

7. For a detailed history of Vishniac exhibitions and publications, see Jeffrey Shandler, "The Time of Vishniac: Photographs of Pre-War East European Jewry in Postwar Contexts," *Polin* 16 (2003): 313–33.

8. Abraham Heschel, "Introduction," in Roman Vishniac, *Polish Jews* (New York: Schocken Books, 1947).

9. Sponsored by Cornell Capa's Fund for Concerned Photography (later the International Center for Photography), the exhibition included both Vishniac's scientific microphotography and his prewar Jewish subjects.

10. In 1999, I consulted the author's undated sixty-six-page typescript of preparatory text for *A Vanished World* in the Vishniac Archive at the International Center for Photography. ICP archivists have since informed me that they are unable to retrieve the document.

11. Josef Grosz noted Vishniac's desire to "save Jewish faces" and to depict people who seemed "unmistakably Jewish." "Dr. Vishniac's Great Document," 334.

12. Vishniac typescript, International Center for Photography, New York.

13. Jeffrey Shandler, "Time of Vishniac." Maya Benton detailed the commission in "Shuttered Memories of a Vanishing World: The Deliberate Photography of Roman Vishniac," unpublished paper, colloquium Looking Jewish, Photography, Memory and the Sacred, New York University, April 29, 2007, for which I was the respondent.

14. Mara Vishniac now claims that "evidence indicates that most, if not all, of Vishniac's pictures were not taken with a hidden camera." Email to the author, July 7, 2013.

15. Vishniac typescript, International Center for Photography, 31.

16. Though the essay does not focus on the decorum and ethics of visuality, for an illuminating discussion of Holocaust representation and the unrepresentable absolute of its "center," see Sidra DeKoven Ezrahi, "Representing Auschwitz," *History and Memory* 7, no. 2 (Fall/Winter 1995): 121–54.

17. For a discussion of yisker bikher as part of a literature of commemoration, see

Jack Kugelmass and Jonathan Boyarin, eds., *From a Ruined Garden: The Memorial Books of Polish Jewry* (New York: Schocken Books, 1983).

18. See Sander Gilman, "The Invention of the Eastern Jew," in *Jewish Self-Hatred, Anti-Semitism and the Hidden Language of the Jews* (Baltimore: Johns Hopkins University Press, 1986, 1990), 270–86. Gilman outlines the development in Germany of Ostjuden double-sidedness—as the "bad" uncultivated and unassimilated Jew and as the "good" spiritual and authentic Jew, but he keeps these two constructs separate, rather than partnered stereotypes.

19. Martin Buber, *Des Geschichten des Rabbi Nachman*, Frankfurt, 1906, and *Die Legende des Baalschem*, Frankfurt, 1908.

20. While not really a presentation of Ostjuden as seen from the West but rather from a more modernized standpoint, Russian Yiddish writers—Mendele Mocher Sforim, Sholem Aleichem, S. An-sky, among others—used shtetl types to parody or unsettle traditional customs and experience.

21. Roskies, *Jewish Search*.

22. I depend here on the Noah Isenberg's fascinating account of Kafka's Yiddish interests. See *Between Redemption and Doom: The Strains of German-Jewish Modernism* (Lincoln: University of Nebraska Press, 1999), ch. 1. "In Search of Language: Kafka on Yiddish, Eastern Jewry and Himself," 19–50.

23. Quoted in ibid., 47.

24. Quoted in ibid., 46.

25. Doblin, "The Petroleum District," 174–80, this 177–78. He also lent the area a hellish dimension in the chapter's epigraph: "the mountains are covered with flames."

26. Born in Brody (now Ukraine) in 1894, Roth lived in Vienna, Berlin, and Paris, where he died in 1939. His grandfather was a rabbi; other relatives were artisans. See Michael Hofmann, "Translator's Pref-

ace," in Joseph Roth, *The Wandering Jews* [Juden auf Wanderschaft], trans. Michael Hofmann (New York: W. W. Norton, 2001), xvii.

27. Ibid., 36–37.

28. Ibid., 32.

29. Hermann Struck and Arnold Zweig, *The East European Jewish Face*, trans. Noah Isenberg (Berkeley: University of California Press, 2004). Maya Benton called attention to Struck's publication and Vishniac's imagery in her unpublished paper "Shuttered Memories of a Vanishing World," and in "Framing the Ostjuden: Mythologies of the Eastern Jew in Hermann Struck's Drawings and Roman Vishniac's Photographs," MA thesis, University of London, Courtauld Institute of Art, 2003. For discussion of the Zweig-Struck publication, see Isenberg's "Preface to the English Edition," ix–xxviii; Leslie Morris, "Reading the Face of the Other: Arnold Zweig's and Hermann Struck's *Das ostjudische Antlitz*," in *The Imperialist Imagination: German Colonialism and Its Legacy*, ed. Sara Friedrichsmeyer, Sara Lennox, Susanne Zantop (Ann Arbor: University of Michigan Press, 1998), 189–204; Paul Mendes Flohr, *Divided Passions: Jewish Intellectuals and The Experience of Modernity* (Detroit: Wayne State University Press, 1991), ch. 4, "Fin-de-Siecle Orientalism: The *Ostjuden*, and the Aesthetics of Jewish Self-Affirmation," 77–132.

30. Zweig, *The Eastern European Jewish Face*, 1.

31. Leslie Morris associates the facial emphases in the Struck-Zweig book with philosopher Emmanuel Levinas's ideas on ethics and seeing the face of the Other. "Reading the Face," 192–93.

32. The Sander Archive informs me that "all the people shown in this portfolio have been jews, [sic] but for his titles Sander finally did not use this term, maybe because he wanted to include also non-jewish persecuted, what he finally did in extra portfolios

such as 'Political' or 'Foreign Workers.'"
Email to author from Sander Archive, Oc-
tober 16, 2013.

33. The most notorious of these com-
parisons is the publication by the architect
Paul Schultz-Naumberg, *Kunst und Rasse*
[Art and Race] (Munchen/Berlin: J. F.
Lehmanns Verlag, 1928).

34. Freud, *Interpretation of Dreams*,
217–19. I thank Deborah Britzman for call-
ing my attention to and discussion of this
dream.

35. Ibid., 218.

36. Ibid., 219.

37. Susan E. Schapiro "The Uncanny
Jew: A Brief History of an Image," in *Tex-
tures and Meaning: Thirty Years of Judaic
Studies at the University of Massachusetts,
Amherst*, ed. L. Ehrlich et al. (Amherst:
University of Massachusetts, 2004).

38. *Fiddler on the Roof*, the musical play
about Tevye the Milkman, adapted from
the tales by Sholem Aleichem, was first per-
formed in New York in 1964, followed by
the film version in 1971.

39. Roth, *Wandering Jews*, 123.

40. J. Hoberman, *Bridge of Light: Yiddish
Film between Two Wars* (New York, Mu-
seum of Modern Art & Schocken Books,
1991), 280.

41. Boyarin, *Unheroic Conduct*, ch. 1 and
passim.

42. Hans Graf von Monts [Hans Paul
Kreutzer], *De Joden in Nederland* (Privately
published, c. 1941), 31, ill. 8. The image ap-
pears as #126 in *A Vanished World*, where
is it captioned: "A small shop in Teresva,
a village in Carpathian Ruthenia." For a
reproduction in van Mont's book see Jan
Coppens, *Foto*, February 2, 1984, 39, where
the original Dutch caption reads: "The leap
to the West has succeeded. The Eastern-
Jewish barbarian has . . . become Dutch. He
stands here, proudly, in his second-hand
shop."

43. Maurice Blanchot, quoted in Young,
*Texture of Memory*, 143.

44. I use this term to designate forms
of Holocaust representation that draw the
viewer to imaginings of boundlessness and
extremes. See my essays "Forbidden Sights:
Images of the *Khurbn*," in *Iconotropism:
Turning toward Pictures*, ed. Ellen Spolsky
(Lewisburg, Pa.: Bucknell University Press,
2005), 37–56, and "Emblems of Atrocity:
Holocaust Liberation Photography," in
*Image and Remembrance*, ed. Shelley Horn-
stein and Florence Jacobowicz (Blooming-
ton: Indiana University Press, 2002), 75–86.

### 4. DIFFERENCE IN DIASPORA

1. There is considerable sociological
and historical literature on the Jewish
Mother and her associates. A recent survey
is Joyce Antler's *You Never Call! You Never
Write! A History of the Jewish Mother* (Ox-
ford: Oxford University Press, 2007).

2. In this sense, my approach differs
from Antler's, whose richly detailed study
presents the cultural representation of the
Jewish Mother in relation to the "truth" of
the stereotype and envisions its disappear-
ance—or revision by real Jewish Mothers
(see *You Never Call!*, chs. 9, 10)—as a social
possibility and sign of cultural success. My
own view is that stereotypical difference,
especially when as here it is created from
within the Jewish community, is a form of
diasporic negotiation or accommodation,
and can disappear only with complete as-
similation into the host (in this case, Chris-
tian) culture.

3. This is the mother of Henry Roth's
*Call It Sleep* (1934), and of Sholem Asch's
*The Mother* (1919).

4. Al Jolson's black-faced singing of
"My Mammy" (1927, written in 1919) is an-
other example of the longed-for mother, far
away in "Alabammy."

5. For overviews of traditional Jewish
domestic life in Eastern Europe, see Susan
Glenn, *Daughters of the Shtetl: Life and
Labor in the Immigrant Generation* (Ithaca,
N.Y.: Cornell University Press, 1990); Da-

vid Biale, "Childhood, Marriage and the Family in the Eastern European Jewish Enlightenment," in *The Jewish Family: Myths and Reality*, ed. Steven M. Cohen and Paula E. Hyman (New York: Holmes and Meier, 1986), 45–61; Iris Parush, "Women Readers as Agents of Social Change among Eastern European Jews in the Late Nineteenth Century," *Gender and History* 9, no. 1 (April 1997): 60–82. Joyce Antler begins her study *You Never Call!* in the 1920s, with little discussion of the stereotype in pre-twentieth-century European Jewish culture.

6. That the Yiddishe Mama is an American construction and a sign of modernity's loss as a compensatory projection of the anxieties associated with assimilation is borne out by her more muted appearance in European pictorial forms. She appears in Alter Kaczyne's documentary photographs (see ch. 2), but only in the traditional bubbe form. The same is true of Moshe Vorobeichic's album *The Ghetto Lane in Vilna* (1933), where the caretaking is assigned to an old woman who enfolds the children within her Madonna-like veil.

7. By 1924 the Johnson-Reed Act or National Origins Act limited immigrants from European countries to 2 percent of resident immigrants from each country.

8. The terms "Muscle Jew" and *muskeljudentum* (muscular Judaism) were introduced by Max Nordau in his article "Muskeljudentum," *Judische Turnzeitung* (a Jewish gymnastics magazine) in June 1900. See Paula E. Hyman, *Gender and Assimilation in Modern Jewish History: The Roles and Representation of Women* (Seattle: University of Washington Press, 1995), 144.

9. George Mosse, *The Image of Man: The Creation of Modern Masculinity* (New York: Oxford University Press, 1996). Among the most useful studies in the large literature on ethnic and national stereotypes, in addition to Mosse, see Homi K. Bhabha, *The Location of Culture* and *Nation and Narration;* Sander L. Gilman's studies

of Jewish stereotypes in *Jewish Self-Hatred* and *The Jew's Body;* Avner Ziv and Anat Zajdman, eds., *Semites and Stereotypes: Characteristics of Jewish Humor* (Westport, Conn.: Greenwood Press, 1993).

10. To some degree, Canada's proud claim to "cultural mosaic" lessens the assimilationist force of the U.S. "melting pot." Difference is further underscored by the official Canadian category of "visible minority."

11. Ritchie Robertson, "Historicizing Weininger: The Nineteenth Century German Image of the Feminized Jew," in *Modernity, Culture and "the Jew,"* ed. Bryan Cheyette and Laura Marcus (Oxford: Polity Press, 1998), 25.

12. See, for example, Gilman, *Jew's Body.*

13. For visual formulations of class in nineteenth-century England, see Mary Cowling, *The Artist as Anthropologist: The Representation of Type and Character in Victorian Art* (Cambridge: Cambridge University Press, 1989).

14. Hutchins Hapgood, *The Spirit of the Ghetto* (N.Y.: Funk & Wagnalls, 1902). Hapgood (1869–1944) was a radical journalist and anarchist who moved in the bohemian circles of turn-of-the-century New York. He claimed no scientific grounding for his study, but rather called it "an attempt by a 'Gentile" to report sympathetically on the character, lives, and pursuits of certain east-side Jews."

15. Ibid., 72, 77.

16. With Rosa Sonneschein at its helm, the journal was published from 1895 to 1899. It is available online at www.quod.lib .umich.edu/a/amjewess.

17. Hapgood, *The Spirit of the Ghetto,* 71.

18. Arthur Gordon's play *Mirele Efros* (1898), subtitled *A Jewish King Lear,* is a Yiddish theater example of the successful businesswoman. See also Hyman, *Gender and Assimilation,* 68–69.

19. The figure of Molly Goldberg echoes the acculturating ideals of Jewish women,

as Sharon Pucker Rivo has shown in her essay on Yiddish films of the interwar period, "Projected Images: Portraits of Jewish Women in Early American Film," in *Talking Back: Images of Jewish Woman in American Popular Culture*, ed. Joyce Antler (Boston: Brandeis University Press, 1997), 30–52. For a detailed account of the Molly Goldberg character and of Gertrude Berg's own career, see Antler, *You Never Call*, ch. 2.

20. Antler notes how Berg's active professional career—as writer and producer of the radio-TV series and its ancillary products, like cookbooks, etc.—differed from the domestic framework in which she confined the Molly character. Antler, *You Never Call*, 56–58.

21. Joyce Antler ties the last appearance of the loving Yiddishe Mama with the anthropological projects of Ruth Benedict and Margaret Mead. In *Life Is with People* by Mark Zborowski and Elizabeth Herzog, a best-selling book published in 1952 and underwritten by Benedict's and Mead's Research in Contemporary Culture project [RCC], the authors idealize Eastern European Jewish culture and the shtetl mother's presumed unstinting love. But despite the participation of Jewish writers and researchers, this configuration may itself be a function of postwar—and essentially Gentile—concern. Operating in the shadow of the war, the RCC project, Antler notes, was meant to study the children-of-immigrants generation; there would have been good reason, among liberal anthropologists, to promote Jewish immigrant success. See Antler's account of the book and the Research in Contemporary Culture project, in *You Never Call!*, 74–86. Barbara Kirshenblatt-Gimblett's "Introduction" in the 1995 edition of *Life Is with People* (New York: Schocken Books) provides a historicized commentary and critique.

22. Hyman, *Gender and Assimilation*, 153–56.

23. Antler, *You Never Call!*, 110–16.

24. Riv-Ellen Prell, "American Jewish Culture through a Gender-Tinted Lens," in *Judaism since Gender*, ed. Miriam Peskowitz and Laura Levitt (New York: Routledge, 1997), 78–81; Martha Ravits, "The Jewish Mother: Comedy and Controversy in American Popular Culture," *Melus* 25 (Spring 2000): 3–26. For a review of the stereotype, see Gladys Rothbell, "The Jewish Mother: Social Construction of a Popular Image," in Cohen and Hyman, *The Jewish Family*, 118–28.

25. Although Ravits argues that "shifting social expectations . . . have brought solace to the stigmatized figure of the Jewish Mother." Ravits, "Jewish Mother," 3.

26. The realism of seventeenth-century Dutch paintings, for example—pictures by de Hooch, Terborch, Steen, and others—is seen by some scholars as secular emblems of the Holy Family or other sacred allegories. For the issues and nuances of this position on seventeenth-century Dutch genre pictures as moralized emblemata, see E. de Jongh, *Zinne-en minnebeelden in de schilderkunst van de zeventiende eeuw* (Amsterdam: Nederlands Openbaar Kunstbezit, 1967); E. de Jongh, *Questions of Meaning: Theme and Motif in Dutch Seventeenth Century Painting*, trans. and ed. Michael Hoyle (Leiden: Primavera Pers, 2000); and Svetlana Alpers, "Appendix," in *The Art of Describing; Dutch Art in the Seventeenth Century* (Chicago: University of Chicago Press, 1983), 229–33.

27. For the secular happy family, see Carol Duncan's important article, "Happy Mothers and Other New Ideas in French Art, *Art Bulletin* 55, no. 5 (December 1973): 570–83. The controversy surrounding Chris Ofili's use of elephant dung in his painting of a Madonna in the *Sensation* show at the Brooklyn Museum in 1999 incorporates this reluctance to deface the maternal, as well as the religious, ideal. Mary Kelly's

*Post-Partum Document* (1973–79) under-
took this critique in its attention to the
mother's subjectivity in the early childhood
of her male child.

28. Sigmund Freud, *Jokes and Their Rela-
tion to the Unconscious,* trans. and ed. James
Strachey (1905; New York: W. W. Norton,
1963), 101. The publication derived in part,
as Freud acknowledged, as an off-shoot of
*The Interpretation of Dreams* (1900).

29. Freud introduces the study with this
joke from revered German writer, Heinrich
Heine (1797–1856), himself assimilated, a
convert, and obviously ambivalent about
his own Jewishness.

30. Freud, *Jokes,* 133.

31. In *Jewish Self-Hatred,* Sander Gilman
explores the lengthy history of German
Jewish stereotypes derived not only from
behaviors but also from their use—or mis-
use (*mauscheln*)—of language.

32. Abstract-Expressionists Rothko,
Newman, Gottlieb, and Guston acknowl-
edged universal and spiritual concerns—
Newman even used biblical titles (both
Jewish and Christian) for his pictures—but
whether Holocaust-induced anxiety or a
refusal of the parochial ("too Jewish"), they
downplayed Jewish interpretations of their
art. The same is true of the Pop artists in
the mid-60s. Only Larry Rivers and George
Segal, in his *Butcher Shop* (1965, Art Gallery
of Ontario, Toronto), occasionally thrust
Jewish content before spectators; for the
most part, this dimension was critically ig-
nored. For discussion of these artists' Jew-
ishness, see Matthew Baigell, *Jewish Artists
in America: An Introduction* (Lanham, Md.:
Rowman & Littlefield, 2007). For an ac-
count of this self-suppressed Jewishness,
especially among women artists, see Lisa
E. Bloom, *Jewish Identities in American
Feminist Art: Ghosts of Ethnicity* (New York:
Routledge, 2006)

33. Lisa Bloom, "Rewriting the Script:
Eleanor Antin's Feminist Art," in How-

ard N. Fox, *Eleanor Antin* (Los Angeles:
Los Angeles County Museum of Art, 1999),
159–89. Calling attention to Jewish dimen-
sions in the artist's early work, she notes
Antin's participation, along with numerous
other Jewish women, in the feminism of the
1970s.

34. Antin, quoted by Bloom, "Rewrit-
ing," 172.

35. Bloom, "Rewriting," 170.

36. Antin, quoted by Fox, *Eleanor
Antin,* 222.

37. Bloom, "Rewriting," 168.

38. Wilke's work was shown in *Too
Jewish,* 153, fig. 36. For an insightful dis-
cussion of Wilke's career-long efforts to
"re-mythologize" Venus along modern and
ethnic lines, see Gannit Ankori, "The Jew-
ish Venus," in *Complex Identities: Jewish
Consciousness and Modern Art,* ed. Matthew
Baigell and Milly Heyd (New Brunswick,
N.J.: Rutgers University Press, 2001),
239–52.

39. Antin, quoted by Fox, *Eleanor
Antin,* 217.

40. The event was sponsored by the
National Foundation for Jewish Culture,
October 2001.

41. Rhonda Lieberman, "Jewish Barbie"
(*Artforum,* March–April 1995), reprinted in
*Too Jewish,* 108.

42. Lieberman, in *Too Jewish,* 113.

43. Donna J. Haraway, "A Manifesto for
Cyborgs: Science, Technology and Social-
ist Feminism in the 1980s," *Socialist Review*
15, no. 2 (1985): 65–108.

44. Boyarin, *Unheroic Conduct,* 33–38.

45. See note 7, above.

46. Hapgood, *Spirit of the Ghetto,* 13, 17.

47. Ibid., 39. Hapgood counted several
of these intellectuals among his friends,
and was a close associate of Abraham Ca-
han, whose work is the subject of ch. 8, "A
Novelist," 230–53.

48. Daniel Itzkowitz, "Secret Temples,"
in *Jews and Other Differences: The New Jew-*

*ish Cultural Studies,* ed. Daniel Boyarin and
Jonathan Boyarin (Minneapolis: Univer-
sity of Minnesota Press, 1997), 176-292,
this 178.

49. Boyarin, *Unheroic Conduct,* xxi. In
his call for a reconsideration of rabbinic
masculinity as a modern model, Boyarin
repeatedly acknowledges and warns against
the patriarchal privilege of Jewish ortho-
doxy. I cite his prefatory "call to arms" to
signal the task at hand and the compelling
argument of his study.

50. *The Hadassah Gross Blog,* www
.blogger.com/profile/3311384. For the Reb-
betzin's website, see: http://hgross
.tempdomainname.com.

51. One might argue that women come-
dians in general exceed the order of femi-
nine comportment; humor's inherent ag-
gression makes it inappropriate for women.

52. David Shneer and Caryn Aviv,
in *Queer Jews,* ed. David Shneer and
Caryn Aviv (New York: Routledge, 2002),
14nn1, 6.

53. *Hadassah Gross Blog.* I retain the
blog's transliterations.

## 5. DIASPORIC VALUES IN CONTEMPORARY ART

1. Kitaj, *First Diasporist Manifesto,* 19.
2. Ibid., 25.
3. Ibid., 101.
4. Ibid., 30-31.
5. Sidra DeKoven Ezrahi, "The Grapes
of Roth: Diasporism from Portnoy to
Shylock," in *Booking Passage: Exile and
Homecoming in the Modern Jewish Imagina-
tion* (Berkeley: University of California
Press, 2000), 221-33. For an anti-diasporic
position and insistence on Israel's "authen-
ticity" as the site of Jewish culture, see
Gershon Shaked, "Alexandria: On Jews and
Judaism in America," *Jerusalem Quarterly*
49 (Winter 1989): 47-84.
6. Janet Wolff identifies the figure in
"The Impolite Boarder: 'Diasporist' Art
and Its Critical Response," in *Critical Kitaj,*

*Essays on the Work of R. B. Kitaj,* ed. James
Aulich and John Lynch (New Brunswick,
N.J.: Rutgers University Press, 2001), 29.
7. A major retrospective of Kitaj's work
at the Tate Gallery in 1987 was panned by
British critics for being, the artist believed,
"too Jewish and parochial." That experience
underscored Kitaj's sense of outsider-ness
in Britain and his decision after thirty-eight
years to see his expatriate life as exile and
to return to the United States. On the anti-
Semitic character of the critical response,
see Wolff, "Impolite Boarder," 29-43.
8. Kitaj, *First Diasporist Manifesto,* 29.
9. "Kitaj," Tate Gallery catalogue on-
line, www.tate.org (Feb. 2008). On Kafka
and the Theater Troupe, see ch. 3.
10. Andrew Benjamin, "Kitaj and the
Question of Jewish Identity," in *Art, Mi-
mesis and the Avant-Garde, Aspects of a Phi-
losophy of Difference* (London: Routledge,
1992), 89-90.
11. Wolff, "Impolite Boarder," 41-43.
12. Juliet Steyn, "The Loneliness of the
Long Distance Rider, *Art Monthly,* Feb.
1988, 9; John Lynch, "*The Murder of Rosa
Luxemburg:* Monuments, Documents,
Meanings," in *Critical Kitaj, Essays on the
Work of R. B. Kitaj,* ed. James Aulich and
John Lynch (New Brunswick, N.J.: Rut-
gers University Press, 2001), 68-68; Giles
Peaker, "Natural History: Kitaj, Allegory
and Memory," in *Critical Kitaj, Essays on the
Work of R. B. Kitaj,* ed. James Aulich and
John Lynch (New Brunswick, N.J.: Rutgers
University Press, 2001), 69-81; Andrew
Benjamin, "Kitaj and the Question of Jew-
ish Identity," in *Art, Mimesis and the Avant-
Garde,* 85-98.
13. Benjamin sees their forwardness as
a Jewish refutation or refusal of the stasis
of (Christian) Synagoga—blindfolded and
her sword broken, blinded and disarmed,
she is the necessary precursor of Ecclesia,
the Church. "Kitaj and the Question of
Jewish Identity," 86.

14. R. B. Kitaj, *How to Reach 72 in a Jewish Art* (New York: Marlborough Gallery, 2005), 34.

15. Kitaj, *Second Diasporist Manifesto.* For excerpts and introduction by Margaret Olin, see "R. B. Kitaj, The Second Diasporist Manifesto: Selections," ed. Margaret Olin, annotations by Caroline Ewing, *Images* 1 (2007): 98–109. Bracketed numbers following quotations in my text refer to Kitaj's numbered propositions.

16. See Mann, *Jewish Texts,* 18–36, and Bland, *Artless Jew,* 109–54.

17. Kitaj, *How to Reach,* 15, 63.

18. Katchor's strips and radio shows are also available on the artist's website, www.katchor.com. For discussion of the distribution issues of class and media in diasporic production, see Paul Gilroy, "Cruciality and the Frog's Perspective: An Agenda of Difficulties for the Black Arts Movement in Britain," in *Small Acts: Thoughts on the Politics of Black Culture* (London: Serpent's Tail, 1993), 100–101.

19. They recall the stand-up figures in children's cutout play books, especially as they appear here in the frontispiece pages with the dotted line to make a "stand" for the figure. This kind of figure was also found in the comics pages of newspapers in decades past. My thanks to Carol A. Kennedy for this observation.

20. Katchor also has produced the multi-chaptered radio cartoon *Julius Knipl, Real Estate Photographer* (1996).

21. Jonathan Sarna, "The Mythical Jewish Columbus and the History of America's Jews," in *Religion in Age of Exploration,* ed. Bryan Le Beau and Menachem Mor (Omaha, Neb.: Creighton University Press, 1992), 81–95.

22. For an account of beadwork production and the Native economy, see Jolene Rickard, *Across Borders: Beadwork in Iroquois Life* (Washington, D.C.:Smithsonian, National Museum of the American Indian, 2002).

23. Jean Gagnon, "The Space to Say," in Vera Frenkel, . . . *from the Transit Bar /* . . . *du Transit Bar* (Toronto: Power Plant/National Gallery of Canada, 1994), 11–17.

24. Ibid., 12.

25. Italo Calvino, *The Castle of Crossed Destinies,* trans. William Weaver (San Diego: Harcourt Brace, 1979). I thank Bethany Leonard, student in my class on "Art and Crisis," York University, Winter 2008, for calling my attention to Calvino's book.

26. Ibid., 6.

27. Irit Rogoff, "Moving On: Migration and the Intertextuality of Trauma," in Vera Frenkel, . . . *from the Transit Bar /* . . . *du Transit Bar* (Toronto: Power Plant/National Gallery of Canada, 1994), 267–43.

28. For an insightful account of allegory in Kitaj's works, and allegory generally, see Peaker, "Natural History."

# BIBLIOGRAPHY

Abramovitch, Raphael R., ed. *The Vanished World* [Der farshvundene velt]. New York: Forward Association, 1947.

Ahad Ha'am [Asher Zvi Hirsch Ginsberg]. *Essays, Letters, Memoirs.* Oxford: East and West Library, 1946.

———. "Nationalists and the Diaspora" [*Shelilat hagalut,* 1909]. In *Essays, Letters, Memoirs,* 213–21. Oxford: East and West Library, 1946.

———. *Selected Essays.* Trans. Leo Simon. Philadelphia: Jewish Publication Society of America, 1948.

———. "Slavery in Freedom." 1891. In *Selected Essays,* 171–94. Trans. Leon Simon. Philadelphia: Jewish Publication Society of America, 1948.

Alpers, Svetlana. *The Art of Describing: Dutch Art in the Seventeenth Century.* Chicago: University of Chicago Press, 1983.

Anders, Jaroslaw. "The Prisoner of Myth." *New Republic* 227, no. 22 (Nov. 25, 2002): 33–42.

Anderson, Benedict. *Imagined Communities: Reflections on the Origin and Spread of Nationalism.* London: Verso, 1991.

Ankori, Gannit. "The Jewish Venus." In *Complex Identities: Jewish Consciousness and Modern Art,* ed. Matthew Baigell and Milly Heyd, 239–52. New Brunswick, N.J.: Rutgers University Press, 2001.

Ansky, S. *The Dybbuk and Other Writings.* Ed. David G. Roskies. New York: Schocken Books, 1992.

Antler, Joyce, ed. *Talking Back: Images of Jewish Women in American Popular Culture.* Boston: Brandeis University Press, 1997.

———. *You Never Call! You Never Write! A History of the Jewish Mother.* Oxford: Oxford University Press, 2007.

Arkush, Alan. "From Diaspora Nationalism to Radical Diasporism." *Modern Judaism* 29, no. 3 (2009): 326–50.

Asch, Sholem. *The Mother.* 1919. Garden City, N.J.: Sun Dial Press, 1950.

Aulich, James, and John Lynch, eds. *Critical Kitaj: Essays on the Work of R. B. Kitaj.* New Brunswick, N.J.: Rutgers University Press, 2001.

Avrutin, Eugene, et al., *Photographing the Jewish Nation: Pictures from S. An-sky's Ethnographic Expeditions.* Waltham, Mass.: Brandeis University Press, 2009.

Azoulay, Ariella. "Photography." *Mafte'akh* 2 (2011): 65–79.

Baigell, Matthew. *Jewish Artists in America: An Introduction.* Lanham, Md.: Rowman & Littlefield, 2007.

Baigell, Matthew, and Milly Heyd, eds. *Complex Identities: Jewish Consciousness and Modern Art.* New Brunswick, N.J.: Rutgers University Press, 2001.

Bartelik, Marek. *Early Polish Modern Art: Unity in Multiplicity.* Manchester: Manchester University Press, 2005.

*Bauhaus Photography.* Cambridge, Mass.: MIT Press, 1985.

Benjamin, Andrew. *Art, Mimesis and the Avant-Garde.* London: Routledge, 1991.

Benjamin, Walter. *Illuminations.* New York: Schocken Books, 1968.

Benton, Maya. "Framing the Ostjuden: Mythologies of the Eastern Jew in Hermann Struck's Drawings and Roman Vishniac's Photographs." MA thesis, University of London, Courtauld Institute of Art, 2003.

———. "Shuttered Memories of a Vanishing World: The Deliberate Photography of Roman Vishniac." Unpublished paper, colloquium on "Looking Jewish: Photography, Memory and the Sacred." New York University, April 29, 2007.

Berger, John, and Jean Mohr. *Another Way of Telling.* New York: Pantheon Books, 1982.

Bernstein, Michael Andre. *Foregone Conclusions: Against Apocalyptic History.* Berkeley: University of California Press, 1994.

Bersani, Leo. *The Freudian Body; Psychoanalysis and Art.* New York: Columbia University Press, 1986.

Betz, Inka. "Jewish Renaissance–Jewish Modernism." In *Berlin Metropolis: Jews and the New Culture, 1890–1918,* ed. Emily D. Bilski, 164–87. Berkeley: University of California Press, 1999.

Bhabha, Homi K. "DissemiNation: Time, and the Margins of the Modern Nation." In *The Location of Culture,* 139–70 London: Routledge, 1994.

———. *The Location of Culture.* London: Routledge, 1994.

———, ed. *Nation and Narration.* London: Routledge, 1990.

Biale, David. "Childhood, Marriage and the Family in the Eastern European Jewish Enlightenment." In *The Jewish Family: Myths and Reality,* ed. Steven M. Cohen and Paula E. Hyman, 45–61. New York: Holmes and Meier, 1986.

Biale, David, Michael Galchinsky, and Susannah Heschel, eds. *Insider/Outsider: American Jews and Multiculturalism.* Berkeley: University of California Press, 1998.

Bilski, Emily. *Berlin Metropolis: Jews and the New Culture, 1890–1918.* Berkeley: University of California Press, 1999.

Bland, Kalman. *The Artless Jew: Medieval and Modern Affirmations and Denials of the Visual.* Princeton, N.J.: Princeton University Press, 2000.

Blonski, Jan. "On the Jewish Sources of Bruno Schulz." *Cross Currents* 12 (1993): 54–68.

Bloom, Lisa E. *Jewish Identities in American Feminist Art: Ghosts of Ethnicity.* New York: Routledge, 2006.

———. "Rewriting the Script: Eleanor Antin's Feminist Art." In Howard N. Fox, *Eleanor Antin,* 159–89. Los Angeles: Los Angeles County Museum of Art, 1999.

Boyarin, Daniel. *Unheroic Conduct: The Rise of Heterosexuality and the Invention of the Jewish Man.* Berkeley: University of California Press, 1997.

Boyarin, Daniel, and Jonathan Boyarin. "Diaspora: Generation and the Ground of Jewish Identity." *Critical Inquiry* 19 (1993): 693–825.

———, eds. *Jews and Other Differences: The New Jewish Cultural Studies.* Minneapolis: University of Minnesota Press, 1997.

Brenner, Frederic. *Diaspora: Homelands in Exile.* 2 vols. New York: Harper Collins Publishers, 2003.

———. *Jews, America: A Representation.* New York: Abrams, 1996.

Bulhak, Jan. "The Problem of Nationality in Pictorial Photography." *Almanach fotografiki Wilenskiej* (Wilno, 1931): 19–21

Calvino, Italo. *The Castle of Crossed Destinies*. Trans. William Weaver. San Diego: Harcourt, Brace, 1979.

Cattan, Nacha. "Murals' Grab by Memorial Site Stirs a Debate in Arts World." *Forward*, July 13, 2001, 1.

Cheyette, Bryan, and Laura Marcus, eds. *Modernity, Culture and "the Jew."* Oxford: Polity Press, 1998.

Chow, Rey. *Writing Diaspora: Tactics of Intervention in Contemporary Cultural Studies.* Bloomington: Indiana University Press, 1993.

Clifford, James. "Diasporas." *Cultural Anthropology* 9 (1994): 302–38.

Cohen, Steven M., and Paula E. Hyman, eds. *The Jewish Family: Myths and Reality.* New York: Holmes and Meier, 1986.

Coppens, Jan. *Foto*. February 2, 1984, 39.

Cowling, Mary. *The Artist as Anthropologist: The Representation of Type and Character in Victorian Art.* Cambridge: Cambridge University Press, 1989.

Czartoryska, Urszula. *Les Chef d'oeuvres de la Photographie Polonaise de la collection du Muzeum Sztuki de Lodz.* Lodz, 1992.

Dawidowicz, Lucy S., ed. *The Golden Tradition: Jewish Life and Thought in Eastern Europe.* London: Jason Aronson, 1989.

"Diasporist Blues." *Economist.* January 11, 2007.

Dmitrieva, Marina, and Heidemarie Petersen, eds. *Judische Kultur(en) in Neuen Europa, Wilna 1918–1939.* Wiesbaden: Harrassowitz Verlag, 2004.

Doblin, Alfred. *Journey to Poland.* Trans. Joachim Neugroschel. New York: Paragon House, 1991.

Dobroszycki, Lucjan, and Barbara Kirshenblatt-Gimblett. *Image before My Eyes: A Photographic History of Jewish Life in Poland, 1864–1939.* New York: Schocken Books, 1977.

Dubnov-Erlich, Sophie. *The Life and Work of S. M. Dubnov: Diaspora Nationalism and Jewish History.* Ed. Jeffrey Shandler; trans. Judith Vowles. Bloomington: Indiana University Press, 1991.

Dubnow, Simon. *Nationalism and History: Essays on Old and New Judaism.* Cleveland: World Publishing, 1961.

Du Bois, W. E. B. *The Souls of Black Folks.* Chicago: A. C. Mcclurg, 1903; reprint, New York: Bartleby, 1999. www.bartleby.com/114.

Duncan, Carol. "Happy Mothers and Other New Ideas in French Art." *Art Bulletin* 55, no. 5 (December 1973): 570–83.

Eban, Abba. "The Toynbee Heresy." 1955. *Israel Studies* 1 (2006): 92–95.

Eisen, Arnold. *Galut: Modern Jewish Reflection on Homelessness and Homecoming.* Bloomington: Indiana University Press, 1986.

*Encyclopedia of Jewish Life before and during the Holocaust.* Ed. Shmuel Spector. 3 vols. New York: New York University Press, 2001.

Ezrahi, Sidra DeKoven. *Booking Passage: Exile and Homecoming in the Modern Jewish Imagination.* Berkeley: University of California Press, 2000.

———. "Representing Auschwitz." *History and Memory* 7, no. 2 (Fall/Winter 1995): 121–54.

Ficowski, Jerzy, ed. *The Drawings of Bruno Schulz.* Evanston, Ill.: Northwestern University Press, 1990.

———. *Regions of the Great Heresy: Bruno Schulz—A Biographical Portrait.* Trans. and ed. Theodosia Robertson. New York: W. W. Norton, 2003.

Fox, Howard N. With essay by Lisa Bloom. *Eleanor Antin.* Los Angeles: Los Angeles County Museum of Art, 1999.

Frenkel, Vera. *. . . from the Transit Bar/ . . . du Transit Bar.* Toronto: Power Plant/ National Gallery of Ottawa, 1994.

Freud, Sigmund. *Jokes and Their Relation to the Unconscious.* Trans. and ed. James Strachey. 1905. New York: W. W. Norton, 1963.

———. *The Interpretation of Dreams.* Penguin Freud Library 4. London: Penguin Books. 1991.

Gagnon, Jean. "The Space to Say." In Vera Frenkel, . . . from the Transit Bar / . . . du Transit Bar, 11–17. Toronto: Power Plant/ National Gallery of Canada, 1994.

Galchinsky, Michael. "Scattered Seeds: A Dialogue of Diasporas." In Insider/ Outsider: American Jews and Multiculturalism, ed. David Biale, Michael Galchinsky, and Susannah Heschel, 185–214. Berkeley: University of California Press, 1998).

Gilman, Sander. Jewish Self-Hatred: Anti-Semitism and the Hidden Language of the Jews. Baltimore: Johns Hopkins University Press, 1990.

———. The Jew's Body. New York: Routledge, 1991.

Gilroy, Paul. The Black Atlantic: Modernity and Double Consciousness. Cambridge, Mass.: Harvard University Press, 1993.

———. Small Acts: Thoughts on the Politics of Black Culture. London: Serpent's Tail, 1993.

Gitelman, Zvi. A Century of Ambivalence: The Jews of Russia and the Soviet Union, 1881 to the Present. New York: Schocken Books, 1988.

Glenn, Susan. Daughters of the Shtetl: Life and Labor in the Immigrant Generation. Ithaca, N.Y.: Cornell University Press, 1990.

Goodman, Susan, ed. Marc Chagall: Early Works from Russian Collections. New York: Third Millennium Publishing, 2001.

Gottesman, Itzik Nakhman. Defining the Yiddish Nation: The Jewish Folklorists of Poland. Detroit: Wayne State University Press, 2003.

Grosman, Moritz. Yiddishe Vilna in Vort un Bild. Wilno: Vorlage Drukkeraj-Hirsh Matz, 1925.

Grossman, David. See Under: LOVE. Trans. Betsy Rosenberg. Picador ed. London: Pan Books, 1991.

Grosz, Josef. "Dr. Vishniac's Great Document." British Journal of Photography 30 (March 1984): 332–34.

Grynberg, Henryk. Drohobycz, Drohobycz and Other Stories. Trans. Alicia Nitecki. New York: Penguin Books, 2002.

Hapgood, Hutchins. The Spirit of the Ghetto. New York: Funk & Wagnalls, 1902.

Haraway, Donna. "A Manifesto for Cyborgs: Science, Technology and Socialist Feminism in the 1980s." Socialist Review 15, no. 2 (1985): 65–108.

Hartman, Geoffrey, ed. Holocaust Remembrance: The Shapes of Memory. Cambridge, Mass.: Blackwell, 1994.

Heschel, Abraham. "Introduction." In Roman Vishniac, Polish Jews. New York: Schocken Books, 1947.

Hoberman, J. Bridge of Light; Yiddish Film between Two Wars. New York: Museum of Modern Art and Schocken Books, 1991.

Hornstein, Shelley, and Florence Jacobowicz, eds. Image and Remembrance. Bloomington: Indiana University Press, 2002.

Hyman, E. Paula. Gender and Assimilation in Modern Jewish History: The Roles and Representation of Women. Seattle: University of Washington Press, 1995.

Isenberg, Noah. Between Redemption and Doom: The Strains of German-Jewish Modernism. Lincoln: University of Nebraska Press, 1999.

———. "Preface to the English Edition." In Hermann Struck and Arnold Zweig, The Eastern European Jewish Face, ix–xxviii. Trans. Noah Isenberg. Berkeley: University of California Press, 2004.

Itzkowitz, Daniel. "Secret Temples." In Jews and Other Differences: The New Jewish Cultural Studies, ed. Daniel Boyarin and Jonathan Boyarin, 176–292. Minneapolis: University of Minnesota Press, 1997.

Jerusalem of Lithuania. Ed. Leyzer Ran. 3 vols. Egg Harbor, N.J.: Laureate Press, 1974.

Jongh, E. de. Questions of Meaning: Theme and Motif in Dutch Seventeenth Century Painting. Trans. and ed. Michael Hoyle. Leiden: Primavera Pers, 2000.

———. *Zinne-en-minnebeelden in de schilderkunst van de zeventiende eeuw.* Amsterdam: Nederlands Openbare Kunstbezit, 1967.

Jurecki, Krzysztof. "The History of Polish Photography to 1990." www.culture.pl /en/culture/artykuly/es_historia _fotografii. Accessed February 2007.

Kacyzne, Alter. *Poyln: Jewish Life in the Old Country.* Ed. Marek Web. New York: Metropolitan Books, Henry Holt, 1999.

Kampf, Avrum. *Chagall to Kitaj: Jewish Experience in 20th Century Art.* London: Lund Humphries, 1990.

Kaplan, Louis, *American Exposures: Photography and Community in the Twentieth Century.* Minneapolis: University of Minnesota Press, 2005.

Katchor, Ben. *The Beauty Supply District.* New York: Pantheon Books, Random House, 2000.

———. *The Jew of New York.* New York: Pantheon Books, Random House, 1998.

———. *Julius Knipl: Real Estate Photographer.* Boston: Little Brown, 1996.

Kirshenblatt-Gimblett, Barbara. "Introduction." In Mark Zborowski and Elizabeth Herzog, *Life Is with people: The Culture of the Shtetl.* New York: Schocken Books, 1995.

Kitaj, R. B. *First Diasporist Manifesto.* New York: Thames and Hudson, 1989.

———. *How to Reach 72 in a Jewish Art.* New York: Marlborough Gallery, 2005.

———. *The Second Diasporist Manifesto.* New Haven, Conn.: Yale University Press, 2007.

Kleeblatt, Norman, ed. *Too Jewish? Challenging Traditional Identities.* New York: Jewish Museum; New Brunswick, N.J.: Rutgers University Press, 1996.

Kugelmass, Jack, ed. *YIVO Annual 21: Going Home.* Evanston, Ill.: Northwestern University Press and YIVO Institute for Jewish Research, 1993.

Kugelmass, Jack, and Jonathan Boyarin, eds. *From a Ruined Garden: The Memorial Books of Polish Jewry.* New York: Schocken Books, 1983.

Kurylyk, Ewa. "The Caterpillar Car, or Bruno Schulz's Drive into the Future of the Past." In *The Drawings of Bruno Schulz,* ed. Jerzy Ficowski, 31–43. Evanston, Ill.: Northwestern University Press, 1990.

Lang, Berel. "Hyphenated-Jews and the Anxiety of Identity." *Jewish Social Studies: History, Culture, Society,* n.s. 12, no. 1 (Fall 2005): 1–15.

Le Beau, Brian, and Menachem Mor, eds. *Religion in the Age of Exploration.* Omaha, Neb.: Creighton University Press, 1992.

"Letter: Bruno Schulz's Frescoes." *New York Review of Books.* Nov. 29, 2001.

"Letter: Bruno Schulz's Wall Paintings." *New York Review of Books.* May 23, 2002.

Levene, Mark. "Nationalism and Alternatives in the International Arena: The Jewish Question at Paris, 1919." *Journal of Contemporary History* 28 (1993): 511–31.

Lieberman, Rhonda. "Glamour Wounds: The Further Adventures of Jewish Barbie." *Artforum.* April 1995.

Lynch, John. "The Murder of Rosa Luxemburg: Monuments, Documents, Meanings." In *Critical Kitaj, Essays on the Work of R. B. Kitaj,* ed. James Aulich and John Lynch. New Brunswick, N.J.: Rutgers University Press, 2001.

Malinowski, Jerzy. "The Yung Yiddish Group and Jewish Modern Art in Poland, 1918–1923." *Polin* 6 (1991): 223–30.

Mendelsohn, Ezra. "The Jewries of Interwar Poland." In *Hostages of Modernization: Studies on Modern Anti-Semitism, 1870–1933/39,* ed. Herbert A. Strauss, 2:989–95. Berlin: Walter de Gruyter, 1993.

Mendes-Flohr, Paul. *Divided Passions: Jewish Intellectuals and the Experience of Modernity.* Detroit: Wayne State University Press, 1991.

Minzceles, Henri. *Vilna, Wilno, Vilnius.* Paris: Editions La Decoverte, 1993.

Miron, Dan. *A Traveller Disguised: The Rise of Modern Yiddish Fiction in the Nineteenth Century.* 1973. Syracuse, N.Y.: Syracuse University Press, 1996.

Mirzoeff, Nicholas, ed. *Diaspora and Visual Culture: Representing Africans and Jews.* London: Routledge, 2000.

Molderings, Herbert. "Wer is Vorobeichic?" *Photogeschichte* 7, no. 26 (1987): 50–56.

Monts, Jans Graf von. [Hans Paul Kreutzer]. *De Joden in Nederland.* Privately published, c. 1941.

Moore, Deborah Dash, ed. *East European Jews in Two Worlds: Studies from the YIVO Annual.* Evanston, Ill.: Northwestern University Press, 1990.

Morawska, Ewa. "Changing Images of the Old Country in the Development of Ethnic Identity among East European Immigrants, 1880s–1930s: A Comparison of Jewish and Slavic Representations." In *YIVO Annual 21: Going Home,* ed. Jack Kugelmass, 273–341. Evanston, Ill.: Northwestern University Press and YIVO Institute for Jewish Research, 1993.

Morris, Leslie. "Reading the Face of the Other: Arnold Zweig's and Hermann Struck's *Das ostjudische Antlitz.*" In *The Imperialist Imagination: German Colonialism and its Legacy,* ed. Sara Friedrichsmeyer, Sara Lennox, Susanne Zantop, 189–204. Ann Arbor: University of Michigan Press, 1998.

Mosse, George. *The Image of Man: The Creation of Modern Masculinity.* New York: Oxford University Press, 1996.

Nadeau, Maurice. "Bruno Schulz (1892–1942)." In Centre Georges Pompidou, *Présences polonaises: Witkiewicz, constructivisme, les Contemporains: l'art vivant autour du Musée de Lodz, Centre Georges Pompidou, 23 juin–26 septembre 1903.* Paris: Le Centre, 1983.

Nelson, Cary, and Lawrence Grossberg, eds. *Marxism and the Interpretation of Culture.* Urbana: University of Illinois Press, 1988.

Newman, Roberta. "Change and Continuity: Photographs of Jewish Children in Interwar Eastern Europe." *YIVO Annual* 99 (1991): 101–23.

Olin, Margaret. "C[lement] Hardesh [Greenberg] and Company." In *Too Jewish? Challenging Traditional Identities,* ed. Norman Kleeblatt, 39–59. New York: Jewish Museum; New Brunswick, N.J.: Rutgers University Press, 1996.

———. *The Nation without Art: Examining Modern Discourses on Jewish Art.* Lincoln: University of Nebraska Press, 2001.

———, ed. Caroline Ewing, annotations. "R. B. Kitaj—The Second Diasporist Manifesto: Selections." *Images* 1 (2007): 98–109.

Ozick, Cynthia. *The Messiah of Stockholm.* New York: Vintage Books, 1988.

Paloff, Benjamin. "Who Owns Bruno Schulz?" *Boston Review.* February/March 2005.

Parush, Iris. "Women Readers as Agents of Social Change among Eastern European Jews in the Late Nineteenth Century." *Gender and History* 9, no. 1 (April 1997): 60–82.

Peaker, Giles. "Natural History: Kitaj, Allegory and Memory." In *Critical Kitaj, Essays on the Work of R. B. Kitaj,* ed. James Aulich and John Lynch. New Brunswick, N.J.: Rutgers University Press, 2001.

Peskowitz, Miriam, and Laura Levitt, eds. *Judaism since Gender.* New York: Routledge, 1997.

Prell, Riv-Ellen. "American Jewish Culture through a Gender-Tinted Lens." In *Judaism since Gender,* ed. Miriam Peskowitz and Laura Levitt, 78–81. New York: Routledge, 1997.

Ravits, Martha. "The Jewish Mother: Comedy and Controversy in American Popular Culture." *Melus* 25 (Spring 2000): 3–26.

Raviv, Moshe. [Moshe Vorobeichic]. *Polen.* Tel Aviv, 1950.

Reeve, Charles. "Balls and Strikes." Review of Alice Goldfarb Marquis, *Art Czar: The*

Rise and Fall of Clement Greenberg. London Review of Books. April 5, 2007, 27–28.

Reik, Theodor. Masochism in Modern Man. New York: Grove Press, 1941.

Rickard, Jolene. Across Borders; Beadwork in Iroquois Life. Washington, D.C.: Smithsonian, National Museum of the American Indian, 2002.

Rivo, Sharon Pucker. "Projected Images: Portraits of Jewish Women in Early American Film." In Talking Back: Images of Jewish Woman in American Popular Culture, ed. Joyce Antler, 30–52. Boston: Brandeis University Press, 1997.

Robertson, Ritchie. "Historicizing Weininger: The Nineteenth Century German Image of the Feminized Jew." In Modernity, Culture and "the Jew," ed. Bryan Cheyette and Laura Marcus. Oxford: Polity Press, 1998.

Rogoff, Irit. "Moving On: Migration and the Intertextuality of Trauma." In Vera Frenkel, . . . from the Transit Bar / . . . du Transit Bar, 267–43. Toronto: Power Plant/National Gallery of Canada, 1994.

Roskies, David G. A Bridge of Longing: The Lost Art of Yiddish Storytelling. Cambridge, Mass.: Harvard University Press, 1995.

———. "Introduction." In S. Ansky, The Dybbuk and Other Writings, xi–xxxvi. New York: Schocken Books, 1992.

———. The Jewish Search for a Usable Past. Bloomington: Indiana University Press, 1999.

———. "The Shtetl in Jewish Collective Memory." In The Jewish Search for a Usable Past, 41–66. Bloomington: Indiana University Press, 1999.

Roth, Henry. Call It Sleep. 1934. New York: Penguin, 1977.

Roth, Joseph. The Wandering Jews. Trans. Michael Hofmann. New York: W. W. Norton, 2001.

Roth, Philip. "Conversation in New York with Isaac Bashevis Singer about Bruno Schulz." In Shop Talk, A Writer and His

Colleagues and Their Work, 78–89. New York: Vintage International, 2001.

———. The Prague Orgy. New York: Vintage International, 1996.

———. Shop Talk: A Writer and His Colleagues and Their Work. New York: Vintage International, 2001.

Sacher, Howard. Diaspora: An Inquiry into the Contemporary Jewish World. New York: Harper & Row, 1985.

Safran, William. "Diasporas in Modern Societies: Myths of Homeland and Return." Diaspora 1 (1991): 83–99.

Sarna, Jonathan. "The Mythical Jewish Columbus and the History of America's Jews." In Religion in Age of Exploration, ed. Bryan Le Beau and Menachem Mor, 81–95. Omaha, Neb.: Creighton University Press, 1992.

Schmidt, Gilya Gerda. The Art and Artists of the Fifth Zionist Congress, 1901. Syracuse, N.Y.: Syracuse University Press, 2003.

Shneer, David, and Caryn Aviv, eds. Queer Jews. New York: Routledge, 2002.

Schoenburg, Nancy, and Stuart Schoenburg. Lithuanian Jewish Communities. New York: Garland Publishers, 1991.

Schulz, Bruno. Le livre idolatre. Warsaw: Interpress [1988].

———. Letters and Drawings of Bruno Schulz. Ed. Jerzy Ficowski; trans. Walter Arndt. New York: Harper & Row, 1988.

———. Sanitorium under the Sign of the Hourglass. Trans. Celina Wieniewska. Boston: Houghton Mifflin, 1978.

———. The Street of Crocodiles. Trans. Celina Wieniewska. New York: Penguin Books, 1977.

Schwabsky, Barry. "An Esthetics of Masochism?" Art in America 92, no. 4 (2004): 66–69.

"Second Thoughts about the Promised Land." Economist. January 11, 2007. Print edition: International.

Shaked, Gershon. "Alexandra: On Jews and Judaism in America." Jerusalem Quarterly 49 (Winter 1989): 47–84.

Shallcross, Bozena. "'Fragments of a Broken Mirror': Burno Schulz's Recontextualization of the Kabbalah." *East European Politics and Societies* 2 (1997): 270–81.

Shandler, Jeffrey. "The Time of Vishniac: Photographs of Pre-War East European Jewry in Postwar Contexts." *Polin* 16 (2003): 313–33.

Shapiro, Susan E. "The Uncanny Jew: A Brief History of an Image." In *Textures and Meaning: Thirty Years of Judaic Studies at the University of Massachusetts, Amherst*, ed. L. Ehrlich, et al. Amherst: University of Massachusetts, 2004.

Shneour, Zalman. "Vilna." 1920. Trans. Angus R. Shamal and William Levy. In William Levy, "Hanging Out with Zalman." http://www.semantikon.com/features. Accessed April 2005.

Shtern, Yekhiel. "A Kheder in Tyszowce (Tishevits)." In *East European Jews in Two Worlds: Studies from the YIVO Annual*, ed. Deborah Dash Moore, 51–70. Evanston, Ill.: Northwestern University Press, 1990.

Silver, Kenneth E., and Romy Golan. *The Circle of Montparnasse: Jewish Artists in Paris, 1905–1945*. New York: Universe Books, 1985.

Silverman, Kaja. *Male Subjectivity at the Margins*. New York: Routledge, 1992.

Spolsky, Ellen, ed. *Iconotropisms*. Lewisburg, Pa.: Bucknell University Press, 2004.

Steinlauf, Michael. "Transmigrations: Dybbuks in Poland." Unpublished paper, conference "Between Two Worlds: S. Ansky at the Turn of the Century." Stanford University, March 2001.

Struck, Hermann, and Arnold Zweig. *The Eastern European Jewish Face*. Trans. Noah Isenberg. Berkeley: University of California Press, 2004.

Tagg, John. *The Disciplinary Frame*. Minneapolis: University of Minnesota Press, 2009.

Teitelbaum, Matthew, ed. *Montage and Modern Life*. Cambridge Mass.: MIT Press, 1992.

Tölölyan, Khachig. "Rethinking Diaspora(s): Stateless Power in the Transnational Moment." *Diaspora* 5 (1996): 3–26.

Toynbee, Arnold J. *A Study of History*. 12 vols. Oxford: Oxford University Press, 1934–61. *Tracing An-sky: Jewish Collections from the State Ethnographic Museum in St. Petersburg*. Ed. Mariella Beukers, Renee Waale. Zwolle: Wanders Uitgevers; Amsterdam: Joods Historisch Museum, 1992.

Vishniac, Roman. *Polish Jews*. New York: Schocken Books, 1947.

———. Unpublished typescript. Vishniac Archive, International Center for Photography, n.d.

"Vishniac's Sad Tour of Duty." *Newsweek*. March 22, 1993, 68.

Vorobeichic, Moshe. *The Ghetto Lane in Wilna*. Zurich: Orell Fussli Verlag, 1931.

Weibel, Peter, ed. *Phantom der Lust: Visionen des Masochism in der Kunst*. Graz: Neue Galerie am Landesmuseum Joanneum, 2003.

Weinreich, Max. Review of M. Vorobeichic, *The Ghetto Lane in Wilno*. *Forverts*. September 20, 1931.

Weintraub, Aviva. "An American in Poland: Photography and the Jews of Eastern and Central Europe." *Jewish Folklore and Ethnology Review* 15, no. 1 (1993): 14–17.

Wertheimer, Jack, ed. *The Uses of Tradition*. New York: Jewish Theological Seminary, 1992.

Wischnitzer, Mark. *Visas to Freedom: The History of HIAS*. Cleveland: World Publishing Company, 1956.

Wolff, Janet. "The Impolite Boarder: 'Diasporist' Art and Its Critical Response." In *Critical Kitaj, Essays on the Work of R. B. Kitaj*, ed. James Aulich and John Lynch. New Brunswick, N.J.: Rutgers University Press, 2001.

Yehoshua, A. A. *Between Right and Right.* Trans. Arnold Schwartz. Garden City, N.J.: Doubleday, 1981.

Young, James E. *The Texture of Memory: Holocaust Memorials and Meaning.* New Haven, Conn.: Yale University Press, 1993.

Zemel, Carol. "Emblems of Atrocity: Holocaust Liberation Photography." In *Image and Remembrance,* ed. Shelley Hornstein and Florence Jacobowicz, 201–19. Bloomington: Indiana University Press, 2002.

———. "Forbidden Sights: Images of the *Khurbn.*" In *Iconotropism: Turning toward Pictures,* ed. Ellen Spolsky, 37–56.

Lewisburg, Pa.: Bucknell University Press, 2004.

———. "Zchor! [Remember!]: Roman Vishniac's Photo-Eulogy of Eastern European Jews." In *Shaping Losses: Cultural Memory and the Holocaust,* ed. Julia Epstein and Lori Lefkovitz, 75–86. Champaign, Illinois: University of Illinois Press, 2001.

Zipperstein, Stephen. *Elusive Prophet: Ahad Ha'am and the Origins of Zionism.* Berkeley: University of California Press, 1993.

Ziv, Avner, and Anat Zajdman, eds. *Semites and Stereotypes, Characteristics of Jewish Humor.* Westport, Conn.: Greenwood Press, 1993.

# INDEX

Page numbers in *italics* refer to figures or maps.

"Age of Genius, The" (Schulz), 64

Ahad Ha'am (Asher Ginzberg), 9–10

*Albert: Used to Be Abraham* (Aptekar), 3, *4*

Allen, Woody, 106, *107*

*Almstadstrasse frühere Grenadierstrasse Ecke Schendelgasse* (Attie), *98*

Altman, Natan, 23

*American Jewess, The* (newspaper), 110

Andersen, Benedict, 26, 33, 147, 159

An-sky, S., 24–26, 29, 171n20

Antin, Eleanor, 6, 15, 118–21, *119*, *120*, 124, 135

anti-Semitism, 9, 86, 87, 94, 102, 107, 172n42

Antler, Joyce, 115, 172n2, 174n21

Aptekar, Ken: Jewish identity in art of, 3–4, 6; Jewish manliness in works of, 4, 15, 129–32; texts in works of, 129–30, 134

Aptekar, Ken, works of: *Albert: Used to Be Abraham*, 3, *4*; *I Hate the Name Kenneth*, 129, *130*; *We Went to the Tailor*, 131–32, *131*

Ararat (Mordechai Manuel Noah's Jewish homeland experiment), 15–16, 151, 153

assimilation: Barbie dolls as symbol of, 126–27; and the desire to masquerade, 3–4, 126–27; and Jewish masculinity, 100–102, 108, 127–30, 132, 134; of Jewish women, 15, 104–107, 113–17, 119–22, 124–26, 173n6; newspaper reading as ritual,

26–27; resistance to, 56, 58, 76, 100–102, 127, 129, 167n7; tension of Jewish modernity, 23, 25–26. *See also* modernity

Attie, Shimon, *98*

Auerbach, Frank, 143

Azoulay, Ariella, 22

backshadowing, 20–22, 23, 83–84, 88–89, 102

bar mitzvah boys, 132, 134

Barbie dolls, 126–27

barrooms. See *Transit Bar* (Frenkel)

Beardsley, Aubrey, 66

*Beauty Supply District* (Katchor), 147

*Behind a Mask* (An-sky), 25–26

Benedict, Ruth, 174n21

Benjamin, Andrew, 142, 176n13

Benjamin, Walter, 22, 143

Benton, Maya, 86, 92

Berg, Gertrude, 113–14, *113*

Berger, John, 22

Berlin, 87, *98*

Bernstein, Michael Andre, 20–22, 23, 83–84

Bersani, Leo, 68

*Between Two Worlds (Tsvishn tsvey veltn)* (An-sky), 25

Bhabha, Homi, 7, 28, 165n21

Bienenstock, Adolf, 168n23

Blanchot, Maurice, 102

Bland, Kalman, 11

Bloom, Lisa, 121, 123

189

## CAROL ZEMEL

is professor emerita of art history and visual culture in the Department of Visual Arts at York University, Toronto. She has written three books on Vincent van Gogh, including *Van Gogh's Progress; Utopia and Modernity in Late-Nineteenth Century Art* (1997). Her work now focuses on Jewish and diasporic issues and on the ethics of visuality in modern and contemporary art. Current work includes a study of Jewish visual humor, and *Art in Extremis,* a study of images made by prisoners in ghettos and camps during the Holocaust.